Cover:

above left: Stanley Spencer. *Self-Portrait.*
Stedelijk Museum, Amsterdam.

above right: Charley Toorop. *Self-Portrait.*
1938. Oil on canvas. Stedelijk Museum, Amsterdam.

below left: John Singer Sargent. *William Merritt Chase.*
1902. Oil on canvas. Metropolitan Museum of Art (gift
of pupils of William M. Chase, 1905).

below right: Alfred Leslie. *Alfred Leslie.* 1966-67.
Oil on canvas. Whitney Museum of American Art (gift
of the Friends of the Whitney Museum of American Art).

the

ARTIST

EDMUND BURKE FELDMAN

University of Georgia

Prentice-Hall, Inc., Englewood Cliffs, New Jersey 07632

Library of Congress Cataloging in Publication Data

FELDMAN, EDMUND BURKE.
 The artist.

 Bibliography: p. 223
 Includes index.
 1. Artists—Psychology. 2. Art and society. I. Title.
N71.F43 1982 701'.1'5 81-21040
ISBN 0-13-049031-8 AACR2
ISBN 0-13-049023-7 (pbk.)

ISBN 0-13-049023-7 {P}

ISBN 0-13-049031-8 {C}

THE ARTIST
Edmund Burke Feldman

Printed in the United States of America
10 9 8 7 6 5 4 3 2 1

Editorial/production supervision by Rita Gilbert and Virginia Rubens
Interior design by Judy Winthrop
Page layout by Gail Cocker
Manufacturing buyer: Harry P. Baisley

Prentice-Hall International, Inc., *London*
Prentice-Hall of Australia Pty. Limited, *Sydney*
Prentice-Hall of Canada, Ltd., *Toronto*
Prentice-Hall of India Private Limited, *New Delhi*
Prentice-Hall of Japan, Inc., *Tokyo*
Prentice-Hall of Southeast Asia Pte. Ltd., *Singapore*
Whitehall Books Limited, Wellington, *New Zealand*

iv

CONTENTS

v

PREFACE

One way to reach an understanding of art is to look at the people who make it: artists. The thesis of this book is that there are several basic types of artists, that these types developed in historical sequence, and that they do not disappear. Works of art may be lost or destroyed, but the kinds of human beings who produce them are always with us. Not only that; new and neglected artistic types are continually being discovered. After finishing the book, however, the reader may conclude that these new types are not absolutely unprecedented.

In discussing the various types of artists as they have emerged historically, I try to make the point that social and artistic evolution proceed side by side. Even so, the development from ill-treated slave to pampered gallery god is not meant to suggest some doctrine of progress in the arts. I merely wish to demonstrate continuity and change among artists—in training and work, in cultural function, in patterns of patronage, in social recognition, in personal ambition, and in economic reward. Notwithstanding the research that "proves" there is a uniquely artistic or creative type, the following pages ought to show that artists are as unlike as hermits and movie stars. Their differences, I submit, testify to the fact that the process of artistic evolution and consolidation is still going strong.

Writing this book has been a refreshing experience. Over the years my students in art criticism—most of them artists—have tried to bring our discussions around to the subject of the artist. And I have stubbornly resisted, preferring to concentrate on the *work of art,* and trying (not very successfully) to talk about meanings and styles without

touching on the personalities, working conditions, and social status of their creators. There are certain theoretical and pedagogical advantages in this approach. Nevertheless, all of us have a natural curiosity about artists and the factors that influence their work. So this book is a kind of surrender to my students. It represents an alternative to my critical approach, and I feel good about having written it.

Here I should express my thanks to Norwell (Bud) Therien, at Prentice-Hall, for creating the itch that resulted in this book, and for his steadfast support as it was planned and written. Rita Gilbert edited the text and scolded the author from time to time, mostly with good reason. A little admonishment never hurts, especially from someone who cares about writing. Virginia Rubens filled the all-important role of traffic cop at Prentice-Hall, coordinating the efforts of author, editor, designer, and publisher at four different geographical points. My sincerest gratitude goes to Virginia Seaquist, who prepared the manuscript, corresponded with museums throughout the world, kept track of illustrations, and never (so far as I know) lost patience with me. Finally, I am grateful to Judy Winthrop for producing a handsome book design, and to Gail Cocker for solving the complex problem of integrating the text with a large number of pictures and captions. The picture labels amply demonstrate my indebtedness to the artists, galleries, museums, libraries, publishers, business firms, and collectors who have given us permission to reproduce the works of art that illustrate the text. Illustrate the text? Actually, the text illustrates the pictures.

EDMUND BURKE FELDMAN

the
shaman

More is known about prehistoric art than about prehistoric artists. Who executed the cave paintings? What sculptors carved the little female figures, the so-called "Venuses," of the Old Stone Age? Who were the Paleolithic engravers of animal images on bone, the painters of pregnant horses, the modelers of copulating bisons in clay? Without doubt they were "artists," but how were they selected, trained, and treated? Was every Stone Age hunter an artist? Were these artists men, women, or both?

Answers to these questions are conjectural to some extent; they have to be inferred from what is known about art and artists in surviving, or recently deceased, Stone Age and hunting societies. Still, all is not guesswork. Archaeologists, anthropologists, and prehistorians have assembled a considerable body of physical evidence about Stone Age art from their study of living peoples like Eskimos, Australian aborigines, Amerindians, African bushmen, Siberian hunters, and remote South American tribesmen. In all of these societies there is a type of person—occasionally a woman but most often a man—who is a combined sorcerer, healer, priest, psychiatrist, magician, artist. Unlike most contemporary artists (and doctors), he does not specialize. But this person, whom we call a *shaman*, is truly an artist and, from the surviving physical

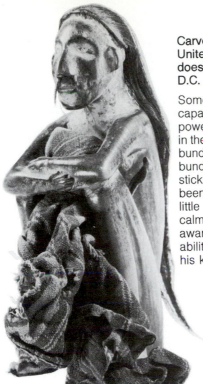

Carved shaman, Caddo tribe (?), South Central United States. Wood, paint, human hair, cloth, doeskin. Smithsonian Institution, Washington, D.C.

Sometimes artists are thought of as prophetic, as capable of revealing the future through the mystical power of their art. That notion may have its origin in the Indian shaman's practice of making a sacred bundle after having a visionary experience. The bundle was used to cure and to prophesy. It held sticks, stones, and animal parts—objects that had been shown to the shaman during his trance. This little sculpture has a strange majesty; it exudes calm and confidence. Possibly it is the shaman's awareness of a peculiar ability to see ahead, an ability conferred by the magical objects between his knees.

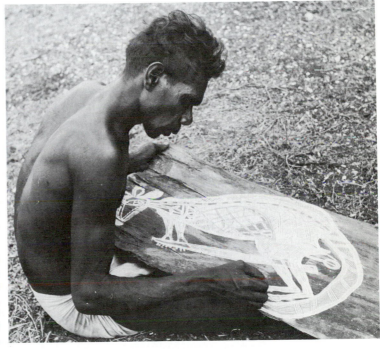

Australian aborigine making a bark painting. State Library of South Australia (Mountford-Sheard Collection).

A Stone Age artist at work. He has no model before him. The kangaroo image is engraved in his brain. He has hunted the animal, killed it, eaten it, and dreamed about it. The X-ray imagery reveals what he knows as well as what he has seen.

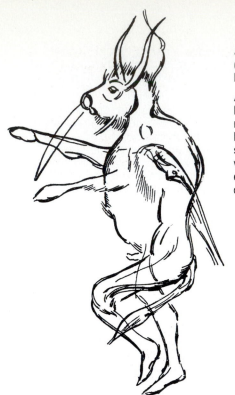

Shaman Disguised as a Bison. Magdalenian culture (15,000–10,000 B.C.). Engraving in Cave of Les Trois Frères, France (after Breuil).

A view of the shaman at work. His mask may be the head of a bison, touched up with color and sweat to make it look and smell real. The cave drawing had to be made by someone who was there, a person who saw or dreamed *and remembered.* And then drew what he remembered. In that interval—between the experience and its visual representation—the artistic consciousness was born.

evidence, a very good one. As the anthropologist Carleton Coon says: "Whatever else he may be, the shaman is a very gifted artist."[1]

According to Andreas Lommel, a Swiss ethnologist and scholar of shamanism,[2] the art of the Old Stone Age cave dwellers was created by artist-conjurors who worked mainly in a self-induced trance. In a trance state the conjuror or shaman received visions—usually of animals —and these visions were the source of his artistic activity: singing, reciting, drumming, dancing, miming, and image-making. Artistic activity was not conducted for its own sake but was part of the shaman's work as a healer. He practiced physical medicine and psychiatry as well as prophecy. In addition, his image-making was connected with hunting rites: the propitiation of angry animal spirits, replacing the bodies of killed animals, showing respect for the souls of admired beasts, depicting desired events such as the migration of herds into tribal hunting lands.

An important purpose of the shaman's painting and acting was to trick or lure game close enough to be slain. After the kill there may have been a certain amount of remorse or guilt, not to mention fear that the animals would be fooled less easily the next time. It was assumed, of course, that animals talk to each other. In so-called primitive society,

every act has spiritual reverberations. So there was a job of "diplomacy" to be done. Adversaries had to be deceived; the spirits of dead animals had to be placated, or bought off. That is where the shaman's art was especially useful.

We can see that complex motives accompanied the magical rites and the artistic activity connected with hunting. From the very beginning of human history, artists were "employed," so to speak, to communicate with unseen powers, to redress wrongs, to invoke supernatural protection, to ward off bad luck, to restore the moral balance of the universe.

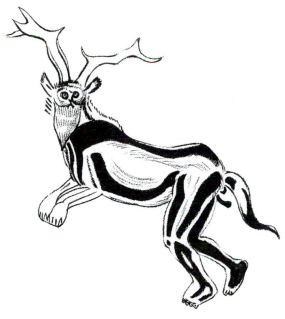

(above) *Dancing Shaman Disguised as an Animal.* Magdalenian culture (15,000–10,000 B.C.). Painting in Cave of Les Trois Frères, France (after Breuil).

The shaman must come very close to an animal in order to cast his spell. So he disguises himself with a kind of mask—the antlers, head, and pelt of a stag, and the tail of a horse. Impersonating animals calls for psychological identification and magical equipment—mimicry and a rabbit's foot, so to speak. Then artistic imitation follows. This painting on a cave wall probably is the shaman's account of his trance experience. Or it may be his report of what actually happened. In either case, the shaman-artist is a clever, devious fellow.

(below) Mask, Tlingit, from Southwest Alaska. Peabody Museum, Harvard University, Cambridge, Mass.

To carry out his responsibilities as a healer, the Tlingit shaman often wore a mask, a sign of his spiritual authority. The mask also functioned as a "transformation" device, putting him in contact with his "spirit-helpers." These were usually the guardian-protectors of his clan: bear, raven, fish, or reptile. Here the mask pictures the shaman's change of identity. As the patient witnessed this miraculous change, his own body was transformed and he was cured.

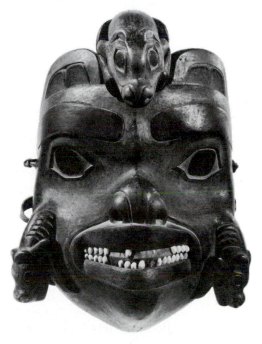

Obviously, the creation of images was more than a narrowly technical activity. To be sure, there was careful technical preparation. Still, formal rituals preceded artistic creation. Mask wearing, banner waving, drum beating, rattle shaking, shouting and leaping, singing, chanting and moaning—these activities often were preliminaries to the artistic act. Much ceremony took place *before* an image was incised in bone, painted on stone, carved in ivory, shaped in clay! The elaborate "get ready" activity of the shaman-artist was necessary to summon the image from its matrix in stone, to draw it out of the artist's consciousness, and—most important—to send appropriate signals to the spirits that preside over sacred ceremonies. Modern "get ready" rituals may be abbreviated, but they have a similar significance. They entail psychic preparation as well as technical mobilization.

The shaman knows that his totemic protectors are watching him and what he does. The earliest artist, then, is never alone—not in a psychological sense. We cannot overemphasize this point: Art at the earliest stages of human culture is meant to communicate. It involves more than technique, more than mixing ochre and red earth with animal fat and smearing it on a stone surface. It is a magical act; it compels as prayer compels. Whoever sees the image or witnesses its making—human, beast, or totemic spirit—will be moved to act as the shaman-artist bids him to act. This is what Stone Age people believed. The same conviction survives among us in altered form: The artistic image has the power to compel. Perhaps that helps to explain our fascination with the blobs, smears, lines, and streaks exhibited in our galleries and museums —the caves, rock ledges, and lodge houses of modern culture.

Personality of the Shaman-Artist

What are the chief characteristics of the shaman as artist? A primary trait is the strong reliance on visual recall. The animal art located in the recesses of a cave had to be created from memory. Its correctness of proportion, precision of contour, and accurate delineation of natural positions testify to the considerable knowledge of animal behavior we would expect among hunters. In addition, there is amazing visual tenacity, as if the sense of sight could be activated by touch and muscular contractions. But despite what these hunters knew, were all of them outstanding artists? Only some were. The ability to draw, engrave, or model living forms convincingly and *in the absence of the animal* points to a superior capacity to summon up identifying visual details from a wide array of sensory and other memories. It is true that modern Eskimos have

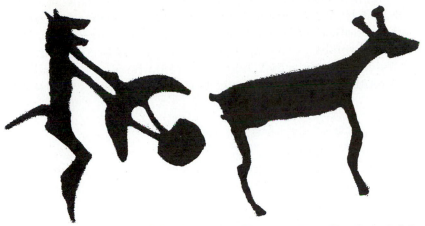

Siberian Sorcerer, cave painting from Lake Onega, northern Russia, U.S.S.R.

This cave painting is probably the shaman's own representation of one of his exploits. Wearing a wolf's head or mask, he gets close to a reindeer, makes a tremendous racket with his drum or noisemaker, and stampedes the animal toward his hunting companions.

Davidialu Alasua Amittu. *Woman Shaman and Apprentice in Tent.* c. 1962. Stone. Eskimo Museum, Churchill, Manitoba.

A rare example of a female shaman. Davidialu shows the shaman practicing her art inside her tent. The walrus between her knees must have been invoked from the spirit world—a magical (unreal?) creature! But the apprentice sees it. And so do we.

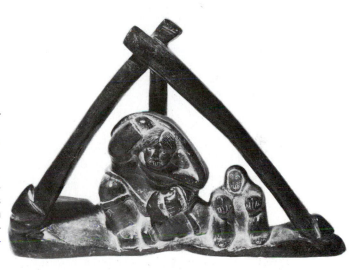

a remarkable ability to reproduce a complex set of behaviors after they have seen it once.[3] They have extraordinary powers of mimicry. Nevertheless, there are mediocre as well as excellent Eskimo carvers. However, the shaman was uniquely "gifted" even among the visually retentive individuals who comprised a Stone Age band of hunters. Why?

The shaman possessed exceptional powers of visualization because of the special circumstances surrounding his birth and training. First, he was identified very early by his family or his group; he may have been sickly, or crippled, or an epileptic. Perhaps a determined mother preserved the life of a defective child who would have been abandoned to die. A potential shaman! The group behaved differently toward this

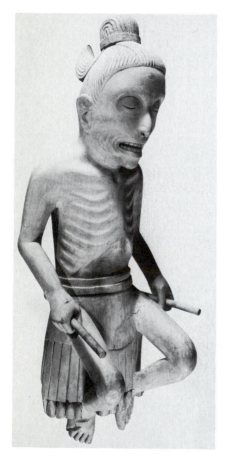

Charles Edenshaw (?), Haida tribe. *Dead Shaman,* from Queen Charlotte Islands. Collected 1882. Wood. Museum of Natural History, Princeton University, Princeton, N.J.

Even in death the shaman is shown as if communing with the spirit world. Through the partially opened mouth, the bent knees, and the hands holding ceremonial sticks, the native artist tries to represent death as a continuation of the shaman's mystical trance.

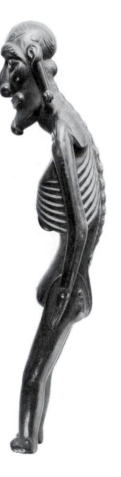

Wooden ancestor figure, from Easter Island. British Museum, London.

There is an extraordinary resemblance between the dead shaman of the Northwest American Indians and the wooden ancestor figure from Easter Island. Notice the emaciation, the bent knees, the facial similarities. At least three ideas are suggested by this resemblance: first, shamanism must have spread from Asia to Polynesia to America; second, the shaman's trance, like death, was seen as only temporary; third, the artistic and magical role of the shaman in hunting societies projected him into an ancestral and then a godlike role among seafaring and farming peoples.

child, reinforcing and augmenting his "strangeness"—that is, his possible power to commune with the protective spirits of the clan. Thus, visionary powers latent in all members of a hunting society were brought to a maximum intensity in this "different" person. The child might seem intended by birth for a special destiny, but in a real sense, his was a socially determined personality. Because of some peculiarity of temperament or physique, the group shaped his consciousness, using him for its communal and psychological survival.

A second trait of the shaman was his capacity to separate a special sort of optical information—contour lines—from all the other things he sensed in an animal. Here we have evidence of strong powers of concentration as well as the ability to distinguish among different kinds of sensory data. The shaman knew how to use *partial* visual information to represent a whole. In other words, we have in Paleolithic contour drawing an early stage of abstraction in thinking and in artistic execution. In fact, the use of the part for the whole in visual representation may have preceded the capacity to think abstractly. The role of abstraction is so important in art that we should comment briefly on its connection to shamanism.

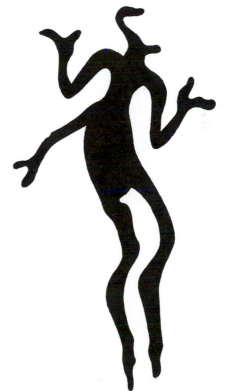

Rock painting of a "sorcerer," at Jarrestad, Skane, Sweden. Early 1st millennium.

Because the Ice Age lingered in the subarctic regions of Siberia, Scandinavia, Alaska, and Lapland, shamanism and hunting art lingered, too. This rock painting shows a shaman or sorcerer wearing horns and an animal pelt. The symmetrical arm gestures suggest that he is casting a spell.

9

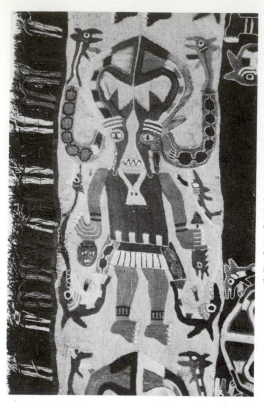

Embroidered textile, Peru. Paracas Necropolis style (c. 400 B.C.–A.D. 400).

Shamanistic imagery persists in richly elaborated forms among farming peoples, here in an often-repeated design that shows a manlike creature wearing a serpent for a belt, carrying a trophy head in one hand and a fish-shaped knife in the other. This idea of the shaman—as one who communes with earth, sky, and water demons—is vividly perpetuated in the multicolored textiles used as mummy wrappings for the noble dead of ancient Peru. The shaman's image and the emblems of his magical power were incorporated into the religious imagination of exceedingly skilled weavers, who spent years producing these ritual fabrics. In the highest development of Andean civilization, the shaman had evolved from sorcerer and medicine man into a miraculous intercessor for the deceased in the spirit world.

Abstraction and Shamanism

Who can say where the power of abstraction begins? We know the "naturalistic" painting and engraving of the caves is already "semi-abstract" and that it was almost surely created by a shaman-sorcerer. Now how did the shaman learn to separate lines, shapes, and colors from the totality of the animals he saw, loved, feared, and dreamed about? The answer lies in the "sickness" and "cure" of the shaman. Typically, he had undergone a long period of delirium or hallucination during his illness (and later in his voluntary trances) during which he experienced his body as *separated from* his spirit. In his hallucination the shaman saw his body dismembered and eaten by animals. (Later, these animals would be his spirit protectors.) Then the shaman "cured" himself by *visualizing* the reassembly of his separated body parts. So healing was closely associated with a reconstructive sort of seeing.

 All of us have dreams in which we "see" ourselves—that is, experiences in which we believe our "I" (our eye) watches our body from a distance. The shaman, however, rejoins the eye and the body, the viewer and the thing seen. He *acts artistically* on the basis of his trance

experience. That is what his group expects. It is his responsibility to recall the details of his adventures in the spirit world so he can assemble them meaningfully and report them in songs, stories, and drawings. We can think of the semiabstract art of the shaman as the product of a spiritual adventure, a vivid recall of hallucinatory images, and a powerful synthesizing act. Since he lives among people who hunt, kill, and eat animals, his art necessarily records what a hunter sees in his mind's eye: deer antlers, bison genitals, mammoth tusks, fish scales, bird gizzards, reindeer entrails. The merest mark or hint of these features is enough to activate his imagination. By "imagination" we mean the power to construct a whole image *mentally.* As for the enveloping contour, the hunter has spent his life watching for it amid the rocks and vegetation around him. That contour is *a thing,* an abstraction of the whole, which has been committed to visual (and probably muscular) memory.

Getting well, rejoining the parts of a broken body, making art—for the shaman these are accomplished in the same process. Through his illness and recovery the shaman developed a distinct idea of the difference between his body and his spirit. That experience led him to make a similar distinction between any substance and its animating force. This was the beginning of the ability to separate, analyze, and abstract. Everything we know about Stone Age culture, about hunting magic and shamanistic art, strongly suggests that the idea of substitution—of using a part to designate a whole—was established by Stone Age shamans.

A third trait of the shaman's art has to do with his skill, his command of craft. The exquisite contour line of the shaman-engraver as well as the sensitive three-dimensional modeling by the shaman-sculptor point to well-developed powers of observation and outstanding forming skills. Carpenter says, "Every adult Eskimo male is an accom-

Shaman's double mask, Niska, from British Columbia. 1850–1900. Museum of the American Indian, Heye Foundation, New York.

Wearing this two-faced mask enables the shaman to shift back and forth between roles. Through one mask he withdraws to the spirit world; in the other mask he speaks. In both masks his eyes are closed, a sign that he appears in the role of seer, as a man inspired by invisible beings. Invisible, that is, to eyes that are open.

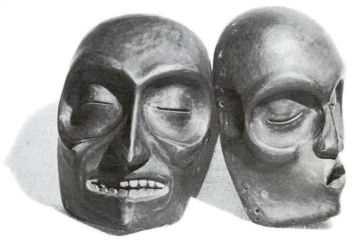

plished ivory carver . . ."[4] Still, different levels of quality exist in Stone Age art. The ability to carve, model, and draw may have been widely diffused among hunters, but some individuals were more accomplished than others. Even in a society where there is a minimum of specialization, the artistically "gifted" person emerges or is "forced" to emerge. That is because the group requires a single, authoritative source of inspiration. Again, we must stress the visionary role ahead of aesthetics: Beauty is an aftereffect.

Even if the shaman-artist enjoyed the exercise of his powers, we must not conclude that he or the members of his band were devotees of "art for art's sake." Purely aesthetic feeling as we understand it existed in a very rudimentary fashion at the dawn of human history. The perception of form as form is essentially a modern development. Practical effectiveness, healing power, negotiation with unseen spirits, the preservation of fleeting sensations and happy experiences—these were the main, essentially useful, functions of the shaman's art. For hunting peoples, a man-made combination of line, color, and shape almost inevitably signaled the presence of an animal. Because they loved that animal, they loved its image. This is as close as we can come to aesthetic emotion in Stone Age experience.

If aesthetics is a secondary concern of the shaman's art, what is the nature of his "gift"? Mainly, it is his possession of a mysterious psychological capacity, the ability to go into a trance in which dreams and sensory memories are revived. In the process of artistic execution the vividness of the shaman's vision depends on the exercise of a mental technique, a mnemonic trick. Lommel insists that the shaman-artist is wholly sincere, in no sense a trickster. Other anthropologists classify him with the medicine man who *does* engage in deception, slight of hand, and so on. Most likely, the shaman could perform in both roles; surely some of his trances were genuine. In any case, it is clear that the practice of shamanism required what we would call artistic inspiration, aided by a mental discipline that reversed the extinguishment of visual imagery.

As the evolution of the artistic consciousness proceeds, we shall encounter seemingly new creative strategies: strenuous physical exercise, automatic writing, drawing with the left hand, scribbling, exploiting images made by chance, staring at cracks in rock or plaster, copying children's art, painting while drunk, using drugs to loosen inhibitions. None of these are fundamentally different from shamanistic practice. The main point is that today's artists continue to rely on visual memories that they dredge up from the deepest levels of the self.

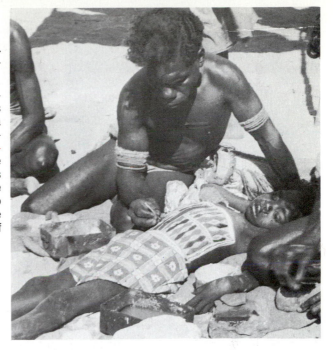

Australian aborigine painting a boy's body. State Library of South Australia (Mountford-Sheard Collection).

Australian body painting is a type of mask-making—with the whole body regarded as a mask. The artist may or may not be a shaman, but he perpetuates the shamanistic use of visual images to change the personality of the individual. Normally, the aborigine is completely naked. When his body is covered with a magical design, he becomes another person—someone who can wander in the spirit realm, someone who can travel back to the primeval time of his people.

Art and Shamanism Today

Any number of modern artists suggest through their imagery and creative methods the persistence of shamanistic impulses. One thinks of Paul Klee, of Marc Chagall, of Vincent van Gogh, of James Ensor, of Louise Nevelson. Perhaps Picasso was the greatest sorcerer and mimic of them all. This is not to say that these artists literally behaved like shamans, although Van Gogh's epileptic attacks and his drunkenness arouse our suspicions. However, we know that many contemporary artists endeavor to suspend ordinary modes of perception during the creative act. They rely, as Redon said, on "the uprush of the unconscious," and this suggests the persistence of shamanistic thought and behavior among men and women we regard as modern, sane, and sophisticated. Indeed, it is considered sophisticated to adapt the art forms of so-called "primitive" peoples; that is what some "advanced" artists do exclusively. Just as the Stone Age shaman relied on tribal memories, these artists attempt to draw on the fund of images that is common to humanity as a whole. It is assumed implicitly that the visual images created by children, by primitive peoples, by the insane, or by naive and unsophisticated artists, resemble the most elementary and fundamental patterns of human mental and perceptual activity.

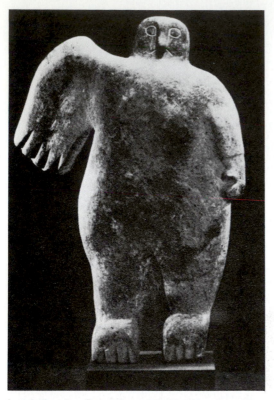

Latcholassie. *One-Winged Spirit,* from Cape Dorset. Soapstone. Courtesy Lippel Gallery, Montreal.

The Eskimo carving is probably more recent than the Klee etching, yet it projects us into the consciousness of a prehistoric shaman. We see a creature part bird, part animal, part human. Klee could not have seen this figure. Then how did he conceive of such a creature—part bird, part animal, part human? (Also, part tree.) Was Paul Klee some kind of wizard?

Paul Klee. *The Hero with the Wing.* 1905. Etching. Museum of Modern Art, New York (purchase).

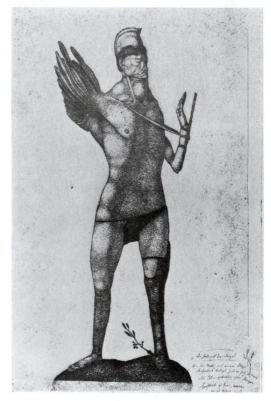

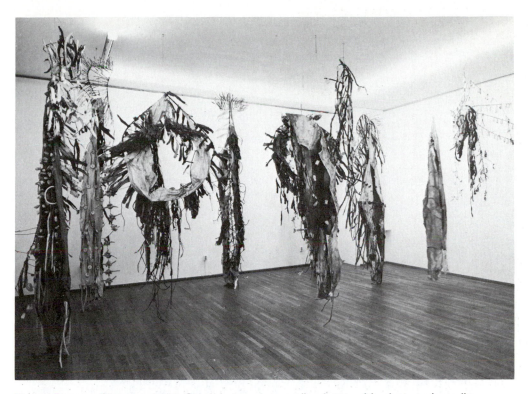

Nancy Graves. *Shaman*. 1970. Steel, Latex, gauze, oil paint, marble dust, and acrylic.
Wallraft-Richartz-Museum, Cologne (Ludwig Collection).

The shaman's costume—his beads, feathers, headdress, and fringed garments—are like
his drum and rattle: they help to summon his guardian spirits. Nancy Graves' multimedia
construction describes the ragged, harum-scarum quality of the shaman's costume. At the
same time Graves conveys the floating, dematerialized state of his consciousness. Does
this give us a clue to the contemporary artist's paint-spattered smock, patchy blue jeans,
scraggly beard, and "holy" shoes?

Whether or not it can be proved scientifically, living artists con-
tinue to work as if there exists within every person a vast, ancient
repository of common images. It is the same reservoir that Freud called
our "archaic heritage" and Jung called the "collective unconscious." But
why would contemporary artists strive to gain access to this primal
substratum of imagery? Because, like Paleolithic shamans, they want to
communicate with their fellow human beings at the deepest levels of
consciousness. So the methods, imagery, and outlook of the prehistoric
shaman constitute a permanent part of the modern artist's consciousness.
It might be said that artists differ only in the extent to which they draw
on their Stone Age legacy.

CHILD ARTISTS AND NAIVE ARTISTS

Before the twentieth century we could not have spoken seriously of "child" artists. The modern fascination with child art began around 1906 with Picasso's borrowings from so-called exotic art—mainly African, Polynesian, and prehistoric Mediterranean art. Aesthetic interest in child art followed. The nonartists' study of child art was part of a general interest in the problems of human origins. Psychologists, of course, had long studied child art in attempting to get at the roots of human perception and thought. But in Picasso's case it was not anthropological or psychological research that led him to incorporate the Dogon masks of West Africa into *Les Demoiselles d'Avignon* (1907); the same can be said about Paul Klee's and Jean Dubuffet's borrowings from the drawings of children. It was the aesthetic power and expressive force of exotic art that attracted these artists and inspired their emulation.

We cannot trace all the factors responsible for the decline of the classical European art tradition as a major influence on modern artists. A key factor, surely, was the sense of exhaustion and overrefinement that had overtaken the nineteenth-century academic scene. The reaction against academicism was angry, and it embraced whatever seemed most different: Oriental art, African art, Polynesian art, the art of the insane, naive art, and the art of children. Child art assumed fresh significance because it seemed natural and pure—uncorrupted by art school rules and

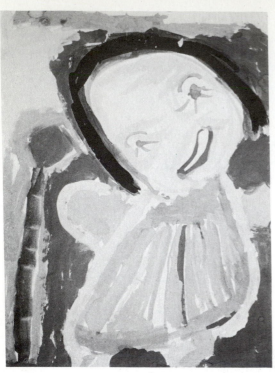

Child's Self-Portrait. Watercolor. Collection University of Georgia, Department of Art, Athens, Ga.

The size relations in the figure are quite correct for a young girl, although the arms are much abbreviated and the tree in the background is greatly reduced. That is because the tree is unimportant. What matters most is the central subject: she has learned to tilt her head and smile at the same time. She bewitches the viewer, and she paints her bewitchery.

theories. Most important of all, it was recognized as an independent mode of expression, governed by its own laws and capable of being admired for its own qualities. Only in this century has child art been seen as something more than imperfect adult art.

In saying that the child is an artist, we make a radical statement. We do not say the child *might become* an artist (which could be true); or that the child is talented; or that the child's work promises to get better. We say the child is an artist in the same sense that the Australian aborigine is an artist, even though the aborigine will never paint like Rubens. It is obvious that children—all over the world—are the creators of a distinctive sort of visual imagery. We recognize it instantly. Children make images just as they babble, speak, and sing; they scribble and draw without being taught. Whatever else it may become, artistic activity— a natural part of the child's social and psychological development—is valuable for what it is.

The connections between children's art and their total development necessarily interests psychologists and educators. The fact that drawing is a spontaneous activity of all children suggests the virtually biological association of art and human development. But here we shall

(left) Drawing by a hebephrenic girl. From J. H. Plokker, *Art from the Mentally Disturbed,* Little, Brown and Company, Boston.

(right) Salvador Dali. *Soft Construction with Boiled Beans: Premonition of Civil War.* 1936. Oil on canvas. Philadelphia Museum of Art (Louise and Walter Arensberg Collection).

When lay people say that modern art looks mad, they are not entirely mistaken. The psychotic artist deals with the same material as the Surrealist, Dali— the processes of transmutation, dismembered bodily parts, the metamorphosis of people into trees or insects, and vice versa. Clutching hands, skeletal arms, skulls, and terrible masklike faces—all are meticulously rendered. Case X, however, was a sick person. Dali pretended to be mad most of his life (except when he went to the bank).

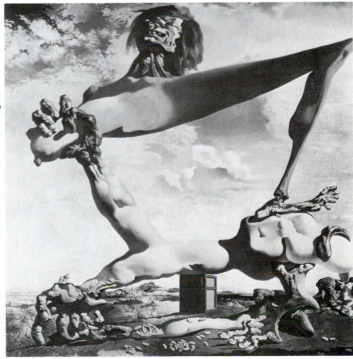

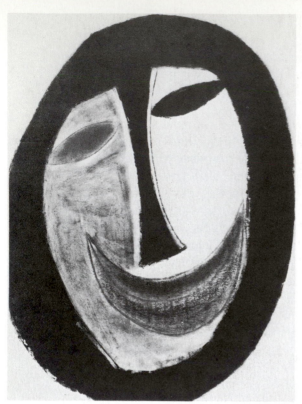

Drawing by a mental patient. Charcoal and chalk. From J. H. Plokker, *Art from the Mentally Disturbed,* Little, Brown and Company, Boston.

(below) Eskimo mask from Good News Bay, Alaska. 1875–1900. Carved wood, painted and trimmed with feathers. Museum of the American Indian, Heye Foundation, New York.

Notice that the face drawn by the mental patient resembles the face painted on the Eskimo mask. The mask belonged to a shaman, and it represented the spirit of a seal in both human and animal form. But it is highly unlikely that the mental patient had seen such masks. She suffered from hebephrenia—a disease of adolescence, mainly. This illness is characterized by hallucinations and reversion to childish behavior. The shaman, too, hallucinates easily, and he behaves like a madman ... when he wants to. The connection between the art of mental patients and the art of the shaman raises tantalizing questions about the way artists function—how they think—during the creative process.

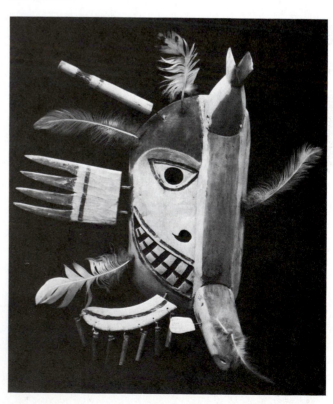

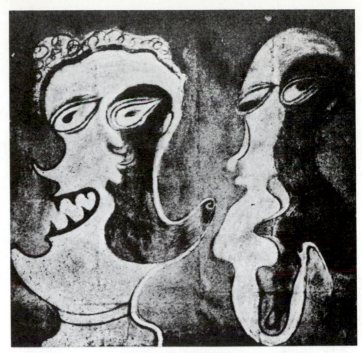

"Case 116." *Two Heads.* From Hans Prinzhorn, *Artistry of the Mentally Ill,* Springer-Verlag, New York.

Is there a connection here to the double mask of the shaman? Or to those heads of Picasso in which we see front and side views simultaneously? Certainly Dubuffet (a collector of psychotic art) drew directly on this sort of imagery. Many modern artists are searching for lost secrets of reality, and some try to find them in the images of the naive or demented imagination. The prehistoric shaman had no art to copy; he simply slipped back into his unconscious. That was his art museum. The psychotic artist *lives* in that museum. Permanently.

not concentrate on the interactions between child art and perceptual, emotional, and intellectual growth. There is a vast literature on the subject. Our main interest is in the child as an artist whose work is intrinsically valuable, socially significant, and aesthetically potent.

Motives of the Child Artist

What are the principal motivations of the child artist? At the earliest stage—the age of two or three—it is difficult to attribute a motive. The child's marks and scribbles are largely spontaneous; they are records of motor activity that please the child but do not as yet constitute artistic expression. Soon, however, the scribble is named or characterized. A

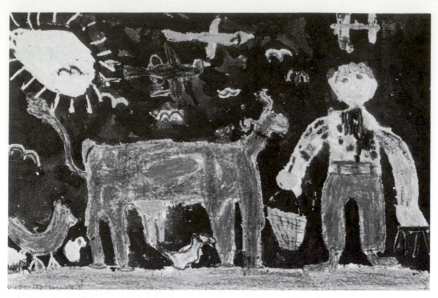

Child's Painting of a Farmer, Cow, and Chickens. Crayon and watercolor. Collection University of Georgia, Department of Art, Athens, Ga.

Child art shows us the world before the concepts of time and historical change have developed. Everything exists in the present: sun and sky and aircraft and farm animals and people. Even so, archaic modes of representation are preserved. The animals and the aircraft are in strict profile. And the major personages—the farmer and the sun—obey the ancient principle of frontality. Conceptually, the picture belongs to Old Kingdom Egypt.

genuinely artistic purpose appears as early as the fourth year: to imitate the appearance of people and things. Steady growth in ability to control lines and shapes follows; there is a clumsy organization of parts. By the age of five there are schematic images of figures and objects, symbolic representations of space and the environment, and a rudimentary ability to compose.

By the time a child is six years old the evidence of a wide array of motives is visible in drawing, painting, and modeling: self-expression, visual imitation, communication with others, symbolic control of reality, and some aesthetic play with form. These motives and purposes roughly parallel the evolution of art history in general. Of course, the parallel lines diverge with the achievement of maturity in the case of the child, and the onset of modernity in the case of art history. Nevertheless, the stages in the development of child art, and the range of artistic objectives pursued, convince us that child art is the reflection of a complete world. It follows that the child artist can experience the full cycle of a creative career. That career ends, as childhood ends, at adolescence.

Child's X-ray Painting of a Cow with a Calf. Collection University of Georgia, Department of Art, Athens, Ga.

Among Stone-Age hunting peoples the X-ray style expresses the belief that in portraying the vital organs of an animal (or a human being) they bring it back to life. But how do we account for the X-ray style in a modern child's painting? Can the child see into the cow's belly? Is it a matter of painting what is known rather than what is seen? Can the child distinguish between the two? Or does shamanistic thinking persist among children until we educate it out of them?

The child artist shares certain traits with the shaman-artist: both try to avert evil through visual imagery; both believe they exert a magical control over any creature they can depict; both have "X-ray vision"— they can *see through* the outer coverings of things. Neither the child nor the shaman is especially interested in the representation of space through perspective, foreshortening, diminished color, and so forth. The main differences between them are in technical control of tools and materials and in ability to recognize discrepancies between the artistic image and the creature or object it resembles. The child artist is convinced of the likeness between an image and its real model; the Paleolithic artist is not: the shaman can see three things at once: the image, its model, and the difference between them.

There is another important difference, in the representation of sexual organs and sexual acts. The Stone Age hunter sees an animal as a sexual being not unlike himself. The reproductive activity of humans and animals is an important part of his artistic activity. This sort of perception is not possible for the child, whose art is innocent in that it

"Case 36." *Cellar, Inn, Salon, Stable.* Pencil and watercolor. From Hans Prinzhorn, *Artistry of the Mentally Ill,* Springer-Verlag, New York.

It is impossible to decipher the title with confidence. What we can recognize is the totemic imagery—the bird and the manlike figure growing directly out of the subject's head, hovering over him much as the hawk god stands watch over the head of an Egyptian pharaoh. Notice also the double or echo image that faces the subject. Again, the psychotic artist reverts directly to the imagery of primitive and ancient cultures. His mental "censor" is damaged, or knocked out of action, so he sees and represents what our ancestors saw.

reflects an earlier stage of psychosexual development. Gender differences are hardly recognized in child art, or they are recognized by nonsexual signs and attributes. And that is a considerable source of its charm! The child artist is not close to nature in the sense that the hunter or stock breeder is. Indeed, there is something very "civilized" about the world the child artist represents. Its distinctions of sex, rank, age, and occupation are made for artificial and largely agreeable reasons. It is a fabulous, invented world; and yet it is psychologically authentic.

The Child-Art Aesthetic

We might look further into the appeal of child art. Surely it has a sentimental foundation—our affection for children and everything they say and do. There is, however, a deeper reason: we recognize in child art the experience of pure joy! Beyond the awkwardness in representation, the optical deficiencies, the sometimes angry explosions of paint, and the

signs of frustration with a line or contour that refuses to obey its author, there is an overriding sense of affirmation. It is the feeling expressed in the lines of Robert Louis Stevenson: "The world is so full of a number of things/I'm sure we should all be as happy as kings." In child art we repeatedly encounter the visual expression of this idea.

Of course, child artists also feel rage and fear. The artistic act is very often their principal means of coping with these emotions. But once they have made an image of a person or thing, they have in effect named it and reduced its threatening power; they share with prehistoric artists a sense of control over what has been successfully reproduced. We need only watch a child drawing or painting to recognize mounting feelings of mastery at difficulties overcome and, in the end, real jubilation. This is what adults—artists and spectators—remember and wish they still had. It is the same feeling the biblical writer ascribes to the Creator: "And God saw every thing that He had made, and, behold, it was very good." (Genesis 1:31)

A further word about the aesthetic interests of the child as artist: We have mentioned the joy in creating an image. But this joy should not be confused with sensuous satisfaction or aesthetic pleasure, which is a

"Case 122." *Woman with Wig.* Crayon. From Hans Prinzhorn, *Artistry of the Mentally Ill,* Springer-Verlag, New York.

Why have modern artists—especially the German Expressionists—been so greatly influenced by psychotic art? Because it gives them access to a world that sanity conceals. In this work fantasy and realism, childishness and maturity, obsessive detail and simplified form exist side by side. They represent the visual and stylistic counterparts of madness. And for a certain kind of artist —Kirchner, Nolde, Schmidt-Rottlauf—madness is the gateway to genius.

late-developing mode of appreciating combinations of shape, color, texture, and so on. The joy of the child artist is more closely related to the elation that follows overcoming fear. It is also an early manifestation of the instinct for workmanship: a child can experience gratification in the successful completion of a job. Finally, when the child artist first recognizes signs of resemblance between drawn imagery and objects in the real world, there comes an intense pleasure. This joy, which is founded on the strong instinct for mimicry in children, heralds the discovery of sameness or similarity, of the ability to make marks and signs that can stand for something else. Once visual likeness is discovered, the ground is laid for symbols, codes and systems, analogy and metaphor . . . language. The artistic development of the child recapitulates the linguistic evolution of humanity.

A social factor in child art activity needs to be mentioned: Young children rarely think of their art as personal property. Often they discard it or give it away. This suggests that much of the value of art *for a child* consists in making it. Interestingly, art in simple tribal societies is frequently abandoned after it has served its purpose. The focus is on the magical, expressive, and social value of the act of making. Contemporary artists share this feeling, but they are also caught up in the system of art exhibition, the selling of their art, and the requirements of an art market. This results in a tension in the art world that is largely unresolved—the tension between art as a precious commodity and art as a satisfying mode of expression, between the collectible object and the message it carries, between the experience of making and the experience of owning.

Naive Art

For purposes of definition, the naive artist is an adult who makes art but has received little or no artistic training. The term "primitive" is sometimes applied here, but it can be misleading if by "primitive" we mean a member of a preliterate or preurban society. The naive artist may be, in fact, a very sophisticated individual. Or, like Grandma Moses, this artist may be a wise and experienced person who has had no art school training and very little formal education. In other words, the outlook of the naive artist is not necessarily naive. It is the technique, the forming skills, that are naive. Even then, we are not sure; the technical achievements of Edward Hicks and of the Douanier, Henry Rousseau, are quite impressive. So in defining the naive artist we should not complain about the adequacy of the technique. It is not necessarily bad, it is *different.*

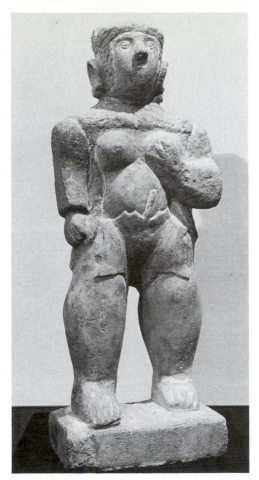

Will Edmondson. *Eve.* c. 1948. Limestone. Tennessee Botanical Gardens and Fine Arts Center, Cheekwood, Tenn. (gift of Mrs. Alfred Starr).

A black man who worked at odd jobs around Nashville for most of his life, Edmondson followed the late-developing pattern of many naive artists: he became a stonemason's apprentice at the age of sixty. At 65 he experienced a vision in which God called on him to carve sacred figures; for his remaining years he was an artist. Edmondson knew little or nothing about ancient statuary in the museums, yet his *Eve* could have been carved by a Sumerian sculptor in the third millennium B.C.

Simon Rodia. Watts Towers, Los Angeles, detail. 1921–54.

Simon Rodia, an Italian immigrant tile-setter, produced what might be called a work of naive architecture/sculpture. It was meant to express his gratitude to America, to its "nice people." Made of steel rods, cement, bits and pieces of bottle glass, seashells, and broken dishes, the towers are usually termed fantasies. But for the naive artist they make a great deal of practical sense: they are made of the same things America is made of. And they are put together very well.

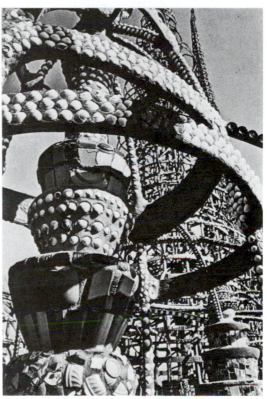

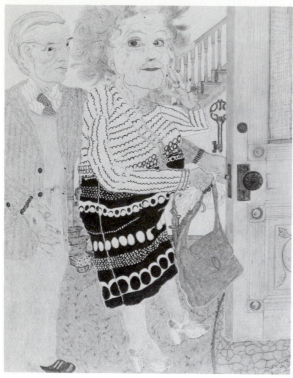

(above) Elizabeth Layton. *All Dressed Up and Going Out.* 1978. Ink, colored pencil, crayon, and metallic paint. Courtesy Don Lambert, Executive Director, Topeka Arts Council; Wichita Art Museum and Kansas Arts Commission Traveling Visual Arts Program.

"Grandma" Layton shows herself about to have a night on the town. She's wearing her best dress (too tight) and her daughter's high-heeled shoes (which make her dizzy). Elizabeth Layton took up art in her seventies. She draws exceedingly well, and—which is more important—she has some fresh and lively things to say.

(below) Pauline Simon. *Woman with Bouquet of Flowers.* 1966. Oil on canvas. Collection Don Baum, Chicago.

Like Elizabeth Layton, Pauline Simon first began to take art lessons in her seventies. But for some good reason, the instruction didn't "take." Her pictures, based on vivid recall of very early experiences, come to us directly, without passing through the filter of art school culture. So we witness a curious combination of childlike proportions and adult intensity. Simon is not trying to paint like Picasso. On the contrary, Picasso was trying to paint like Simon.

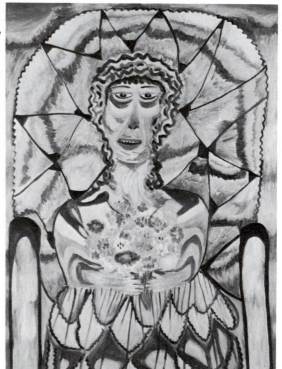

What we mean to say is that the naive artist works outside the standard traditions and conventions of art history and aesthetics.

Often the work of the naive artist is recognized by what it is not. It usually betrays no knowledge of linear or aerial perspective, no understanding of color theory, of classical proportion, of modeling forms with contrasts of light and dark, of depicting space through overlapping shapes and intersecting planes, of the difference between local color and optical color. Naive painters tend to outline forms and then fill them in with flat color. They compose additively and rarely employ the principles of optical or psychological subordination. Every detail is rendered fastidiously, and all are usually given equal rank. In addition, there is often considerable evidence of literary or oral inspiration. Naive artists tend to work rather ploddingly, inspired by craft and the mechanical pleasures of artistic execution. Aesthetic theory is not their game. Indeed, they may be good artists in spite of any theory they profess.

Lizzie Wilkerson. *Fishing at Pensacola.* 1979. Felt-tip pen and watercolor. Collection Jean Ellen Jones, Atlanta.

The elderly artist often draws and composes like a child. The space conception is very unsophisticated—no overlapping forms, no linear perspective, few changes in the size of figures as they recede. This may lead us to conclude that the *artist* is naive. Not really. Lizzie Wilkerson can represent a great many objects and events *simultaneously.* And she re-creates them as a kind of tapestry—the tapestry of her life. How many art school graduates can do as much?

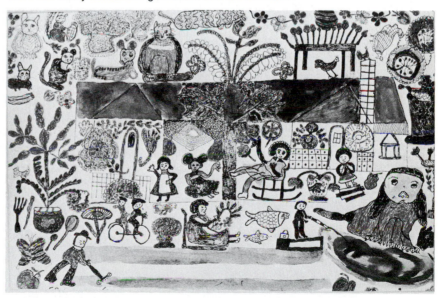

Naive Art and Bad Art

If naive artists lack professional knowledge of their craft, are they merely bad artists? Some are. However, professional artists can also be bad. In other words, badness is not solely a technical matter; anyone can fail artistically. Despite its lack of professional technique (or because of it), the work of naive artists attracts us. We recognize that it has achieved more than the artist intended or knew could be accomplished. This is a characteristic of naiveté in general. In art, naiveté is appealing because we are convinced of its sincerity and genuineness, its authenticity. Sophisticated viewers are often attracted to naive art because they have grown bored with cleverness, the repetition of familiar themes, the same devices of visual organization, the simulation of emotions that are not felt, the reference to ideas that are not truly understood.

Max Reyher and his painting, *Wailing Wall.* c. 1930. Oil on wood panel. From Sidney Janis, *They Taught Themselves*, Dial Press, 1942.

Naive artists are not ignorant people. Max Reyher was a gymnasium graduate, a student of optics at Heidelberg, and a good amateur entomologist. Without formal art instruction, he appears to have arrived at a Surrealist style independently. The same thing happens among professionals; Winslow Homer arrived at Impressionism independently. Unfortunately, art history cannot record the thousands of artistic inventions that are made "artlessly." A painter like Max Reyher reminds us that ideas and images do not care who discovers them.

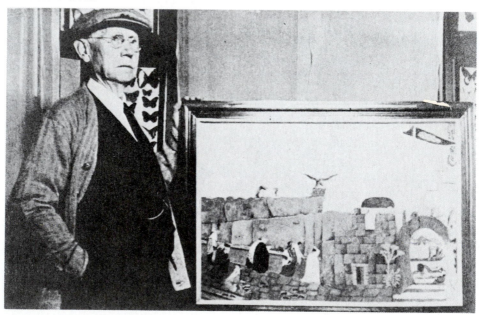

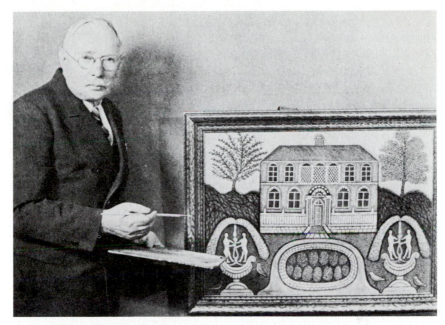

Morris Hirshfield and his painting, *Home with Fountain.* c. 1940. Oil on canvas. From Sidney Janis, *They Taught Themselves,* Dial Press, 1942.

Morris Hirshfield had been a garment worker and then a successful manufacturer of women's coats, suits, and slippers. Again, the naive artist is often a very competent person who simply decides it is time to make art. We can't assume that person thinks art will be easy. On the contrary, it is the difficulty that is appealing. After all, Hirshfield had succeeded in New York's cloak-and-suit industry! The aesthetically sophisticated person may be overwhelmed by the prospect of learning to manage shape, color, space, modeling, texture, rhythm, balance, anatomy, and composition. For Morris Hirshfield it was not especially terrifying. Meeting a payroll of three hundred garment workers is terrifying.

Simplicity of technical approach, freshness of vision, inability to deceive—these are traits of the child artist, too. And that is why we treat child and naive artists together. However, there is an important difference that ought to be mentioned.

Naive artists are adults, which is to say they are not innocent, unworldly, inexperienced. Their full physical growth has been completed, and therefore their visual imagery cannot be explained in terms of immature neurological and muscular development. The distortions of shape, size, or proportion we see in naive art cannot be attributed to ignorance of the real world. On the contrary, these distortions show us the real world as seen, experienced, and represented by a mature person.

So a trick has been played on us, a strange reversal of values; we are forced to acknowledge that the imagery of the naive artist is the product of honest observation and truthful representation. It is the world of the professional artist that is distorted! And that is because the standard artistic devices—perspective, fixed point of view, light-and-dark modeling, and so on—are themselves arbitrary. Naive artists *know* that the telephone poles in the distance are no smaller than those up close; they build a world on the basis of facts directly perceived, rather than facts screened through pictorial conventions—the nonfacts that artists pretend are true. So the work of the naive artist is potentially very important. It raises fresh possibilities of seeing and representing; it passes reality through a different filter, so there is a real chance that it may catch what the conventional filter loses.

John Kane in his milieu, 1929. From Sidney Janis, *They Taught Themselves*, Dial Press, 1942.

From an early age John Kane had liked to draw. But he was a poor Scottish immigrant, one of seven children, and had no chance for art lessons. Instead, he worked in the mines and mills of western Pennsylvania and eventually became a carpenter and housepainter in Pittsburgh. And an all-round tough guy. Underneath the barroom bravado, however, was a painter who built pictures as carefully as he constructed buildings. The naive artist usually has spent a lifetime at some other kind of work. And it shows; it has stylistic consequences, especially when it comes to creating forms. Forms have to be built up stitch by stitch, board by board, brick by brick. What we see is an artisan's approach to pictorial structure. When Kane painted a bridge, you knew it wouldn't fall.

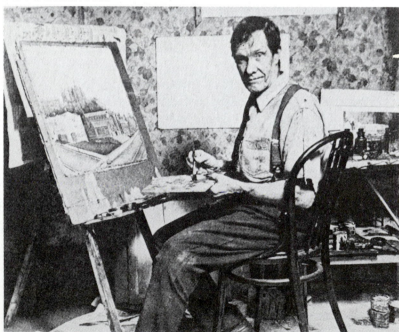

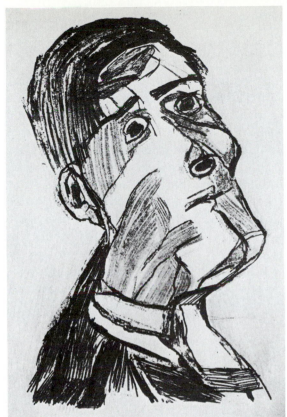

"Case 244." *Self-Portrait.* Crayon. From Hans Prinzhorn, *Artistry of the Mentally Ill,* Springer-Verlag, New York.

Here we see an extraordinary resemblance to the self-portraits of Oskar Kokoschka (who was, incidentally, badly shell-shocked in World War I). The genius of modern expressionistic artists consists of mastering a mental technique: they project themselves into the hallucinated, fear-ridden consciousness of the paranoiac or the schizophrenic. It is an extraordinary act of mental gymnastics, something that teachers of acting, like Stanislavsky and Lee Strasberg, cultivate in their students. Emotion comes first, technique follows. Painters are like actors: they must simulate ideas with their bodies before they can feel, know, and represent the ideas.

Oskar Kokoschka. *Self-Portrait.* 1920. Lithograph.

While Kokoschka lived in Dresden—from 1917 to 1924—his wild bohemian life style earned him a reputation as a mad genius—or at least a crazy person. He did, in fact, have a complete nervous collapse after the war. But his "madness" was self-induced. It had a purpose, a method: the development of an imagery that completely bypasses rational artistic processes; the representation of personal feelings without censorship of any kind; the communication of the artist's manic excitement as he feels himself entering an autistic state. Persuaded that the everyday world is truly mad, Kokoschka decided to see it as a psychotic sees it. And he succeeded.

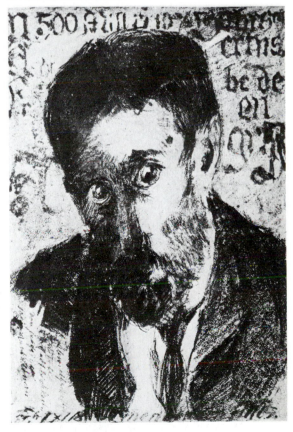

Conclusion

In both child art and naive art we see entire worlds represented according to different systems of perception. To be sure, there is some overlapping with the system employed by professional artists—that is, artists trained in Western methods of representation. But it is an error to believe that the visual systems of the child and the naive artist are defective. They become defective only when child artists grow dissatisfied with their work and decide they want to see and draw like adults. As teachers know very well, this normally occurs around adolescence and is accompanied by a kind of panic, an artistic paralysis. The transition from one system to the other is usually painful. For some it never occurs; for others it is accomplished visually but not artistically. So we have the anomaly, the frustration of a population of adults who see the world through eyes conditioned by the conventions of Western art but cannot produce artistic images according to those conventions.

PEASANT AND FOLK ARTISTS

if a peasant is someone who lives on the land and belongs, like a serf, to whoever owns the land, then peasants are virtually extinct in Western societies. But the habits and outlook of peasants live on in plain folk, whether rural or urban. Today, peasant art and music are made and appreciated by urban dwellers just as city music and art are enjoyed in the countryside. Modern communication has ended the isolation that maintained peasant art for centuries. Not all "rustics" live in the backwoods; it is possible to be isolated and provincial in the bowels of the metropolis. But if there are no peasants left, in the dictionary sense of the term, there may still be peasants from a cultural standpoint. It would be better to speak of them as "folk"—people who are unsophisticated, industrious, intelligent but not highly educated. They belong mainly to the skilled working class. Their imaginations, like those of their ancestors, tend to be governed by the rhythms of their work. These folk are psychologically descended from those first farmers whose lives were regulated by the land, the seasons, the weather, and long-established tradition. The qualities that characterize such folk—simplicity, honesty, predictability, resistance to change—also characterize folk art.

When using the word "folk," we tend to think of "country" folk, and that helps us to define the traditional folk artist, who might be

Bicycle Boy, trade sign for a bicycle shop in Greenpoint, Brooklyn. c. 1922. Painted wood and metal. Brooklyn Museum, N.Y. (H. Randolph Lever and Dick S. Ramsey Funds).

Folk art continues to be made—in urban as well as rural settings. This sculpture might be called commercial folk art. Nevertheless, it exhibits the typical qualities of the age-old folk art tradition: frontality, semiabstract form, realistic detail, careful finish. Notice how the mechanical knee and foot are combined with an almost classical naturalism in the face and chest. Consistency of form or technique does not especially worry the folk artist. This pragmatic approach to the job is what "fine" artists seem to envy . . . and imitate.

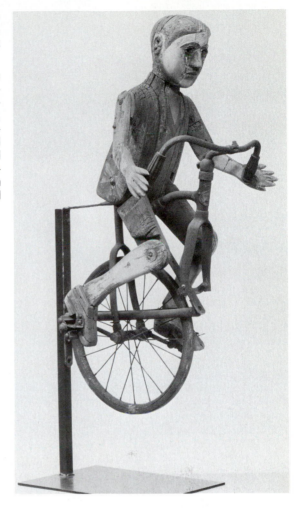

a farmer or a farmer's wife, a sailor, a miner, or a fisherman—someone involved in an ancient kind of work. What these people had in common was living and working in remote settings, away from cities. If they carved, painted, sewed, or built, it was in addition to performing a variety of other tasks. Some folk art was made by full-time craftsmen, a few of whom became "commercial" and insincere. The saving grace of the folk artists was that they produced for their fellow folk. The product was usually honest, but the fear of displeasing neighbors and friends prevented the taking of risks. Artistic innovation came from outside and was accepted slowly and grudgingly. The folk artist's talent had two com-

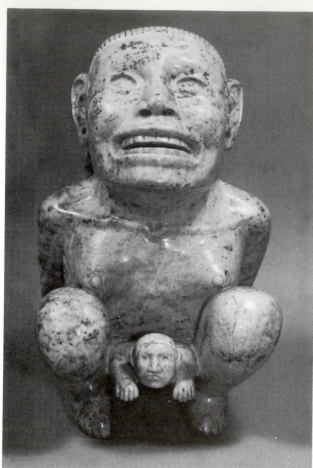

(below) *Tlazolteotl, the Aztec Goddess of Corn.* American Museum of Natural History, New York.

(left) *Tlazolteotl Giving Birth to Centeotl, the God of Corn.* A.D. c. 1500. Dumbarton Oaks, Washington D.C. (Bliss Collection).

Women and their birth-giving powers are one of the main preoccupations of art and religion in early agrarian societies. The idea of woman as the creator of all living things—even gods—has an important bearing on art and artists. Male artists obsessively repeat the same images of women and their reproductive organs, hoping that will maintain the earth's fertility. Female artists repeat their abstract (hence secret) magical formulas on pottery, basketry, and cloth, hoping their geometrical patterns will cause the germination of the seeds they have planted.

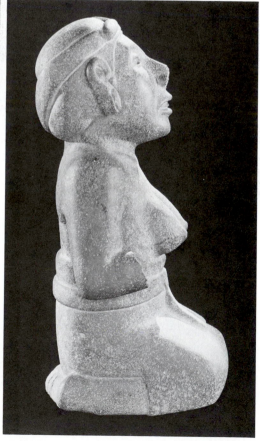

ponents: breaking down and simplifying high art imports; and producing objects that closely resembled what the community had always liked.

Today we speak of the "gaily decorated" character of folk art— the embroidery of a peasant skirt, the flowers painted around the edge of an earthenware bowl, the cheerful designs carved into the plain surface of a piece of furniture. From the standpoint of the folk artist this ornamentation enlivens the object, makes it bright and attractive. It is a concession to aesthetics. From another standpoint, the artist's wish to freshen up an object goes deeper than aesthetics. It reflects a deep need to cover vacant surfaces—the result, perhaps, of *horor vacui,* the fear of emptiness. The same motive may impel urban youngsters to cover the walls of a building or all the surfaces of a subway train with spray-can graffiti. Plain, undecorated objects make the folk uneasy.

An important fact about folk art is that almost all its ornamental motifs can be traced back to early, often Neolithic, magical signs. Without knowing it, the folk artist uses exceedingly old fertility and evil-

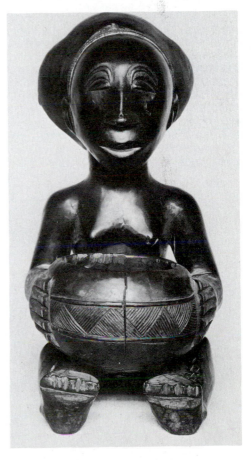

Seated Female Figure Holding a Bowl, Baluba, from Congo-Kinshasa. Wood carving. University Museum, University of Pennsylvania, Philadelphia.

The seated or kneeling woman holding a bowl is a standard sculptural type among the Baluba, a matriarchal people who live mainly by farming. Placed before the house of a woman expecting a child, these "begging" figures ask for alms for the goddess of childbirth. In agrarian societies female deities preside over human as well as plant reproduction, so they have to be propitiated. These sculptures are exceedingly impressive from an artistic standpoint, but they excel apart from their formal qualities. A sculpture works if it establishes an immediate connection between popular belief and real life. The folk artist realizes that practical and religious purposes must be served first. The formal aesthetic effect is good because the collective concerns of the Baluba have been dealt with simultaneously.

averting symbols. These symbols—now abstract or semiabstract—were once fairly recognizable images, but they have been copied from copies for centuries and thus have lost many of their distinguishing features. Nevertheless, they retain some of their original magical potency: they can comfort us and make us feel safe. Their bright colors and lively shapes still carry the message of seeds germinating, of fruit ripening, of winter giving way to spring.

Folk art is almost always utilitarian or applied art. Yet, it may be collected by dealers and connoisseurs who prize it for formal and decorative values. The "quaintness" of folk art is another of its attractions. But as far as the artist is concerned, these creations are meant to be used—physically used. Concepts of beauty, quality, and expressiveness are closely tied to the efficiency and durability of the object. Of course, folk artists exercise great care in selecting materials, in execution, and in the

Pottery jar, Hopi Indians, Arizona. National Museum of Natural History, Smithsonian Institution, Washington, D.C.

This pot is about a century old, but very little separates it from the Neolithic pots made in Europe about 8,000 B.C. Both wares were constructed by women using coils of clay, shaped and pressed by hand, and then dried, scraped, painted, and fired in outdoor kilns. This design, a stylized bird, belonged personally to the potter who made it. At the same time it belonged to the Hopi tradition. The potter dreamed the design and then painted it without any preliminary drawing; she dreamed the collective dream of her tribe and transferred it directly to her ware. To us it looks abstract; to her it was real. The Pueblo peoples are very conservative. Despite European influences, their religion and art have changed hardly at all since prehistoric times. These images are what the Hopi see inside their heads. When they can no longer see them, their culture will be dead.

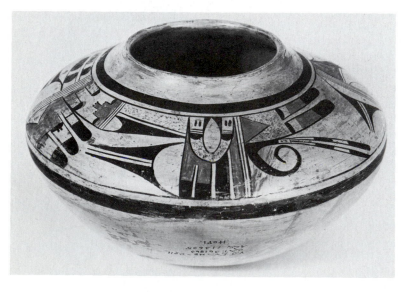

correct use of tools. They have convictions about rightness of finish and suitability of size and shape. However, they belong to a community of hard-working people, so the idea of art that "bakes no bread" is not easy for folk artists to accept.

It should be stressed that peasant or folk art is usually a sideline. Much of it is made in time spared from other jobs. The same is true of folk medicine, folk preaching, and genuine country music. This characteristic makes it sound like the work of amateurs or hobbyists, but the folk artist's quilts, signs, furniture, and baskets exhibit high competence. It would be a mistake to think of these objects as inferior from the standpoint of craft or utility. Again, as with the naive artist, we are dealing with work of genuine artistic worth created *outside* the norms of art-historical development and outside the high-art tradition. But folk art does belong to a tradition—the Neolithic tradition, which is the oldest continuous tradition we have.

Women and the Beginnings of Folk Art

Rural folk have produced a distinctive kind of "decorative" art since Neolithic times—from about 8,000 B.C. to 3,000 B.C. It can be argued that many of the arts and beliefs of the New Stone Age, substantially created or inspired by women, are very much alive today. Beginning in what V. Gordon Childe[1] calls "the Neolithic Revolution," the folk arts and crafts were established, along with the foundations of civilized life. During this period the male-dominated culture of the Paleolithic hunter gave way to the female-dominated culture of the agriculturist. The old shamanistic imagery centered on animals was supplanted by images dedicated to deities of the soil and vegetation. Gods and spirits associated with the seasons, with growing grain and renewing the fertility of fields, now preoccupied the human imagination. In a sense, the arts of landscape, still life, and decorative painting had their beginnings.

Women had always been gatherers of plants, collectors of seeds, berries, and roots. From this work they learned to domesticate wild cereal grains, thus becoming keepers of lore about the earth's fertility. Men had long worshiped women's personal reproductive powers; that is what the "Venus" figurines celebrated. Now, when women discovered the crucial processes of plant germination, men viewed them almost as sorcerers. With the dramatic increase in the food supply, there came a great improvement in women's status. Both the knowledge and the mystique were handed down from mother to daughter.

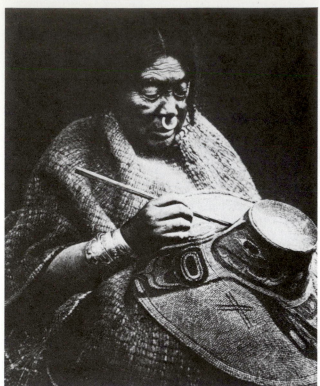

Kwakiutl woman painting totemic symbol on a chief's hat. c. 1914.

The bird image this woman paints on a chief's hat is more than decoration; it is a sacred symbol, the identifying mark of her clan. Here is evidence that women were artists even among hunting and food-gathering peoples. Indeed, the woman-artist functioned as preserver and recorder of the tribe's identification and protection system.

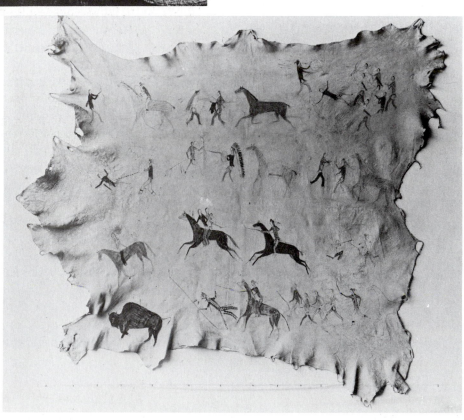

More food on a regular basis led to a population explosion during the New Stone Age. But larger populations could not possibly be sustained by food from hunting alone, so the hunter's status declined. As game disappeared, some groups became wholly dependent on agriculture, leading to the establishment of matriarchal societies. Male dominance continued where mixed farming, hunting, and stock raising prevailed. Only the pastoral peoples refused to settle down and submit to female dominance, choosing to remain nomadic and to live less securely outside the Neolithic villages governed by "earth goddesses." It was believed that these agrarian wise women controlled the Tree of Life (a persistent motif of Neolithic and folk art). From the standpoint of pastoral tribesmen these mothers consorted with the most mysterious and awesome powers of the earth.

(left) Painted skin robe illustrating the autobiography of the Shoshoni chief, Washakia. Department of Anthropology, Smithsonian Institution, Washington, D.C.

Chief Washakia records his exploits as a warrior and hunter. Compared to the imagery of the Kwakiutl woman, his art is freer and more naturalistic. The chief is on an "ego trip," whereas the Kwakiutl woman is constrained by the religious and artistic conventions of her clan. There are interesting stylistic trade-offs here; he gains realism and narrative interest by sacrificing abstract design; she gains symbolic power and visual potency by sticking to well-established tribal motifs.

Effigy jug, from Bath, South Carolina. c. 1817. Glazed clay. Augusta Richmond County Museum, Augusta, Ga.

It is typical of folk art that practical and symbolic functions are combined in the same object. The slave craftsman who made this jug managed somehow to retain the African tradition of the portrait jug, the container whose usefulness is enhanced by its bearing the likeness of a human being.

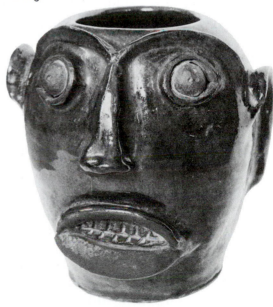

New artistic technologies were also created by New Stone Age women: spinning, weaving, and, most likely, clay pottery. These crafts were practiced by women as they clothed their children, prepared food, and stored seeds. The surfaces of their useful and ritual objects had to be "strengthened" with the kinds of signs that necessarily concern a community dependent on agriculture. There were symbols of human and animal fecundity, of course, but in addition these Neolithic women artists produced a new, geometric, and highly rhythmic type of imagery. It may seem to us flat and repetitive, but there is no doubt that this "decoration" was a magical art devoted to making plants grow. Especially on pottery and textiles, we see geometricized symbols of sun, moon, sky, clouds, thunder, rain, seeds, gardens, flowers, and fruit. Pleasing to the eye, but not dynamic like hunting art, this imagery served as a kind of visual blessing; no object was complete without it. Scholars argue about whether the geometric "designs" in folk art grew out of the processes of weaving and plaiting, or whether they represent abstract and generalized versions of the naturalistic images inherited from the Paleolithic. Both explanations are probably true. Herbert Read speaks of two kinds of geometric art from this period: "one, a disinterested ornamental art arising out of and during the course of technical processes; the other a purposive art determined by symbolic ends."[2]

This early art of women, which is the prototype of folk art in general, is repetitive and conservative. Differences in style and technique are visible *between* tribes or regions but not *within* tribes or regions. Several factors account for this fidelity to tradition. First, Neolithic (and folk) art are magical, and therefore their effectiveness depends on following inherited formulas and recipes exactly. Second, orginality is not regarded as a virtue in tribal (or folk) societies. Third, Neolithic woman was not a hunter whose life depended on acuteness of vision and ability to recall optical impressions. Her memory was focused on methods, on following learned patterns, on precise sequences for doing things. Even in modern Neolithic societies, women's lives consist of much hard work, especially repetitious handwork. There is little variation from established routine and no reward for independence. The work style would inevitably be reflected in the art-style. Finally, the whorls, spirals, circles, waves, arrows, meanders, eggs, and dots of Neolithic art belong to the long process of transition from optical image to pictograph to written symbol. Visual imitations of natural forms now yield to marks that signify words and ideas. The oral tradition has become so strong that it threatens to overwhelm the pictorial tradition. But if the vital, organic contours of Paleolithic animal art were sacrificed in the schematic art of

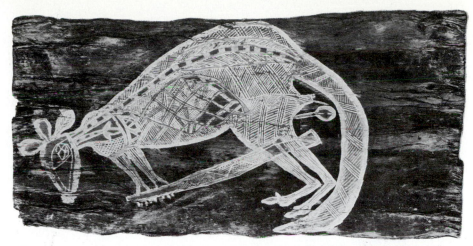

Australian aborigine bark painting of a kangaroo, from *Australia Aboriginal Paintings–Arnhem Land.* © Unesco 1954. Reproduced by permission of Unesco.

The lines inside the contours of the kangaroo figure are based on ancient X-ray images of the animal's bones and internal organs. Here they have been virtually absorbed into an overall linear pattern. Ribs, heart, lungs, and intestinal forms have become the framework for an integrated semiabstract pattern. In a single bark painting we can see how hunting art evolves into a type of folk art. The aborigine folk artist repeats a formula passed down from father to son, and today, in some parts of Arnhem Land, from fathers to mothers and daughters.

the New Stone Age, there were linguistic gains: the ability to record complex processes; the compression of meanings into economical signs and symbols; the establishment of a foundation for mathematics.

Traits of the Folk Artist

At first it seems difficult to distinguish the folk artist from the naive artist, the amateur, or even the child artist. But there are differences. The first is social: folk artists are adult members of the working class. Their formal education is limited; their art is made for family, friends, and neighbors, the people they know. The second difference has to do with purpose: folk art was originally, and now is unconsciously, magical, which is to say that it is related ultimately to Neolithic thought and behavior. Third, naive and amateur artists exhibit a wider range of aesthetic aims. Aside from their lack of skill or art-school training, they often have the same intentions as professional artists and craftsmen.

It is true that the folk artist and the child artist have a common bond in their affection for growing things. They share a love of repetition and rhythm. And the qualities of joy and humor are often visible in their

Afro-American Cigar Store Indian. c. 1810. Laminated wood, black stain, green and gold paint. New York Historical Association, Cooperstown, N.Y.

Some of the carvers of nineteenth-century cigar store Indians were black. It is believed that this figure was made by a slave named Job, from Freehold, New Jersey. Of course, slave craftsmen were cut off from the African woodcarving tradition. Nevertheless, the modeling and the arrangement of forms in the upper half of the sculpture are reminiscent of African statuary. The folk artist learned his art in four ways: by copying, by transferring the skills of another trade, by trial and error, and by intuition. Here intuition plays a major role.

José Rafael Aragón (?). *St. Jerome (San Gerónimo),* Chapel of Our Lady of Talpa. c. 1838. Carved wood, gesso, and tempera paint. Taylor Museum Collection, Colorado Springs Fine Arts Center, Colo.

Rafael Aragón, the *santero* who probably carved and painted this sculpture, was a part-time farmer. But he also received many commissions, which he carried out with his helpers. In other words, he was a professional. Then what makes him a "folk" artist? Two factors. First is his simplification of the Spanish Baroque forms that served as the ultimate models for these *santos.* Second is his adaptation to the plain but intense religiosity of his clients, the ordinary people in the parishes of nineteenth-century New Mexico. Aragón's artistic strategy was in some respects very sophisticated. He converted the academicized Baroque of the cities into a vehicle that suited the unworldly faith of the isolated villagers. He was a "folk-professional."

work. But there is nothing spontaneous about folk art; its approach to ornamentation and composition is carefully worked out in advance. This is especially true of the geometric designs—the permutations of square, circle, and triangle—that pervade folk art. In addition, the hand and mechanical skills of the folk artist are superior to those of any child. Finally and most important, child art continues to evolve stylistically, whereas folk art changes hardly at all.

If only because of their backgrounds as skilled workers, folk artists are good craftsmen and are frequently ingenious in improvising and using new materials and techniques. At the same time, they are conservative, like their Neolithic ancestors, about introducing new themes and stylistic motifs. The folk artist tends to avoid controversial ideas or painful subject matter. There are two reasons for this cautious traditionalism. First, folk artists have no connection with the "high art" tradition, the connection gained through art school training, and therefore they know nothing about the evolution of styles, the search for artistic individuality, the art-exhibition system, and the world of ideas that flourishes around professional artists and dealers. Second, the folk art process takes place within an organic community. Folk artists have face-to-face relationships with the people who own and use what they make. Because artist and "consumer" live close together, the exchange of cash or the delivery of the object does not end their association. The bridal gown, the infant's cradle, the lace bedspread, the linen chest—all are made for specific persons, either as gifts or because they were individually commissioned. Thus, the requirements of a real customer take precedence over the artist's drive toward self-expression. The work of the folk artist may appear to be virtually anonymous, but it belongs to a set of highly personal interactions.

There is a tradition of folk artists imitating "high art," for example in copies of religious paintings and temple or church statuary. There is also a "copying down" of secular objects, as in the French or Italian provincial versions of court and palace furniture. The scroll-sawn, carpenter Gothic farmhouses of nineteenth-century America are a good example of "native" ingenuity in copying, adapting, and missing the point of high art originals. That is folk art's appeal, the appeal of the sophomore—clever and foolish at the same time. Concerning a widely admired type of folk architecture, Talbot Hamlin says: "Indeed, much of the charm of many California missions comes from just this combination of sincere effort, naive ignorance, and unskillful execution."[3]

Folk artists usually fail, or they perpetrate unconscious humor, when they try to reproduce the art of the museums and galleries. Like the mythological giant Anteus, the folk artist loses strength when away from home ground. What is home ground? Frontality, symmetry, and rhythm are its trademarks. The best folk art productions—whether the object is a weathervane, a scarecrow, a portrait painting, or a gravestone carving—rely on these three principles. This preference for frontality, symmetry, and rhythm constitutes a mental legacy from Neolithic art. We see traces of it in "modern" folk art, even when the material used is steel, glass, or plastic and the artistic instrument is a computer stylus or an acetylene torch. The characteristic fault of the folk artist is *technical overcompensation*—excessively complicated surface effects used to cover up fundamentally simple ideas.

The Folk Artist Today

As mentioned earlier, it is hard to maintain the distinction between rural and urban in modern society. The folk artist used to be a farmer who painted or carved during the winter; a farm wife who sewed and embroidered in her spare time; a sailor who whittled when he was off watch. However, industrial society has its off-seasons too. There are part-time jobs, real or enforced vacations, periods of unemployment, long weekends, early retirement. There is also the seven- or eight-hour day. In other words, modern factory or office workers have regular periods of free time to make art; they have basement workshops, kilns, photography darkrooms, space to paint, tools to cut, weld, solder, and cast. And, like folk craftsmen, they produce for family and friends.

Can we speak of such workers as folk artists? To my mind, there is no question that industrial society breeds its own kind of "folk" who produce authentic folk art. Perhaps we should call it "proletarian" art. We see it at country fairs, in suburban shopping centers, on city sidewalks, in the back streets of resort towns, in provincial galleries, in out-of-the-way frame shops. Whoever has judged many of these shows can quickly identify the familiar themes and styles of the folk-art tradition. The old folkish tendencies are still visible. Certainly the ornamental motifs and the compositional schemes are much the same. Neolithic thinking dies hard.

The term "amateur" is satisfactory for only some of these sidewalk and fairground exhibitors. The amateur tends to produce banal imitations of big-city "sophisticated" art; the absence of authenticity is

Chilkat blanket, from Southeastern Alaska. National Museum of Natural History, Smithsonian Institution, Washington, D.C.

Lee Bontecou. *Study for Lincoln Center Mural.* c. 1965. Pencil. Weatherspoon Art Gallery, University of North Carolina at Greensboro (Dillard Collection).

High art or museum art often derives from folk art, although the artist may not be aware of it. In music, Brahms built on the dances of Hungarian peasants. (Actually, he got those dance rhythms at second hand, from a pianist friend.) Lee Bontecou follows the Chilkat tribal imagery quite literally. But she *builds up* the forms in her construction, and this relates them to the contemporary "shaped canvas" style. Even so, the power of the Chilkat totemic bird shows through.

Walker Evans. *Penny Portraits in Photographer's Window, Birming-ham, Alabama.* 1936. Library of Congress, Washington, D. C.

Snapshot portrait photography is a good example of the folk art of indus-trial society. No stylistic pretensions, no aesthetic effects—just an honest, workmanlike job. Along comes Walker Evans with his documentary camera, and these unpretentious "mug shots" become—in the aggre-gate—the stuff of high art.

readily recognized. Even so, we can detect traces of Stone Age magic in the pretty watercolors and oils of little old ladies and gentlemen; in the wicker baskets, embroidered towels, and fantastic pots of weekend craftsmen; in the drawings, prints, and mixed-media productions of in-credibly unoriginal Sunday painters. Like gallery artists, they want to sell their work (and some do very well). But if no one buys it, they are just as pleased. Making it was fun.

THE CLASSICAL ARTISAN

\mathcal{T}oward the end of the Neolithic era—around 2,500 B.C.—small villages grew, and outside settlements were amalgamated into city-states. True civilizations began to emerge, featuring large populations living under centralized administration, food surpluses based on improved methods of irrigation and tillage, increased division and specialization of labor, and professional armies that conducted wars of defense and aggression. These wars produced masses of prisoners who, if they were not killed, became slaves. The economies of the ancient and classical civilizations were built on a foundation of slavery.

In examining the role of the artist in the ancient world, we need to understand the influence of slavery because (1) it provided a more or less permanent supply of low-cost labor and tended to discourage technological innovation; hence changes in the arts and crafts took place very slowly; (2) slavery made it possible for a small class of free citizens to enjoy leisure, social pleasures, the delights of contemplation, political debate—anything but manual labor; and (3) the association of manual labor with slaves or ex-slaves became a permanent feature of aristocratic culture.

So we have to use the term "artisan" to designate painters, sculptors, and craftsmen in the ancient world, because the concept of the artist

Egyptian Artisan Forming a Pot on a Wheel, from Giza, Egypt. Third millennium, B.C. Limestone carving. Oriental Institute, University of Chicago.

The potter here is using a "slow" wheel, turned with the left hand while the clay is modeled with the right. The mechanical wheel, introduced later, enabled the potter to use both hands, to increase production, and to create more varied shapes. Craftsmen in ancient Egypt were serfs or slaves, even if they worked for the government—in the pharaoh's palace or in a temple workshop. According to Sir Leonard Wooley, "All who worked with their hands, builder or smith, stone-mason or baker, were as contemptible as they were unfortunate."[1] Outstanding artisans might receive better treatment, if recognized by a royal or priestly overseer, but they could not organize into guilds. They were, in effect, household slaves of their noble masters. Because their trades were hereditary, they were attached to their place and their craft, like serfs to a plot of land.

did not exist. No one thought of painters and sculptors as being any more than skilled workers, or technicians. Indeed, the word "technician" has its origin in the Greek word, *techne,* which means "making." This is distinguished from making inspired by wisdom, *sophia,* or inner knowledge; it is just plain making.

Before the concept of the artist could emerge—or the notion of "genius" as applied to certain artists of the Renaissance—it was first necessary to regard the artisan as a person whose work develops from *inner ideas* and *self-directed effort.* This was not possible in the ancient world, because the artisan was someone closely associated with the slave class, subject to external direction and supervision. From the Greek point of view, the artisan engaged in *praxis,* or ordinary making. An artisan did not enjoy the prestige of the poet who engages in *poesis,* which is inner-directed or "inspired" making. The distinction between the manual arts and the liberal or free arts began in the ancient world, and its vestiges linger on. To this day, it is difficult to persuade people that artists think while they work, that the hands of a painter, sculptor, or craftsman are guided by mind as well as muscle.

Ancient Attitudes Toward Craft

The almost universal disdain for artisans in the ancient world had its source in the warrior outlook. To raiders, pirates, and marauders, the only honorable work for a man was fighting, looting, capturing prisoners, and taking women. This is what the classical hero sang, talked, and dreamed about between battles. Among the Greeks it was believed that *agon,* or struggle, brings out the best in human nature. Their noblest women and men would rather die than be captured and, as slaves, forced to do manual labor. If the "best" people conquered or died in battle, then it follows that captives must be the worst. In other words, slaves were not only at the very bottom of the social scale, they were also morally unworthy.

When ancient warriors captured a city, they killed those who might continue resistance. Then they set themselves up as governors of the subdued population, married the wives of their dead enemies, and went about producing a ruling class that called itself an aristocracy—rule by the best. Because the slaves worked, the time of the governing class could be spent playing war games and attending to civic affairs. The defeated inhabitants of the city—some slave, some free—carried out the practical tasks of daily life. They, too, produced offspring who were destined from birth to work at the menial jobs needed to maintain the city. Some might rise socially when new war captives were brought in to do the dirtiest work. Others might rise because their skills were in short supply. But anyone with working class origins—even a person who owned slaves, became rich, and enjoyed the benefits of leisure—was marked inferior because of not having descended from the city's conquerors. So there were two, mainly aristocratic, reasons for the contempt toward classical craftsmen: the warrior's revulsion toward any work but fighting or governing; and the low birth, equivalent to moral inferiority, of those who labored with their hands.

Another, more realistic, reason for the low status of ancient artisans was the danger inherent in their work. Some were crippled, crushed, and suffocated in the mines; others were burned at the forge, asphyxiated in kiln fires, poisoned in the tanneries. For male artisans, there was another problem. The ancient Greeks had strong ideas about the beauty of male bodies. They thought of the blacksmith's or stonecutter's bulging muscles as deformities. The notion of the artisan as physically deformed was widespread. It may have originated in the practice of ancient agricultural peoples who deliberately maimed metalsmiths so they could not run away. Others were branded so escapees could be identified. The

Relief carving, from the Palace of Sennacherib at Nineveh, Assyria (modern Iraq). 704–681 B.C. British Museum, London.

These are slaves dragging a colossal statue to Sennacherib's palace. The idea of repetition is uppermost—in the forms of their bodies, in the identical slant of their backs, and in the solemn immobility of their features. All this testifies to the majesty of the king . . . and the absolute wretchedness of the slave. The ancient artisan was just a notch above these miserable creatures.

Egyptian Artisans Making Mud Bricks, from the tomb of Rekh-mi-Re, Thebes. c. 1450 B.C. Painted frieze. Metropolitan Museum of Art, New York.

The labor-intensive idea of art comes to us from the slave system of the ancient world: mixing mud and straw, shaping the mass, and drying the soft bricks . . . endlessly . . . for thousands of years. This process gives us the idea of art in a society where the cost of workmanship is almost nil and the time for construction is almost endless. But however consistent in quality, the element of inspiration is notably lacking in Egyptian art. Originality implies a degree of artistic freedom that is relatively recent in human history.

Roman god of the forge, Vulcan, was usually represented as lame, because slaves and skilled workers were in fact crippled by their masters. In ancient Egypt, the sight of Israelite slaves in chains, building pyramids under the brutal supervision of their overseers, inspired little envy. The same can be said of the convicts and German prisoners of war who worked as miners, stone crushers, and galley slaves for the Romans. So, aside from considerations of honor or prestige, the earliest civilized ideas of manual labor were associated with pain, ugliness, and brutality.

Education of the Craftsman

For most artisans in the ancient world, training in a craft was the natural result of being reared in a craftsman's household. Sons learned from their fathers, and daughters from their mothers; thus the secrets and skills of a trade were handed down in the family. It was generally assumed that the son of a tanner would be a tanner, the son of a harness-maker would be a harness-maker. The state had an interest in maintaining family craft traditions, because this ensured a good supply of artisans—especially metalsmiths, armorers, carpenters, brickmakers, and stonecutters—for military reasons and for public works construction. Hence, there were strict laws that made it difficult for a child to leave his or her parent's occupation.

Formal schooling for artisans did not exist—no lessons, exercises, grades, diplomas. The glassblower or the mosaicist learned by watching and helping out. The workshop was the only art school. There were few legal or technical standards and no explicit rules covering the use of materials and tools. Only the force of example prevailed. A potter or a stonecutter was considered good if he or she followed the established craft traditions, the traditions passed on by capable artisans. It was important to have been trained by a good master. Teaching and learning was by a kind of osmosis. The ancients believed that talent was mainly inherited, but inherited ability meant little without hard work—hard work supplemented by corporal punishment or ridicule.

There was also an informal system of apprenticeship: two or three years for a low craft like shoemaker, five to seven years for a higher craft like carpenter or vase painter. A carpenter or mason might become an architect; a cobbler or a blacksmith could not make the jump. The sculptor or pottery painter who had no children might teach the craft to relatives or to the offspring of friends. Sometimes an owner of slaves

Painting on a calyx krater, from Greece. 410–400 B.C. British Museum, London.

Late Classical red-figure vases give us an idea of the Greek artist's superb skills in drawing and characterization with line. By this time the best painters had completely overcome the old Archaic stiffness. They fully understood the figure—in action and repose—and were capable of a kind of theatrical narrative style. (This is probably a scene from a play.) We can recognize a certain amount of exaggeration in the fighting-dancing positions of the warriors, as if the painter were recording a stage burlesque. There were about 80,000 slaves in Athens when this vase was painted. It would have been made in a shop employing as many as fifty slaves, a dozen of whom might be painters. The owner of the shop was most likely a freedman or a metic (a resident foreigner)—as high in status as a blacksmith or a good cook. Even so, he might be rich.

would arrange for them to be apprenticed in a good workshop, either because their skills were needed or because the owner hoped to make money by selling their work. So slave apprentices worked side by side with the children and relatives of a master craftsman. They may not have been treated identically, but the workshop enforced the sort of rough democracy that still operates among apprentices in the skilled trades.

Discipline in the shops was strict. Dull or unwilling workers might be cuffed or beaten. In the mines and quarries, of course, they might be killed. We have to remember that the artisan tradition was not too far removed from the conditions of unfree labor. As far as the ancients were concerned, slaves were best motivated by beatings or starvation—and in some cases by the promise of freedom. Purchasers or users of an object cared little about the status of its maker or the conditions of its making. The concept of quality had no relation to the experience of the worker. That is a modern idea. Artisan training and craft "manufacture" in the classical world emphasized technical excellence. It was common for a number of specialists to work on a single helmet or vase. Little or no attention was paid to artistic expressiveness, because no one, including the craftsman, thought the artisan's psyche or soul was particularly worthy of interest.

Nevertheless, we can say that the artisan's training, which began with humility, dirty jobs, and the indignity of corporal punishment, culminated in a high level of competence and a genuine sense of pride. The master craftsman knew what no one else knew. And in the end it was knowledge—theoretical knowledge—that lifted a small group of superior artisans out of the ranks of ordinary technicians.

Class and Sexual Differences in the Crafts

The ancient textile arts—spinning, weaving, sewing, and embroidery—continued to be practiced by women at home, as they had been since Neolithic times. In wealthy households, servant girls and female slaves helped their mistresses with spinning and weaving. However, dyeing or fulling, a dirty and smelly business, was usually done by outside artisans.

Woman Making Beer. 2563–2423 B.C. Painted terra cotta. Egyptian National Museum, Cairo.

When it comes to secular art—especially the representation of everyday tasks by ordinary people—the Egyptian artist could produce lively work. That is because the sculptor was allowed to ignore sacred formulas, or canons, when depicting "low life." The slave woman shown here must have been observed directly; she even has the suggestion of a smile, something we never see in the immobile countenances of kings, queens, and princesses. Naked to the waist, her hands immersed in a mash of barley and wheat, she evinces the same irrepressible spirit we see in Millet's peasants chopping firewood or boiling clothes.

Pottery-making, tanning, and metalworking were male occupations conducted in village workshops, in separate quarters adjoining a master craftsman's house, or outside the town. Metalsmiths might work near mines just as stonecutters would locate next to a quarry. But for the most part, craftsmen lived close together; there was even a potters' section in ancient Athens. Proximity as well as the force of tradition led to marriages mainly between families in the same or related crafts. A shoemaker's son might marry a leatherworker's daughter; a carpenter's daughter might marry a stonemason's son. But it would have been difficult for a shoemaker's son to marry the daughter of a painter or an architect. In the eighth century B.C. a good leatherworker was the equal of a good vase-painter. Five centuries later there would be some social distance between them. These distinctions between "high" and "low" crafts, and between those who practice them, continued to be felt well into modern times.

Sexual specialization in the crafts was very strong among the ancients. Women's crafts were practiced for home consumption, whereas potters, blacksmiths, carpenters, and stonemasons produced for sale or trade or export. So we witness, at least three thousand years ago, the establishment of crucial differences between the work of male and female craftsmen. These differences were based on the fact that men

Woman Teaching Her Daughter How to Cook. Greek, 6th century B.C. Terra cotta. Museum of Fine Arts, Boston (Perkins Collection).

An informal kind of master-apprentice system has always been employed for training girls in the domestic arts. The "apprentice" was a daughter, or, in wealthy households, a slave girl. Teaching by demonstration and learning by imitation were the most natural and agreeable ways of acquiring technique. At the same time, ancient craft traditions were perpetuated. Originality for its own sake was not especially valued in the classical world. We, on the other hand, encourage inventiveness in the arts; so our technique suffers.

Hephaestus and the Cyclopes Making Achilles' Shield. Marble relief. Palazzo dei Conservatori, Rome.

These workmen are gods, observed by two goddesses, Athena and Achilles' mother, Thetis. Notice the contrast between the grace and stately calm of the goddesses and the furious activity of the armorers. This sculpture gives us a good idea of the ambivalent status of the classical artisan. His work is crucially important (that is why the forge god, Hephaestus, is in charge). But the men work half-naked, and the faces of the two central figures, at least, betray the unclassical emotions associated with strain and severe exertion.

worked mostly outside the home and they worked for pay; women worked at home and they received no wages.

Interesting artistic consequences flow from the sexual division of labor in classical culture. The textile and culinary arts were practiced by women as extensions of their domestic and child-rearing functions. However, the male artisans who worked in stone, wood, metal, and so on produced for a market that might dry up if the work did not live up to expectations. Hence the "male" crafts were professionalized before the domestic arts, because the "inside" crafts had little exchange value and no relation to a market. Here it should be mentioned that the classical world regarded any work done for wages as somewhat degrading—in effect, slave work. So a woman's cooking and sewing for her children, like a farmer's raising food for his family, was considered nobler than other kinds of manual labor. Nevertheless, it was unpaid.

Etruscan Noblewoman. 2nd century B.C. Life-size painted terra cotta. Museo Archaeologico, Florence.

In Etruscan high society, women were the equals of men, something that could not be said of Greek or Roman women. This handsome gentlewoman, recumbent on her cushioned couch, is adorned with the best in gold earrings, bracelets, and necklaces. She is dressed in the finest linen. Furthermore, she dyes her hair and uses lipstick and eye-shadow! The sculptor who made this figure for her tomb has portrayed her as high-born Etruscan ladies wanted to be portrayed, as they wanted to live in the afterlife. She adjusts her veil, looks up suddenly from her mirror, and faces the world with all the confidence and vivacity of a woman who has always been well-treated. A small army of craftsmen, entertainers, servants, and slaves were needed to maintain her life style.

The Craftsmen's Mystique

Even though the artisan's life and person were seen as sordid, the product of the artisan's effort was highly esteemed. The irony of this situation was recognized by the Roman philosopher Seneca when he said: "We offer prayers and sacrifices before the statues of the gods, but we despise the sculptors who make them." How did classical artisans deal with a situation that seems to us unjust as well as illogical? To some extent, they accepted the general view of themselves as low creatures. But artisans were also inheritors of an old tradition of temple construction and decoration. They were the free descendants of the slave craftsmen who served

the ancient temple priests. It appears that classical artisans persuaded themselves that they worked for religious and cultic purposes as much as to earn a living. Marbleworkers, bronzesmiths, carpenters, masons—each of these trades labored under the protection of a particular divinity, often Athena herself. It was the religious motive as much as artisan's pride that made it difficult for the ancient craftsman to cut corners, to use shoddy materials, to turn out a half-baked product. The same set of attitudes carried over into secular work.

Thus begins the *mystique* of the craftsman. It was first cultivated in the brotherhoods of architects, carpenters, stonecutters, sculptors, painters, and mosaicists of the ancient world. In late Roman times the pride and loyalty focused in the craft brotherhoods was transferred to social, religious, and artistic associations known as colleges or corporations. These "fraternities" of workmen survived into the Middle Ages as guilds. Their roots were in the craft shops established around ancient temple sites, much as the guilds grew out of the lodges set up next to the medieval cathedral sites.

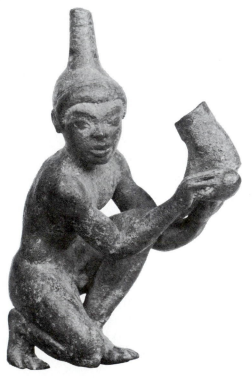

Black Slave Cleaning a Boot (perhaps base of a lampstand). Greek, c. 460 B.C. British Museum, London.

Toward the end of the fourth century A.D. the Roman Empire began to fall apart. Army deserters, escaped slaves, and gangs of thieves roamed the countryside and made travel and communication exceedingly dangerous. Even so, wealthy Romans lived well and managed to run their estates by employing a combination of tenant farmers and household slaves, all under close supervision. This sculpture of a black household slave is an example of the Romans' taste for exotic, well-made *objects d'art*. It was a cosmopolitan taste inherited from the Hellenistic Greeks. The artisans who fed that taste operated out of busy shops with plenty of assistants, and they commanded enormous prices for their work. Even in a time of social decay, the market for luxury goods holds up.

The classical craftsmen's shop was small—from half a dozen to fifty men and boys. Despite specialization in a prosperous pottery shop (clay mixers, handle makers, wheel workers, color mixers, vase painters, kiln workers), the artisans helped each other. Consistency of quality was assured because of close supervision by a foreman or by the owner of the shop. Excellence was well understood: it consisted of realism or exactitude in representation, precision of shape, smoothness of surface, fine detail, flawless finish. Any falling off of quality would be quickly detected. Besides, Greek customers were connoisseurs, and other craftsmen were severe judges.

The craft brotherhoods were not so much enforcers of standards as perpetuators of ancient ways of doing things. Artistic ideas were a product of social and religious custom. We cannot really separate technique from cult observance and the sense of continuity in the craft. The quality of classical work and the maintenance of its standards of workmanship rested on a foundation of four parts: (1) the sense of working for a divine patron; (2) the determination to preserve the methods of the artisans who had handed down a shop's tradition; (3) the individual's ambition to make a name in the city, to be honored among fellow craftsmen, and to receive good wages for labor; and (4) the unified artistic control exercised by the master of a shop. These factors account for the craftsmen's *mystique.* It had a religious or cultic base on which was built a powerful social and psychological superstructure.

Conclusion

We cannot overestimate the importance of the craft *mystique.* It accounts for the high average of technical achievement by a class of workers who had very low social standing. It offered the *banausos,* the lowly artisan, a psychological escape from the stigma of laboring for others. The craftsman's *mystique* began as a means of establishing human identity; it persisted as an instrument of social and economic protection; it survives as a spiritualized artistic ideal.

Perhaps this discussion helps to explain why it is difficult to persuade a trained craftsman to change tools, style, or outlook. It may tell us why the "true" craftsman works mainly according to internalized standards; why a customer, employer, or shop foreman can influence, but cannot fundamentally alter, basic ways of working. In the end, the craft mystique transcends purely economic considerations. It has the force of an instinct, a biological drive. So it persists even amid today's industrial and artistic conditions.

THE MEDIEVAL GUILDSMAN

The professionalization of the artist made its greatest strides under the organized master craftsmen of the medieval guilds. Indeed, there is no period in the history of the West when craftsmen have had so much social and economic influence. Individual geniuses shone more brightly during the Renaissance, and some of today's artists have become the objects of cult worship. Nevertheless, the capacity of artists to affect their society was never greater than in the Middle Ages. The irony of the situation is that they were largely anonymous. Although we would not hesitate to call them artists, they were still regarded as skilled workers —some social distance away from gentlemen. Excellent though they were as weavers, furriers, carpenters, masons, and sculptors, these craftsmen affected medieval life mainly in their collective capacity, through their ability to control the manufacture and distribution of essential goods.

By himself, the medieval craftsman would not have been able to make his wishes felt in town councils, among local merchants and foreign suppliers, or in the Church. But as a guildsman he had to be reckoned with. At a certain level of social complexity, craftsmen's associations emerge almost inevitably. They existed in China and Japan, in the ancient Middle East, in Byzantium, and in the world of Islam. In Europe

Draper's Market in Bologna. 1411. Miniature painting. Museo Civico, Bologna.

Narrow, crooked spaces, open stalls and booths, street noises, human bustle and commotion—these features of the late medieval town provided the scale and setting in which skilled artisans labored, watched the passing parade, displayed and sold their work, joked and argued with the other trades, and kept an eye on their competitors. Inevitably, the visual variety and excitement for the senses was incorporated into the craftsman's product. Here we see the kind of social environment that many contemporary artists and art students seem to crave but cannot find. They go instead to bars and bistros, cocktail lounges and student hangouts, hoping to exchange a word with someone who knows. But it is not the same.

the guilds established the foundations of modern industry and capitalism. And in their anonymous ranks, the idea of the "true" artist had its beginnings.

The Feudal Background

The craftsman's loyalty to his guild must be seen against the background of feudalism. Unlike the tenant workers of the feudal manor, the guildsmen were urban freemen. There were artisans on the feudal manorial estates, but from a social standpoint they were little more than skilled peasants. They were bound to the landed nobility and could become citizens only by managing to live and work (for a year and a day) in one of the self-governing towns that began to emerge in Europe in the twelfth and thirteenth centuries. Under the feudal system, which lasted from the collapse of the Roman Empire (around A.D. 360) to the revival of town life a thousand years later, the craftsman was just a notch above a serf. He may have lived and worked on the lord's manor or in the village

Masons at Work, manuscript illustration. 13th century.

around it, and he may have been an equal among the other servants, tenants, craftsmen. But he was legally dependent on his lord and economically dependent on the manorial estate, which his lord owned and controlled. It was like a "company town" next to a collection of share-croppers' farms. He could not move or work for others, or sell to strangers. Trade was sluggish, and there was little money in circulation. A true market hardly existed, with only some minor barter between villages—again, controlled by the landlord. The feudal craftsman received physical protection and a kind of social security, in return for which he was required to fight in wars, perform gang labor, and work at odd jobs and estate maintenance.

The rural artisan was more like an all-around handyman than an independent craftsman; certainly he lacked the professionalism of a Greek or Roman artisan. Although slavery was nominally ended, feudal serfdom was very little better. Still, it appears that most rural craftsmen were satisfied with their lot. Most continued to live and work outside the guild system until the advent of modern industrialism. The guildsmen in the cities—probably descended from itinerant artisans and lodge masons —were made of different stuff.

Craft and Merchant Guilds

The guild system emerged after a profound deterioration of the arts and of the condition of artisans. The collapse of the Roman Empire was followed by the disintegration of its colleges and corporations of artisans. Classical standards of building, fabrication, and decoration broke down,

Medieval Masons at Work. c. 1240. Miniature from an Old Testament manuscript. Pierpont Morgan Library, New York.

If anything went wrong at a building site, the masons would stop work or quit the job altogether. They could always travel to another city and get good pay. There was a continuous shortage of skilled stonemasons in the medieval world, especially of figure carvers in marble and alabaster. The masons' lodges were very selective about the boys they admitted to apprenticeship, which lasted seven years. That kept numbers down. Furthermore, the masons knew their lives would be shortened by stone dust settling in their lungs. Hence, they tried to retire early. That is, they saved their money and bought a business, or they did only supervisory work, delegating the rough, dirty jobs to common laborers. By monopolizing their skills, by keeping wages as high as they could, and by leaving town when working conditions were not right, the medieval masonic orders raised both the standards of their craft and the dignity of their work.

Steelworkers constructing Chase Manhattan Bank, New York. Courtesy Chase Manhattan Archives.

Modern high steel construction. Today's building craftsmen work at greater heights than their medieval counterparts. Otherwise, little has changed. They work in teams; they continue to use hoists and pulleys; they have to nudge heavy beams into place. The work is still dangerous. The men are still unionized.

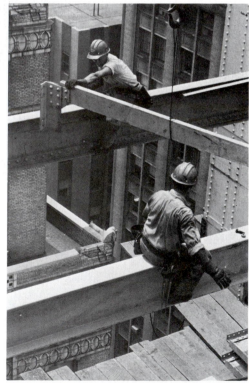

and centuries passed before skilled artisans were able to pull themselves out of the ranks of estate slaves, day laborers, and serfs to establish associations that could protect their personal freedom, institute higher traditions of work, and guarantee their economic survival. Some scholars maintain that the masons' lodges and craftsmen's guilds of medieval Europe were the direct successors of the old Roman corporations of artisans. Others say they emerged from Germanic fraternities. They could have orginated in gangs of escaped serfs. Or perhaps the guilds were wholly new institutions. All these explanations are probably right about different places, but we cannot go into the question here. What matters for us is that similar needs among craftsmen called forth similar social and professional solutions. Urbanism had a lot to do with the appearance in the eleventh and twelfth centuries of a system of guilds that strongly resembled the artisans' brotherhoods of the ancient world.

By the fourteenth century there were many splits and subdivisions among the guilds—mainly between merchants' and craftsmen's guilds. But at first, everyone connected with an industry must have belonged to the same guild, mostly because the scale of production was

Artists Decorating a Nobleman's House. Manuscript illumination. Pierpont Morgan Library, New York.

House-painting and fresco painting were carried out by the same artisans, although the figure work probably was done by someone who had a special knack for it. These men also built, decorated, and maintained the medieval cathedrals and churches. Their guild masters acted as contractors who took on private, secular jobs during slack periods of church construction.

small and no one could afford to be very specialized. Craftsmen, merchants, and traders met and dealt with each other as equals. Their roles were often interchangeable: the master craftsman was a buyer of materials, an employer of workers, and a seller of "manufactured" goods. He probably borrowed money to finance his purchases, paid interest (disguised because the Church disapproved of interest), and made a profit (not called profit because the Church disapproved of profit). So he was a kind of businessman. But some craftsmen restricted themselves to personal production, and this necessarily limited the amount of work they could turn out. In other words, by avoiding business affairs, or letting others handle business for him, the producing craftsman limited the amount of money he could have made by selling the work of others. In modern jargon, he restricted his "cash flow." In an expanding market, the full-time trader in craft goods could earn much more. With his earnings employed as capital, he could finance more economical purchases of raw materials; he could "put out" work to peasants and nonguild craftsmen; he could produce goods on a large scale. Thus, some craftsmen became manufacturers, after which they entered the ranks of traders and merchants. A few became bankers and princes after several

Woman Painting a Self-Portrait, manuscript painting from "De Claris Mulieribus." Bibliothèque Nationale, Paris.

Women might be the subjects of art, but they rarely practiced painting. Sewing, embroidery, weaving, and music were their provinces. Why has this woman taken up painting, and why a self-portrait? Perhaps she has a courtly lover who swears she is very beautiful. Perhaps she is very, very lonely; the medieval lord of the manor was away more than he was at home. The lady shown here is obviously privileged. She has her own room to use as a studio. She has good furniture. And she has privacy, which was unusual even for the nobility. The mystery is how she learned to draw, color, and model with paint. Maybe she applied the lessons of weaving and embroidery.

generations of factoring (acting as business agents). This was probably how the Medici—Italy's great family of merchant-bankers—got started.

To some extent, guild membership was hereditary. Wealthy men and their relatives continued to play a role in the craftsmen's guilds. But the old basis of equality among the brothers had become a fiction. The sons of merchant princes would not soil their hands with paint and clay and dyes, nor subject their nostrils to the smell of curing hides. They used their membership to influence guild participation in the religious, political, and economic activities of the city. Inevitably, there was a divergence of interest and outlook between guild merchants and guild producers. The successful merchants, growing richer and more powerful, began to resemble the financiers and captains of industry of modern capitalism. The craftsmen and their guilds, under pressure from these "larger" men, began to resemble modern trade unionists. Increasingly, their regulations took on the character of economic defenses.

From Apprentice to Journeyman to Master

The long and arduous process of becoming a master gives us an idea of the membership and production controls a guild could exercise. Apprenticeship was strictly limited by guild regulations. Usually, a master could have no more than two apprentices at one time. The period of training might last from two to seven or eight years, depending on a boy's natural ability and the difficulty of the craft. The start of an apprenticeship was around the age of twelve. A boy's parents paid a fee to a master craftsman who, following a trial period of a few weeks, took the boy into his household, more or less as a member of the family. At first the apprentice was given odd jobs and menial tasks around the shop. But it was understood by the terms of the apprentice agreement that he would get real training, not just shop-sweeping assignments. In practical terms "real training" meant the opportunity to learn the correct use of tools, to do preparatory work, to make copies under supervision, to receive criticism, and finally assist the master with his own work. In other words, the apprentice had to be taught, not merely used as an unskilled laborer.

Before an apprentice was allowed to set his hand to even a minor part of his master's work, he had spent a great deal of time—years—on shop exercises and trial pieces. Also, as in the classical workshop, much emphasis was placed on "get ready" work: sharpening tools, grinding pigments, cleaning brushes, roughing out stones, mixing clay, firing kilns, stoking furnaces. None of these jobs called on great powers of

Villard de Honnecourt. Drawings from an architectural sketchbook. 13th century. Bibliothéque Nationale, Paris.

Villard was a traveling master-builder and architect. In these drawings he shows how geometrical figures—rectangles, triangles, circles, and stars—can be used in constructing any form: bird, animal, human, or building. Geometry elevated the medieval mason from a trial-and-error artisan to a true architect, a professional designer working from a theoretical—that is, mathematical—base.

imagination or ingenuity, yet they had to be done correctly. Certainly the high technical quality of ancient, classical, and medieval art can be attributed, in part at least, to the diligence of apprentices. The tasks that many of us regard as dirty-work and drudgery were carried out according to exacting standards by teenage boys who took them seriously. To get the flavor of this, we must watch a plumber's helper, an apprentice chef, an electrician's assistant—again, the craftsman's *mystique*. Most workers and craftsmen who have gone through this sort of training look back on it with satisfaction and even with gratitude.

After his apprenticeship was done, the young craftsman paid a fee, took an oath, received communion, and was initiated into the ranks of journeymen. Perhaps he was eighteen or nineteen years old. As journeyman he was presumed good enough to work for wages but not yet mature or experienced enough to set up his own shop. So he traveled for two or more years, working for masters in other cities, polishing his skills, lodging in special hostels for journeymen, and learning about the

outside world. He traveled with the recommendation of his home guild, whose overmasters kept track of his behavior. At the same time, the journeyman was looking around for a place to settle down after his "wander years" were over. Most journeymen hoped to return to their home towns. Some found good places elsewhere by marrying a craftsman's widow or daughter; others remained bachelors and worked longer as journeymen. There was a connection; unmarried journeymen could not be masters.

To set up shop as a master, the journeyman was required to produce his "masterpiece" which had to be approved by the overmasters of the guild in which he sought membership. Given the right economic conditions, town friends to support him, and a well-finished piece of work, he *might* be admitted. There was still the necessity of showing he had the requisite tools, character, and cash. Guild membership implied the economic resources to operate a shop, some business sense, Christian faith, upright moral character, and legitimate birth. It helped, too, if the journeyman planned to marry and promised to buy a house in town.

It may seem that the religious, moral, and financial requirements for guild membership were as great, or greater than, the artistic qualifications. But high technical competence could be assumed; a craftsman's apprenticeship and journeyman years amounted to a guarantee of ability to perform. The guild system operated on social assumptions exactly the reverse of those in ancient and classical times. The master craftsman in late medieval Europe was regarded as a decent, honorable, responsible member of society—much like a banker in a midwestern American town. There was nothing disreputable about him, his household, or his work. Indeed, the excellence of his character and the produce of his shop were seen as directly related. Moral integrity—that is, standing in the Church, participation in civic affairs, and commitment to family and bourgeois values—was basic to the guild system.

It can be argued that, unlike the feudal nobility, the medieval craftsmen were the "best" people in their society—best from the standpoint of honesty, dedication to fair dealing, charitable works, and sense of social responsibility. Furthermore, the guildsmen did in fact rule in the towns. Actually, they were better fitted to rule than the landed aristocrats in the countryside, who preserved the old warrior values of ignorance, disdain for manual labor, exploitation of the weak, and irregularity in family life. The high civilization that emerged in Europe in the fourteenth and fifthteenth centuries received its backbone of moral and civic virtue from the medieval craftsmen's guilds. It was a case of noble character filtering upward.

Quality and the Guilds

The economic interests of the guilds led to the enactment of a mass of regulations that seem totally unrelated to art. Arguments among guildsmen seem to center mainly on commercial matters: apprenticeship fees, journeymen's wages, interest on guild loans, legal expenses, and payment of fines. Social matters are prominent: attendance at festivals, support for civic celebrations, contributions to the needy. The masters' shops were generally all in the same quarter of town, and goods were sold from the shop premises. Did some of the honorable guildsmen lure customers into their premises? Ply them with food and wine? Offer special bonuses and discounts? This sounds like dishonest advertising; clearly, it had to be regulated.

Perhaps aesthetic questions are approached indirectly in dealing with problems of display, establishing standards of quality, deciding on fair prices for everyone's production. We should realize that today's

(left) *Henry of Reyns,* first architect of Westminster Abbey. Stone carving. Courtesy Dean and Chapter of Westminster, London.

(right) Théodore Géricault. *Portrait of an Artist in His Studio,* detail. 1818. Louvre, Paris.

Henry of Reyns was the architect for Windsor and York, as well as Westminster. He must have traveled back and forth among his various jobs. Here was a master mason who functioned very much like a modern architect—one who designs and supervises but does not build with his own hands. His stone bust conveys that idea: Master Henry is a thinker and a dreamer, almost a poet. We might compare the carving with Géricault's *Portrait of an Artist in His Studio,* executed five hundred years later.

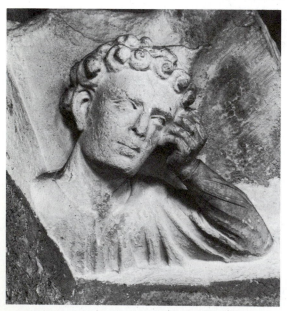
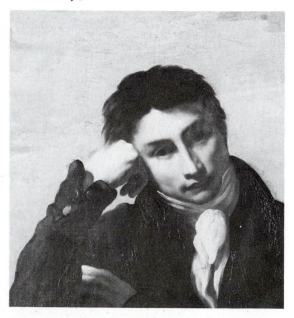

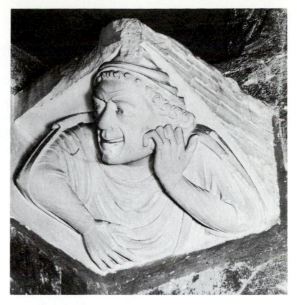

Corbel Head of a Craftsman, from Westminster Abbey. Stone carving. Courtesy Dean and Chapter of Westminster, London.

Not all craftsmen were masons, lodge-members. Quarriers, plasterers, mortar-makers, and other subordinate craftsmen were frequently employed as common laborers. Some, no doubt, were conscripted from the countryside or from prisoners of the crown. The craftsman here seems to be scratching himself—a sign, perhaps, of his churlish origins. Masons, on the other hand, prided themselves on their descent from "great lords," their legitimate birth, their high moral standards, and their financial probity.

artists talk about dealers, galleries, collectors, and prices more than is generally realized. Behind the guildhall talk and regulation there was the nagging problem of attracting customers and maintaining a good market for all the masters. Officially, competition was considered dangerous, so the guilds attempted to eliminate it by fixing wages and prices. As a result, some craftsmen tried to compete indirectly through the quality of the goods they put up for sale. There were reasons for being secretive about certain refinements of technique and artistic approach.

The concept of the cunning craftsman, and of technical processes jealously guarded from strangers or competitors, pervades the medieval idea of art. The prosperity of a town—its foreign trade especially—depended on preserving the old magical recipes: secrets of weaving gold and silver brocades, painting in enamels, dyeing leather, tempering blades for knives and swords. This remainds us of modern patent law, not to mention industrial espionage. In addition, the guild closely supervised the quality of its members' work to protect the public from fraud. It hired inspectors to make sure that used or shoddy goods would not be passed off as new and first class. For example, gold and silver *plating* (the application of precious metal to a cheaper material) was forbidden. The same was true about using fake or glass gems. Old saddles could not be repainted and sold as if new. The idea was to sell new saddles. But although the guild's interest in quality was sincere, it also provided a cloak to mask a monopolistic intention. The overall thrust of guild regu-

lations was to prevent "unfair" competition—that is, to preserve the livelihoods of the honorable brothers.

How was quality defined and regulated? Mainly it was measured in quantitative terms. It could be specified in material costs, labor costs, and purity of ingredients: the weight of the gold leaf in an altar painting, the amount of silver inlay in a breastplate, of ivory in a carved chest, of gold thread in a woven garment. Ale could be made of grain, hops, and water—nothing else. Today's beer would have given the medieval brewer a stroke! Another index of quality was fine, detailed work—that is, the visible evidence of painstaking labor. As with ancient and classical art, the individuality or personal "stamp" of the craftsman was a minor consideration. Craft work was stamped with the collective mark or seal of the guild. That was a guarantee of its weight, dimensions, purity of ingredients, and correctness of construction. The seal even testified to the training of the person who made it.

This technical hair-splitting, niggling over prices, and over-specification of materials and processes suggest that the spirit of inquiry, inventiveness, and intellectual adventure was foreign to the craft guilds and their notions of artistic excellence. We see more liveliness in the

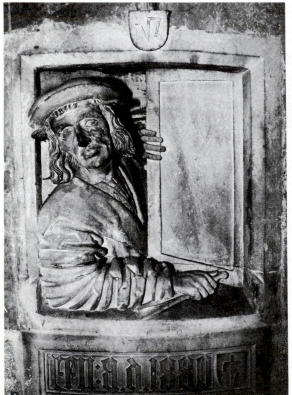

Portrait of Anton Pilgram, designer of the nave pulpit, St. Stephen's Cathedral, Vienna. 1512.

Anton Pilgram is shown with calipers and a kind of drawing board, as if he is about to make a sketch. A certain amount of designing was done on the spot. From these drawings—made on the ground of the masons' hut, on a wooden slab, or on a plaster panel—the masons carved stones into the right shapes. But it is a mistake to believe that medieval building was improvised. The space and fabric of a Gothic church had to be visualized and planned. Pilgram's calipers are an important symbol of his profession and his role as planner. They signify the architect's knowledge of geometry. For the medieval mind, geometry was the science used by God to create the world. It also declared that the architect was an educated person; he was a gentleman.

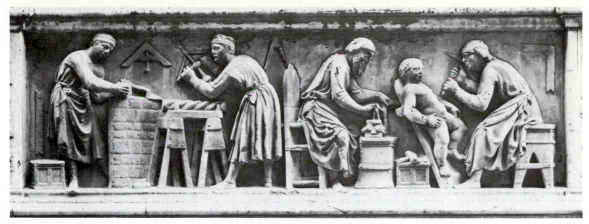

Nanni di Banco. *Sculptor's Workshop*. 1408–14. Marble. San Michele, Florence.

A typical stonecarvers' *bottega*, or workshop, early in the fifteenth century. One team of carvers works on an architectural molding, another on a figure. The shop is run on a quasi-industrial basis: almost every piece of work is the product of several hands. These carvers have moved well beyond the status of the stonecutters who worked at a building site. But they are not yet independent sculptors. They are still subject to guild regulation and discipline.

manuscript paintings and small ivory carvings created in the monastic workshops, possibly because the artist-monks lived and worked in a setting where there was more play of ideas. It is clear from guild documents, as well as from the evidence of the work itself, that the intelligence and resourcefulness of the masters was mainly devoted to standardizing production, stabilizing trade, eliminating competition, and protecting each other's comfort. These motives—generous as well as self-serving—foreclosed the possibility of fresh artistic content. The mentality of small shopkeepers pervades guild affairs, and, while that is not dishonorable, it must have been artistically stultifying.

Conclusion

The main purpose of the ancient brotherhoods and colleges of artisans was to provide decent burial for their members, to look after their widows and orphans, and to protect each other economically. The same is true of the medieval craftsmen's guilds and of our modern trade and industrial unions. Regulation of wages and prices, control of production, monopolization of markets, and so forth resulted from the zealous and generally successful pursuit of the guild's religious, social, and economic objectives. The artistic effects were indirect, but they are important.

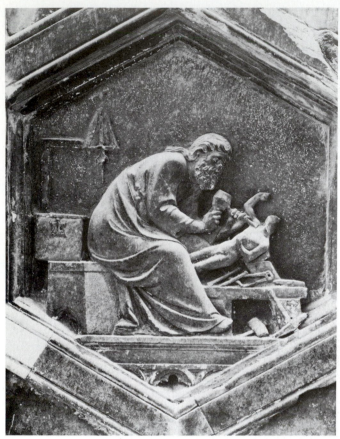

Andrea Pisano. *The Sculptor at Work.* 1337–40. Marble relief. Campanile, Cathedral of Florence.

During the fourteenth century, medieval sculptors, selected from the most capable stonemasons, began to emerge as specialists. They continued to work with the other carvers, in a hut next to the building site; and they followed the instructions (given through sketches and measurements) of the building's master mason or architect. Andrea Pisano worked closely with Giotto, the official architect of Florence and the designer of the Campanile. Perhaps Giotto laid out the compositions for Andrea's reliefs. But we can see that Pisano had a personal style—more graceful and less earthy than Giotto's. The artistic individualism of the Renaissance was beginning to assert itself.

First, the aim of keeping out "foreign" goods and craftsmen stimulated a continuous and strenuous effort to maintain high qualities of material and workmanship. Second, there was a rise in the value of manual work during the Christian Middle Ages, although it was not so high in status as mental work, prayer, or contemplation. Still, the skilled craftsman enjoyed more dignity in the medieval world than in the ancient world. In the free towns, at least, work lost some of its sordid and servile associations. Third, the limits on production prevented or postponed the frenzied manufacture of goods for profit alone, which would eventually have deplorable consequences for makers and users during the early stages of modern industrialism. Finally, despite what seems to be their antiprogressive economic outlook, the guild masters established the foundations of a radical idea: The quality of an object is closely related to the human condition of the person who makes it.

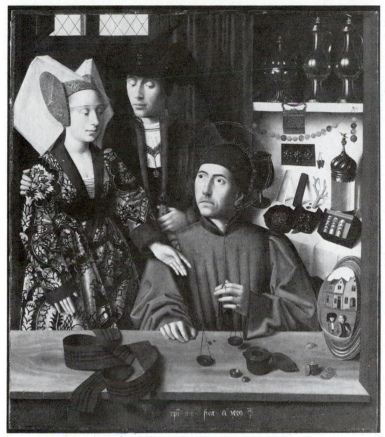

Petrus Christus. *St. Eligius.* 1449. Oil on panel. Metropolitan Museum of Art, New York (Robert Lehman Collection, 1975).

The saint as a Flemish goldsmith in his shop, weighing the wedding rings of a betrothed couple. We see holy matrimony closely associated with the measurement of money values. At the same time we witness the elevation of the craftsman from the status of skilled worker to that of merchant-capitalist. Even a priest! The marriage cannot be consummated unless a goldsmith guarantees the weight of the wedding rings.

THE RENAISSANCE GENIUS

If we ask a passerby on the street to name some artists, it is very likely the person will mention Leonardo, Raphael, or Michelangelo. The person might not be able to tell their works apart but would probably know something about the artists' lives (from novels or movies) and the names of a few of their masterpieces: *The Last Supper, The Sistine Madonna,* or the statues of *David* and of *Moses.* My point is that most people know, regardless of their social or educational background, that the title "artist" is correctly applied to these masters of Renaissance art.

Now scholars know the names of some medieval painters, sculptors, and architects—the Limbourg brothers, Gislebertus, and William the Englishman, for example—but they don't know much more about them. To the general public these men are hardly household names. The public assumes, quite correctly, that the great works of the Christian Middle Ages—the magnificent Romanesque and Gothic cathedrals with their gorgeous stained glass, intricately carved wooden pulpits and choir stalls, dazzling gem-encrusted caskets and reliquaries, and painted and gilded altarpieces of unearthly beauty—were made by anonymous craftsmen. Yet Gislebertus, who carved several of the stone figures for the cathedral of Autun (c. 1130) was a very great sculptor to anyone's way of thinking. Still, he is not famous because, aside from the paucity

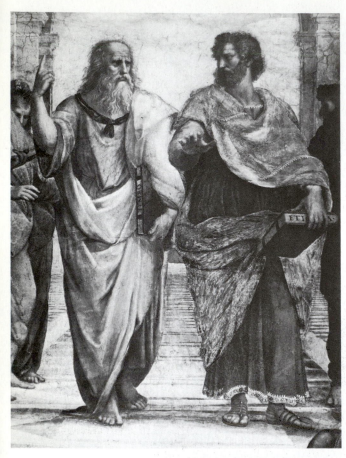

Raphael. "Plato and Aristotle," detail from *School of Athens.* 1510–11. Fresco. Stanza della Segnatura, Vatican, Rome.

Raphael was only 26 when Pope Julius II engaged him to paint a series of frescoes on the walls of three rooms in the Vatican. At the same time, Michelangelo was working on the ceiling of the Sistine Chapel, just across the court. Both artists were trying to produce a synthesis of ancient and modern thought, a grand intellectual and theological reconciliation: between the pagan philosophers and the fathers of the Church; between the Old and the New Testaments; between the mysteries of religion and the powers of human reason. The ambition and scope of these schemes added substantially to the growing respect for the artist's intellect (although Raphael had the help of scholars, humanists, in planning his fresco programs). But the fact that artists could aim so high, using only a mixture of paint and brains, had important practical results: the development of a competitive market for their services. Popes and princes schemed and fought for their work. So the great ones, at least, were freed from the restrictions of the guilds, which had grown increasingly self-serving. In a very short time—perhaps twenty years—a combination of Italian genius, papal ambition, and the play of market forces produced an immense improvement in the status of the artist. The memory of that great time lingers on.

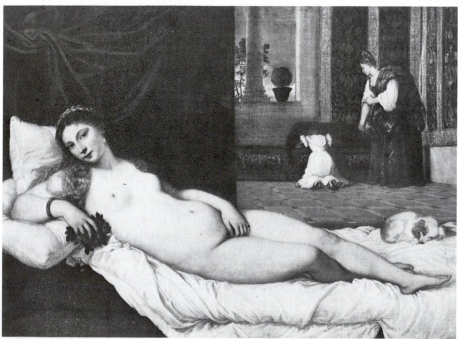

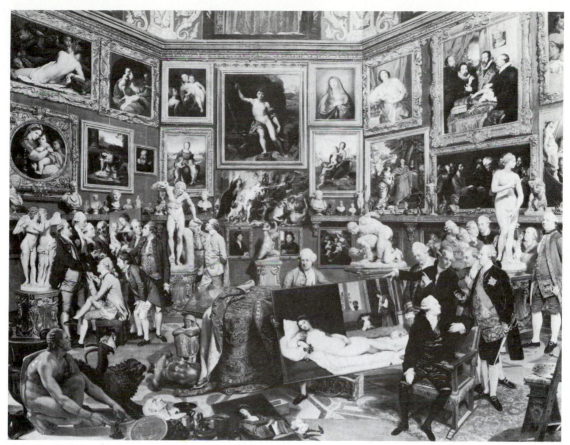

Johann Zoffany. *Tribuna of the Uffizi.* c. 1775. Oil on canvas. Royal Collection, Windsor Castle (copyright reserved).

During the eighteenth century a wealthy young Englishman's education was completed with a Grand Tour of Europe. Then, as now, the Uffizi in Florence was a major attraction for lovers of art. Hordes of aspiring connoisseurs invaded a principal gallery in the Uffizi, the Tribuna, to see the sculptures and paintings stacked up to its ceiling. Zoffany's huge canvas, filled with notables, shows a group of stately English gentlemen engaged in animated conversation before Titian's *Venus of Urbino.* Here, then, is a painting about paintings; a crowd of eager art enthusiasts; a good deal of talk about art; a gallery so loaded that no single picture or sculpture can be seen properly. What does it all signify? That the Renaissance has conquered all of Europe. That there is no such thing as too many Italian paintings. That the right way to see the world is through the eyes of Raphael and Titian and Rubens.

(left) Titian. *Venus of Urbino.* 1538. Oil on canvas. Uffizi, Florence.

Michelangelo said it was a pity the Venetians couldn't draw. He was probably objecting to the way Titian painted flesh: it was too sensual, too florid. Titian was not sufficiently aware of the body as an arena of moral struggle. Well, Renaissance Venice was a very sophisticated place. Wealthy, cosmopolitan, and tolerant (despite a ruthless police and spy system), the city appealed to artists especially. They were attracted by its generous patronage, its marble palaces and sparkling canals, its atmosphere of luxury . . . and vice. Venice was a city of beautiful and intelligent courtesans. Their arts were lovemaking and good conversation. And that is what Titian painted again and again: the spirit of love guided by very clever women.

of information about him, he lived in an age that saw him as a stonemason—a very good one, but a stonemason nevertheless.

Why are the painters, sculptors, and architects of the Renaissance so much more admired, so much written about, so *famous?* In part, it is because a Florentine named Giorgio Vasari, himself a painter, decided in 1546 to write a book, *The Lives of the Painters, Sculptors and Architects.* Naturally, it was mostly about his fellow Florentines. They were not modest people, and they had good reason to be proud. Vasari's book discusses their careers and personalities in a manner that leaves no doubt about the importance of a crucially new idea: A great artist is also, and necessarily, a great person.

Of course, the fame of Masaccio, Ghiberti, Donatello, and Piero della Francesca rests ultimately on the merit of their work (although it did not hurt to be celebrated by a publicist like Vasari). It relies also on a new way of perceiving works of art and the people who make them.

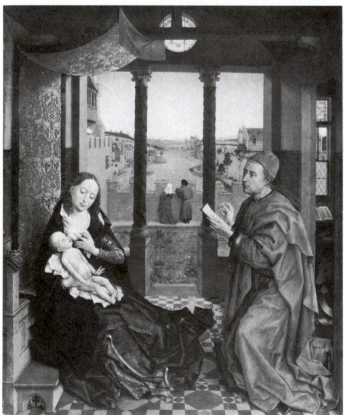

Rogier van der Weyden. *St. Luke Painting the Virgin*, detail. c. 1435. Oil on panel. Museum of Fine Arts, Boston (gift of Mr. and Mrs. Henry Lee Higginson).

An early Christian tradition said that St. Luke was a painter and the Virgin posed for him. Thus, Luke became patron saint of artists and their guilds. During the Middle Ages that meant a healthy turnout for the annual Festival of St. Luke and fines for those who did not attend. During the Renaissance the guilds of St. Luke evolved into *academies* of St. Luke. Besides looking after their members' business interests, these academies were places where artistic, theoretical, and cultural matters were discussed. Van der Weyden's *St. Luke* exemplifies the piety of the late medieval artisan tradition in Flanders. The more sophisticated Italian idea of the artist had not yet crossed the Alps. Still, van der Weyden's picture testifies to the seriousness—the professionalism—of the artist's calling. In 1435 van der Weyden was named official painter to the city of Brussels. That title carried an annual stipend and the right to wear the cloak of a town official!

A fundamental change in attitude—toward the best craftsmen at least—took place in Florence during the Quattrocento (the 1400s), and it spread to Milan, Rome, Venice, and the lesser cities and towns of Italy. From Italy, it passed over the Alps into Northern Europe, becoming finally a part of our common heritage.

Here we cannot possibly examine all the social, economic, and intellectual factors that caused a small group of fifteenth-century craftsmen to become heroes of culture. What we can do is attempt to explain what led to so remarkable a transformation in their status and self-regard. Why were these painters and sculptors, once respected as skilled artisans, now worshipped as geniuses?

Material Prosperity and Greatness

There is no escaping the fact that fifteenth-century art is intimately related to wealth. It was a rich commercial society that lifted the Renaissance artist out of the artisan class. By 1400 Italy was beginning to recover from the devastating effects of the Black Death, the plague that had killed off more than a third of Italy's population between 1347 and 1349. Although Italian capitalism featured cycles of boom and bust, and although there were plenty of poor people in Florence (despite its flourishing international trade in woolens), there were still a substantial number of rich merchants and bankers in the main cities of Italy who prospered regardless of economic cycles. They wanted to live splendidly. Much wealth was accumulated in the late Middle Ages, too, but it was not combined with the spur that appears uniquely in commercial civilizations: the drive to compete, to excel, to be seen as rich, great, and deserving of respect.

Above all, the mercantile aristocracy of fifteenth-century Italy sought equality with the old feudal nobility. Hence, wealthy merchants competed with princes and high churchmen in generosity to their home cities, in endowments to the churches, hospitals, monasteries, convents, and schools of the communities where they had grown up. For these men, greatness was closely connected with public display; it was not enough to *be* rich; one must be *seen* to be rich. One must demonstrate the power (and judgment) to command the finest talents, the most costly materials, and the highest reaches of imagination to carry out projects that would amaze the multitude. That meant art. The same energies that had amassed fortunes were now expended to attract the best artists—luring them with flattery, ideal working conditions, and money into the

service of an astute, upward-bound middle class. Through its patronage of major civic monuments, that class would compensate, in a sense, for the low wages, the unconscionable profits, and the usury through which its wealth had been acquired.

So the rise of the artist during the Renaissance depended on a number of nonaesthetic factors: prosperity, the existence of great fortunes, social ambition, competition for personal splendor, civic pride, and bad conscience.

The Learned Artist

We must not imagine that the patrons of the Renaissance were merely acquisitive, ostentatious, and power-hungry. The leading personalities of the age were connoisseurs of power, to be sure, but they were also learned and cultivated people. The households of great dukes and merchant princes were filled with poets and philosophers, mathematicians and scholars. Books and manuscripts, paintings and statuary, collections of gems, coins, and finely wrought silver and gold—all of these, plus much good and civilized talk by persons of taste and wit, made up the heady atmosphere of the Renaissance palaces. And here the most privileged artists were now admitted. Indeed, some lived and worked there, associating with their patrons on terms of considerable familiarity if not social equality.

The artist who could function comfortably in such an environment had been trained in a craftsman's shop and had done the dirty apprentice jobs. Artists continued to work with their hands, but if they had paint stains on their clothes, this could be forgiven provided they knew the manners of a court, understood the talk, and could contribute something in the way of ideas. For this reason, perhaps, artists stressed the importance of liberal studies in their training—everything from theology to medicine. Painters and sculptors were anxious to show they were learned individuals—closer to poets and philosophers—people who did not soil their hands. At least they might be nearer to architects, who were known (on the authority of the classical theoretician of architecture, Vitruvius) to command all sorts of theoretical knowledge.

In their eagerness to ascend the social and intellectual ladder, the painters and sculptors of the Renaissance may have claimed too much. Perhaps, also, they tried in practice to live up to their intellectual claims, with the result that their work sometimes lost its connections to life as directly felt and observed. Antonio Pollaiuolo's *Battle of Naked Men*

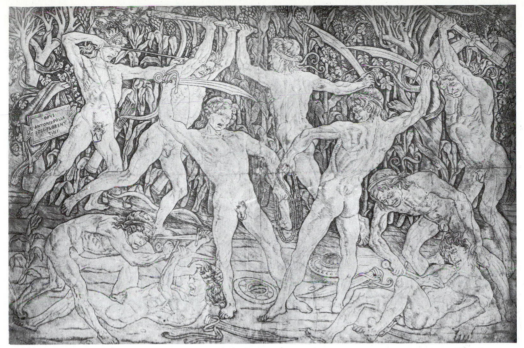

(above) Antonio Pollaiuolo. *Battle of Naked Men.* 1465. Engraving. Uffizi, Florence.

(below) Andrea Mantegna. *Battle of the Sea Gods* (right half). c. 1493. Engraving. Art Institute of Chicago (Palmer Collection).

Whether depicting fantastic or actual events, the Renaissance artist is determined to show a mastery of anatomy in action. The point made by both of these engravings is that drawing is based on real knowledge of nature. Both artists meant to prove they were learned men.

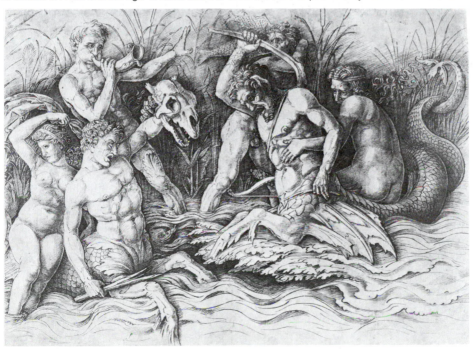

(1465) is stiff and unbelievable; we can understand it only as a demonstration of the artist's anatomical knowledge. Ucello carried his passion for perspective to the point at which it dominates his subject matter. Perhaps his subject matter *is* perspective. But from a professional standpoint, the artist succeeded. By the end of the fifteenth-century the arts of painting and sculpture could be regarded as "liberal," not servile, professions. Their practitioners were "near gentlemen."

From Competition to Criticism

The medieval guilds, we know, were organized to prevent competition. The idea was to spread the available business evenly among the master craftsmen. But the market for the services of excellent artists increased greatly in the fifteenth-century, so much that the fee of a highly skilled painter might be three times greater than that of a mediocre painter. In other words, patrons would not let the guilds control the award of commissions. They created a market that put a premium on superior ability, always in short supply. Now artists could compete for money as well as prestige. And inevitably, the competition among artists involved nonartists: patrons, collectors, connoisseurs, theoreticians. Humanists befriended artists. According to Alberti "a great appreciation of painting [is] the best indication of a most perfect mind." Then as now, critics acted as guides to art "consumers" as well as allies of the artists they favored. In their pursuit of major commissions artists themselves engaged in polemics with their competitors.

The interaction between the Renaissance artist and the new class of humanist intellectuals has a very modern ring. Then as now, artists shaped and composed their works according to principles of design that only well-informed persons—"insiders"—would understand. Vasari speaks of *disegno* (design) as a science second only to theology. Obviously, there are mysteries in the organization of a work of art, mysteries that will escape the untutored eye and the untrained mind. To be sure, the general public could recognize the people, places, and things represented in Renaissance art, and from their religious training they might understand its Christian symbolism. But without instruction by humanists, it is doubtful that they could catch the allusions to pagan mythology, the arrangements of figures according to Platonic categories of existence, the echoes of antique philosophy, astrology, and apocryphal books of the Bible in the art of Raphael and Michelangelo. So we witness

the beginning of a modern dilemma: as artists gain status in the eyes of a social elite, a special class of scholars—historians, critics, philologists—is needed to explain the real meaning of their work. We might say that rivalry among patrons begets competition among artists, both of which breed criticism.

Expanded Culture of the Artist

Notwithstanding their growing prestige, the artists of the fifteenth-century were still brought up in the medieval craft and trade system. Painters, for example, still belonged to the goldsmiths' or the pharmacists' guild. Sculptors still belonged to the stonemasons' guild. And the great workshops in Florence—like Verrocchio's, in which Leonardo was trained—continued to take on all sorts of decorating and display jobs. This helps to account for the extraordinary versatility of the Renaissance artist, the ability of one person—Leonardo or Michelangelo, most notably—to work as painter, sculptor, architect, or engineer. But versatility does not convert a craftsman into a gentleman. To be a gentleman required a good income and a liberal (that is, a nonvocational) education. How did this come about?

Andrea del Verrocchio. *Lorenzo de' Medici.* 1480. Terra cotta. National Gallery of Art, Washington, D.C. (Kress Collection).

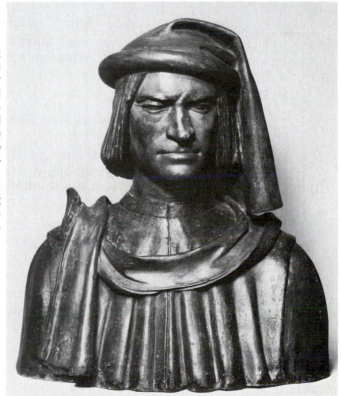

This is hardly the face of an aesthete. Yet Lorenzo was a poet, an intellectual, and the greatest patron of the arts that Florence ever knew. Botticelli, Signorelli, Leonardo, and Michelangelo were beneficiaries of his encouragement and support. But above all Lorenzo was a financier and politician. The Medici had plebeian origins; their rise to wealth and power was through business— something the old nobility would not touch. Florence, moreover, was an industrial town; it lived by the manufacture of cloth. And that was the combination that produced the Renaissance: astute businessmen and a population of industrious artisans.

An apprenticeship of eight or ten years was still the rule during most of the fifteenth-century. However, that period was not devoted to mastery of craft alone. Verrocchio gave regular lectures on geometry and mathematics to his apprentices and shop assistants. There was a good deal of informal liberal education. The excitement about Greek and Roman antiquities, the translations of classical writers, the clever talk based on the ideas of the ancient philosophers—all this penetrated the craftsmen's shops. The brighter and more ambitious artists were caught up in the intellectual ferment. Whereas the medieval craftsmen talked about guild fees and obligations, the "modern" artists were obsessed with problems of ideal beauty, truth to nature, inventiveness, the purpose of ornament, and principles of proportion. Aside from natural curiosity, their professional ambitions were involved. Potential patrons were obviously fascinated by the poetry, philosophy, and mythology of the ancient writers. An alert apprentice would try to learn everything possible *over and above* the tools and techniques of art. Also, when studying anatomy, perspective, and geometry, the artist made logical connections with classical philosophy and natural science. The connections between mathematics and perspective, anatomy and sculpture were clear. As for Beauty—the supreme ideal of Renaissance art—it depended on harmonious, that is, mathematical, relationships. Those relationships were embodied in the laws of design—Vasari's *disegno* again. And the laws of design, said Vasari, originate in the intellect. The clutter and confusion of medieval art had been caused by the fact that it was guided by accident, not design. Artists' must train their minds. Ignorance was not only a social liability, it was a professional disaster.

Nature as the Artist's Model

The association of painters and sculptors with humanist intellectuals— that is, with people versed in ancient philosophy, mathematics, languages, and science—led to significant changes in artistic subject matter and approach. It was not only a matter of introducing new themes based on classical writings. There was also a fundamental transformation in the way leading artists looked at religion, at history, at society, at nature— especially nature. Once painters began to see the physical and biological world through the eyes of ancient science, their imagery had to change. They might continue to use the techniques of the medieval craftsman, but these techniques were now employed according to a "deeper" conception of nature and the universe. Artistically speaking, the earth was no longer flat.

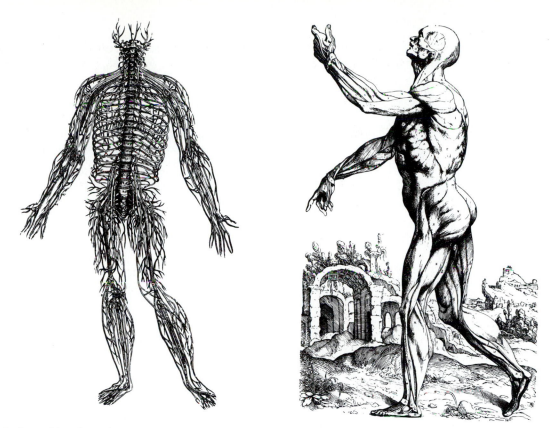

Andreas Vesalius. *Anatomical Studies*, from "De Humani Corporis Fabrica" (1543). Woodcuts. New York Academy of Medicine, Rare Book and History of Medicine Collections.

These studies, based on dissected cadavers, were made for painters, sculptors, and physicians alike. During the Middle Ages artists and physicians had relied mainly on traditional and carefully followed recipes. Now, as art and medicine became professions, they grew increasingly dependent on scientific knowledge—that is, on knowledge of nature gained through direct observation and experimentation.

Late medieval art, encouraged by the preaching of St. Francis, had already opened its eyes to nature. As earthly existence slowly improved, the representation of living creatures could be undertaken with less fear and guilt. Unfortunately, medieval artists lacked a three-dimensional framework in which to locate their vision of the world. Until that framework—linear and aerial perspective—was created, the possibility of a convincing realism was foreclosed. But once Renaissance painters had built the illusion of deep space, they could populate that space with every sort of creature, object, or growing thing. The floodgates were open; even nudes were now possible.

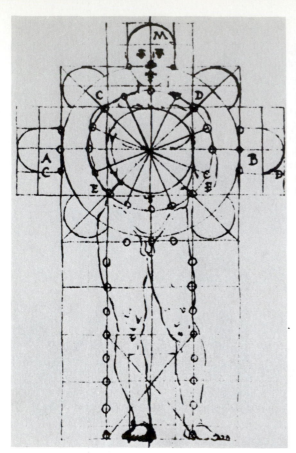

Francesco di Giorgio. *Church Plan Based on the Human Figure.* c. 1490–95. Pen drawing. Biblioteca Nazionale, Florence.

In addition to a knowledge of perspective and anatomy, the artist engages in speculation concerning the laws underlying the structure of all things—from the principles of the universe to the ideal proportions of a human body to the design of a church. Drawing was more than the imitation of visible forms. It was a means of demonstrating the essential unity of humankind with the cosmos.

Linear perspective was the chief dividend of the collaboration between Renaissance painters and mathematicians. It could not have been discovered through intuition or through trial and error. The idea of representing the world from a fixed point of view owed something to Renaissance individualism—its celebration of the ego and its confidence in the reliability of human sense perception. But the practice of making all lines converge at one or more vanishing points depended on sophisticated geometrical and optical thinking. The visual results were spectacular! The painter's ability to create visual illusions on a flat surface was a triumph of knowledge, not just craft. Here was the ultimate demonstration of theory as the indispensable tool of the artist.

We must stress the fact that the natural realism achieved by the Renaissance artist rested on a theoretical base. Not only were the visual results impressive, but so were the social and professional dividends! The painter's ability to represent credibly anything that could be seen or

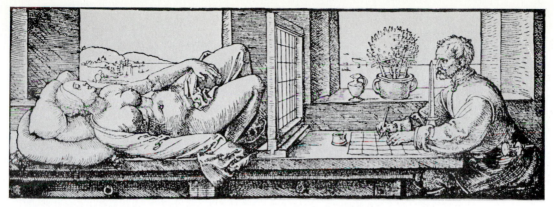

Albrecht Dürer. *The Artist Sighting and Drawing His Model.* 1525. Woodcut, from Dürer's treatise on perspective.

In this woodcut, meant for the instruction of his fellow artists, Dürer shows how a difficult problem in foreshortening can be handled by a system of grids and by sighting the figure from a fixed point. The model's pose is slightly suggestive, in the Venetian manner, but Dürer—ever the pious and respectable citizen of Nuremberg—portrays the artist as an utterly detached observer.

imagined was the result of intellectual effort.[1] Leonardo was quick to point this out when he argued the superiority of painting to sculpture: Sculptors had to make real three-dimensional objects; painters created miracles. Thus, painting had moved far beyond the mere manipulation of colored pastes; it created virtual realities, as if by the hand of God.

Emergence of the Architect

We think of a mason as someone who works in stone or brick, but for most of the Middle Ages, anyone who worked at a building trade was called a mason. That included quarriers, stonecutters, mosaicists, glaziers, carpenters, sculptors in wood and stone, painters, and master builders or senior masons. In the building of the Romanesque churches, there had to be someone who planned the structure and supervised the various workers engaged in its construction. This person was called a master mason, not an architect. Most likely, he had risen from the ranks of stonemasons, carpenters, or sculptors. Aside from making patterns and drawing plans, he could and did take a hand in the construction work. In other words, he was a craftsman before he became a designer, a building contractor, or a work supervisor.

The Renaissance witnesses a profound change of role for the master builder. The introduction of antique examples as models for "modern" construction—mainly by Brunelleschi and Alberti—greatly complicated Quattrocento building design. Medieval building was

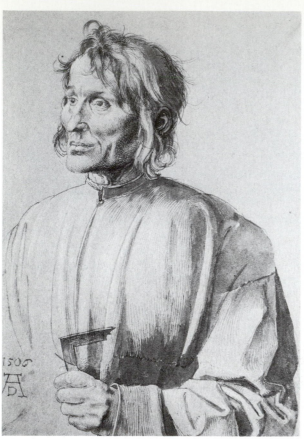

Albrecht Dürer. *Portrait of an Architect.* 1506. Drawing. Staatliches Kunstgewerbe, Berlin.

This drawing was made as a study for an altarpiece commissioned by a group of German merchants in Venice. Dürer included an architect among the citizens grouped around the Madonna and Child, the Pope, and the Holy Roman Emperor. Holding a square, symbolizing his profession, the architect exhibits the traits that mark a reputable member of the late medieval establishment: intelligence and piety, reverence and self-respect, professional competence, and civic responsibility. He has come a long way from the mason who labors with his hands.

largely a matter of solving difficult engineering problems, often on an improvised or empirical basis. The master mason had to be on hand for the shaping and placement of virtually every stone. Visual effects were necessarily subordinated to the main task of enclosing space safely. Even the High Gothic style, slender and graceful though it is, can be seen as a triumph of the engineering imagination. But Renaissance architecture concentrates primarily on *qualities of appearance.* The presumption is that Italian masons know how to build; the problem is to design beautiful, harmonious, well proportioned façades and then to assemble them coherently. This was the meaning of the art of building in the fifteenth-century, and it called for a new type of master builder, an architect, who would be visually minded before anything else.

The visually minded architects were influenced by the same forces that affected painters and sculptors. Their rise owes something to their experience as managers and their command of theoretical knowledge: geometry, mathematics, and physics. But they really should be

called designers; they began to spend more time in a studio and less time at the building site. This removed them physically (hence socially) from the building craftsmen. But we should emphasize another factor. The Renaissance architect had much the same training as a painter or sculptor. Michelangelo was not unique in working at all three arts. What these arts had in common was perspective drawing. Perspective enabled architects to visualize a building much as they might visualize a sculpture or

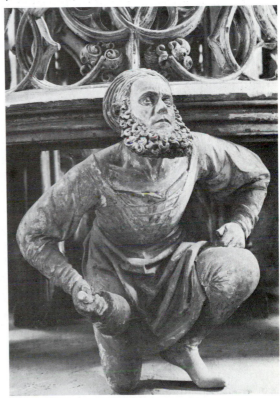

(below) Adam Kraft. *The Master.* 1493. Stone supporting figure for the tabernacle, St. Lorenz, Nuremberg.

Like Ghiberti, Adam Kraft belonged to both the late Gothic and the early Renaissance sculptural traditions. This figure of a master mason is a self-portrait. Not only does it convey the intelligence and energy of the craftsmen who built the cathedrals, it also carries the idea of an awakening: the eyes of the artisan have been opened. There is a relaxation of the old Gothic drapery; the folds of the apron fall down gently and naturally; the forms of the figure are clear and untroubled. The position of the body may be humble, but the expression in the face is modestly proud.

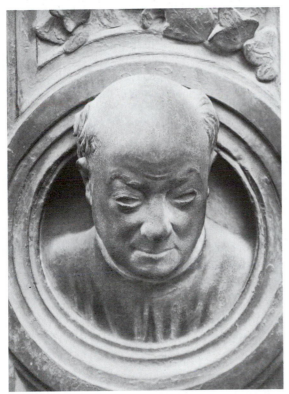

Lorenzo Ghiberti. *Self-Portrait,* from the "Gates of Paradise." 1425–52. Baptistry, Florence.

Ghiberti was a goldsmith, with one foot in the Gothic artisan tradition and the other in the intellectual tradition of Renaissance humanism. From his Gothic roots came a scrupulous attention to detail and quality of finish. From the new spirit of the Renaissance came a refreshing naturalism and sense of self-acceptance. This self-portrait captures a moment: It has taken Ghiberti over a quarter of a century to finish these doors and now, an old man, he is quietly pleased.

Unknown Urbino artist. *View of an Ideal City*. c. 1475. Tempera on panel. Palazzo Ducale, Urbino.

With perspective the Renaissance artist could visualize space relations as never before. The medieval city had been a more or less disorderly collection of buildings and spaces; their appearance of mutual adjustment was the product of centuries of improvised growth and renovation. Now cities could be *designed*. That is, their buildings and spaces could be organized deliberately, according to a single harmonious vision.

a painting. Drawing plans and elevations had been used by medieval builders, but they were mainly guides for the various building craftsmen. The Renaissance architect now had the ability to show how a building would look to the ordinary spectator. Perspective—we see it at its peak in the *Ideal Town* sometimes attributed to Piero della Francesca—introduced a new *design* device to the art of building. It enabled the architect to relate the shapes and dimensions of a building to its total environment. The architect could assess its visual impact on the individual, even change the appearance of a building before it was built. Thus, perspective became the ultimate design weapon. That is what removed architects from the shop floor to the drawing board: They visited the worksites, but they did their thinking in the studio.

From Hand to Brain

Problems of theology, philosophy, and aesthetics were not confronted by the medieval guildsmen. Guild workers were content to organize themselves, regulate their conditions of work, and guarantee each other's livelihood. Apart from religious and communal activity, they found meaning in work, in the process of making things well. The artists of the Renaissance had higher purposes. They wanted to make art a means of searching for the meaning of existence. They wanted to live up to the expectations of the humanists who saw significance mainly in *the idea behind* a work of art: its definition of human nature, its notion of the

divine, its description of humanity's place in the universe, its explanation of character, conflict, and destiny.

To carry out their lofty ambitions artists had to show they were intellectual workers. That meant making the case for painting or sculpture as one of the liberal arts. It was necessary to show that art implied more than physical activity. Again, the classical bias against manual labor was a factor. Sculpture was still regarded as lower than painting, because it involved more muscular work and more noise. The mental and imaginative effort was ignored. Leonardo da Vinci tried to prove that painting, at least, was "truly a science." Directing his remarks to literary men, because they were the acknowledged arbiters of the distinctions between higher and lower activities, he said: "If you call it [painting] mechanical because it is, in the first place, manual, in that it is the hand which produces what is to be found in the imagination, you writers also set down manually with the pen what is devised in your mind." In the final analysis, however, it was in his art that Leonardo made his point: Thinking of a very high order *precedes and accompanies* the successful artistic act.

Leonardo da Vinci. *Self-Portrait.* 1514. Red chalk drawing. Palazzo Reale, Turin.

Leonardo perfectly embodies the concept of the artist-genius. This is not because he was highly productive (he was not); or because he knew more than others (Alberti knew a great deal); or because his art surpassed that of his contemporaries (Michelangelo might well be the greater all-around artist). But Leonardo penetrated more deeply into the nature of things than did anyone else of his time. And he did this by employing drawing, the distinctive tool of the artist. He made drawing, or *disegno,* a major instrument of inquiry—into botany, anatomy, geology, psychology, physics, mechanics, and mathematics. Although he was not a scholar (his classical learning was meager), he was a true intellectual, an artist fascinated by ideas, a scientist fascinated by art. After Leonardo, the artist who is not intelligent and curious seems to be an aberration.

Although the logic of Leonardo's statement is very compelling, the question it deals with is alive today, surprisingly so. Aestheticians still quarrel about whether art deserves the status of knowledge. Apparently, some are convinced that a system of notation—writing—is the exclusive vehicle of thought. Even modern artists—"conceptual" sculptors especially—act as if manual activity is demeaning or, at least, creatively unnecessary. Their procedures would have pleased the Neo-Platonic thinkers of the Renaissance. Some of our sculptors conceive a work in the mind (or on paper); then they telephone instructions for making it to a metal-fabricating shop. Thus, their commerce with art-as-making or *techne* is minimal. The metalworkers who actually build the sculpture use their hands and get dirty, while the artist uses only the mind (plus pencil and paper) and remains clean. Eventually, the artist will instruct a computer by voice (no need for pencil and paper). So the classical stigma attached to manual labor has been wondrously transcended. Today's artist can literally carry out the conviction of Michelangelo that "a man paints with his brain."

Pieter Bruegel the Elder. *The Painter and the Connoisseur.* c. 1565. Brown ink on paper. Albertina, Vienna.

The connoisseur watches delightedly and reaches for his purse . . . to buy the picture before it is done. By the sixteenth century the collector has become a potent figure on the artistic scene: as patron, as critic, as investor.

Conclusion

The social elevation of Renaissance artists and their liberation from the medieval guild system does not mean that they were free or autonomous in the modern sense. They were still dependent on powerful patrons. Despite considerable latitude in carrying out commissions, artists did not, as a rule, work at projects and themes of their own choosing. Respected and highly rewarded as they may have been, Renaissance artists were nevertheless hired hands—celebrators of great men or women who paid well for the honor; propagandists for princes; supreme decorators for the city; ingenious fabricators of visual allegories that displayed humanistic lore while supporting Church dogma.

Andrea Pisano. *A Woman at Her Loom.* 1337–40. Marble relief. Campanile, Cathedral of Florence.

The prosperity of Renaissance Florence depended largely on the woolen industry—on the shearing, combing, carding, spinning, dyeing, weaving, and export of cloth made in over two hundred workshops in the city and surrounding villages. Among the lowest-paid weavers were women who worked at home or served as domestics in a manufacturer's house. Pisano portrays their labor with noble dignity. That may have been the case if the woman was mistress of her own household. Otherwise, she was a drudge like any rural serf.

But despite their dependence on powerful persons and institutions, Renaissance artists established the foundations of an important new artistic principle, namely that the process of art is a process of inquiry, not just technical execution. By convincing their betters that artistic work depended on theoretical knowledge, the artists opened up the possibility that painting, for example, is more than a reflection of what is seen. It is also a way of studying and interpreting reality. For its professional benefits and its aesthetic results, therefore, we celebrate the association of artists and intellectuals begun more than five hundred years ago in Italy.

Another dividend extends beyond the community of painters, sculptors, and architects. The emergence of the artist-type during the Renaissance signaled a new recognition of individuals for their own ability. During the Middle Ages collective belonging and social origin had been far more important in the determination of human worth. Now birth and occupational caste gave way to personal competence, in any field. As we have seen, it was possible for the best craftsmen to rise socially because their accomplishments were visible and their services were needed. The principle of merit was accepted as never before. Thus, two important principles were established: (1) excellence in art as in other fields depends on the right support systems; and (2) the quality of a civilization depends on its capacity and willingness to honor *individual* achievement.

the REVOLUTIONARY ARTIST

As long as painters and sculptors belonged to the artisan class, their themes were substantially controlled by people with a strong interest in maintaining the status quo. But when it was shown—by Leonardo and others—that art is a product of independent thought and inquiry, the way was open for society and all its institutions to become objects of inquiry. The Renaissance created the theoretical possibility of a revolutionary art, although little of it appeared until the late eighteenth and nineteenth-centuries. Of course, an art of social description had long existed. For example, *genre* scenes—the representation of events from everyday life—could be found in Neolithic rock art, on Greek vases, or in medieval manuscript paintings. But a genuinely revolutionary potential emerged only when artists, and thoughtful people in general, realized that they could play a role in the shaping of human destiny. The idea of directed change in human affairs—the idea of progress—seized the Western imagination about two centuries ago. From it grew a new conception of the artist's role: The artist could participate in the transformation of society by employing visual imagery as an agent of social progress. Art could be a critical as well as a descriptive representation of life.

The blessings of science and technology did not fall evenly on nineteenth-century society. In fact, the promise of a better life through

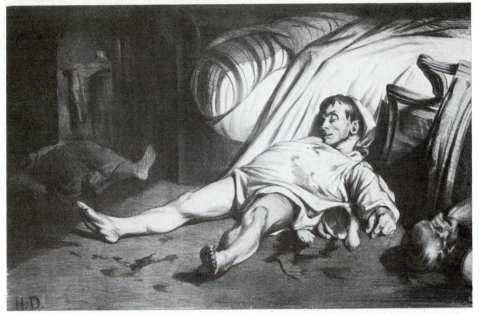

Honoré Daumier. *Rue Transnonain, April 15, 1834.* 1834. Lithograph. National Gallery of Art, Washington, D.C. (Rosenwald Collection).

An innocent workingman and his family slaughtered by the police! Daumier reports the event with the eye of a journalist; he lets the scene speak for itself. By avoiding visual rhetoric, allegory, and classical or religious allusions, Daumier drives home the ordinariness of the tragedy. We are told, in effect, that when the press is gagged, when poor people cannot protest, when agents of the king commit legal murders—then we have a revolutionary situation.

industrialism coincided with a pronounced deterioration in the lives of working people. The irony of this situation was not lost on intellectuals, who had expected science and technology to produce a steady advance in the happiness of humankind. And it was painfully clear to artists who found themselves cut adrift from their accustomed sources of support and ill-equipped to join the new business civilization coming into existence. A saintly artist like Van Gogh might choose poverty and eagerly share the lives of exploited Belgian miners. Others longed for what they had lost—aristocratic patronage, attachment to a princely entourage, participation in courtly fun and games. Thus the nineteenth century presided over the development of two artistic attitudes, both of which are still with us. One amounts to nostalgia for the patronage, the social stability, and the material comfort of the prerevolutionary past. The second constitutes a determined effort at self-transformation: artists endeavor to realize the revolutionary potential of Renaissance art; they want to enter the process of radical social change.

Revolutionary Types

There are three basic types of revolutionary artist. The first tries to make fundamental political changes by directly attacking the persons, classes, legal forms, and religious institutions that support the status quo. Such artists are often called propagandists, because they literally illustrate revolutionary dogmas. Kollwitz and the Mexican muralists Rivera, Orozco, and Siqueiros would fit this category. A second type is indirectly revolutionary: the artists are not doctrinaire; they do not offer a scheme for political change; but their representation of social conditions is so

Käthe Kollwitz. *Uprising.* 1899. Etching. Courtesy Galerie St. Etienne, New York.

The image of workers and peasants marching—with scythes and pitchforks as their only weapons and a proletarian angel to inspire them—recurs again and again in revolutionary art, literature, and cinema. It expresses the longing of the left for a general revolt, an uprising by the least politicized elements of society. Kollwitz lost a son in World War I and a grandson in World War II. She belonged to the tradition of evangelical Christian socialism, which looked at revolution as the only cure for war and the terrible sufferings of the poor. Significantly, in her prints, it usually is a woman who incites the peasants to rebel. Her art was her "war against war."

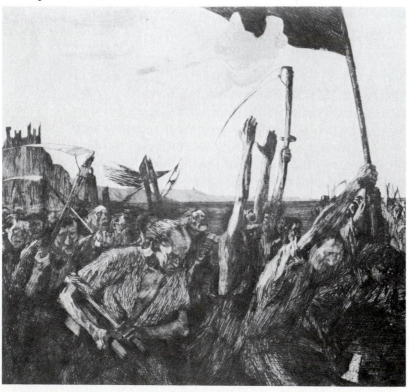

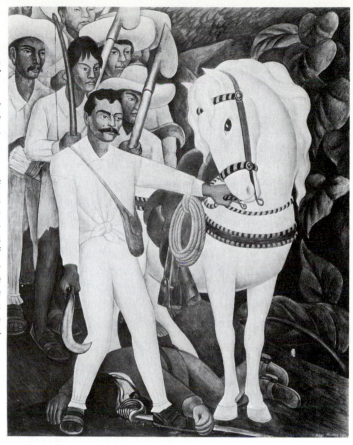

Diego Rivera. *Agrarian Leader Zapata.* 1931. Fresco. Museum of Modern Art, New York (Abby Aldrich Rockefeller Fund).

For weapons these peasants have only farming implements and a primitive bow and arrow. Just like the peasants of Koll- witz. Even their leader, Emiliano Zapata, carries a scythe, or sickle. It is, of course, the Communist symbol of agrarian protest, and it has prevailed over a poor soldier of the opposition—a soldier who carried a sword but fell anyway. Rivera was an ele- gant designer. Supporting his carefully ar- ranged heroics and neat symbolic dramas was an almost musical organization of form. But his ideas are angrier than his im- ages. The distinctively revolutionary feature of his art was its emphasis on race as the badge of the oppressed. For Rivera it is race that polarizes society. Before they are farmers or Mexicans or rebels, these *Zapa- tistas* are Indians.

scathing and outraged that viewers feel they cannot support the existing social order. Goya, Daumier, and Munch would fit this category. A third type might be called revolutionary for purely artistic reasons. Their im- agery introduces radical changes in visual form, but it has little or noth- ing new to say about society or politics. Cézanne, Matisse, and even Picasso would fit this category. As we shall see, there is some question whether they are revolutionary artists in terms of this discussion. Still, critics often apply that adjective to their work, implying that fundamen- tal changes in the language of art have deeply unsettling, and hence revolutionary effects on society.

We ought to look more closely at this third type of "revolution- ary" artist because of its obvious bearing on our contemporary situation. The changes wrought by a Cézanne, a Matisse, or a Picasso are essentially internal developments within the history of art. These artists are origina- tors of visual, not political or social ideas. From a revolutionary stand- point they may be radical with respect to visual form, but their art does

not lead to basic changes in the ownership of property, the distribution of wealth, or the control of the political apparatus. A Marxist[1] would say their work is highly innovative but it is not revolutionary, because it does not point the way to fundamental change in people's lives.

One reply to this argument is that form and content are inseparable, and that basic changes in visual form signal underlying changes in society as a whole. The question we might well ask, then, is whether a painting of apples by Cézanne or a still life by Picasso reflects underlying social conditions or whether it anticipates social change. That question is not easy to answer. Still, it is hard to see how a still-life painting could improve the treatment of farm laborers, secure voting rights for the disenfranchised, or create jobs for the unemployed. Perhaps the most we could claim for its social effectiveness is that it causes unique satisfactions for the privileged persons who own it. Purged of anger or bitterness, these individuals may be disposed to deal more fairly and generously with their fellow human beings. But from a revolutionary standpoint, that is a weak reed to lean on.

Artists and the "Left"

We associate revolutionary artists with leftward or radical political views —anarchism, socialism, or communism. "Left" is a term that originated in France around the time of the Revolution of 1789. It designated the delegates seated on the left side of the French chamber of deputies. After the Revolution all sorts of people, not just politicians, tended to be classified as left-wingers, right-wingers, or in-betweeners, as if they sat in a certain place in that legislative chamber. Social and political radicals located themselves at one extreme; royalists, "reactionaries," and so on were at the other.

The use of the terms "left," "left-wing," "right," and "right-wing" to designate artistic views is a sign of the substantial integration of social, political, and cultural attitudes in Europe beginning in the late eighteenth century. That integration was not always thorough and consistent. We can think of many artists, then as now, who lean to the "left" politically, while occupying a "rightist" position artistically, and the other way around. Still, the idea of revolutionary art and artists is closely tied to the political experience of France, especially the "fallout" of the revolutions of 1789, 1830, and 1848. There were other countries in which revolutionary artists lived and worked; the Spain of Goya is a good example. And in Italy, Caravaggio was a kind of Baroque revolutionary.

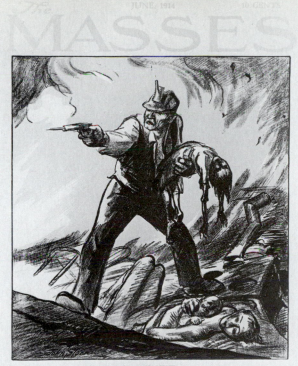

(above) John Sloan. "Class War in Colorado," cover for *The Masses* magazine, June 1914. Delaware Art Museum, Wilmington (John Sloan Collection).

A prime example of revolutionary art: standing on the broken bodies of women and children, holding a dead child, the beleaguered miner fights back. The worker's revolution has reached its violent phase. Sloan based this drawing on a real event—the brutal suppression of a strike at the Ludlow mines in Colorado. The style and the pathos go back to Daumier's murder victim in the rue Transnonain and to Kollwitz' etchings of weavers' uprisings in Germany in 1899.

(below) George Grosz. *Pillars of Society.* 1926. Staatliche Museen, West Berlin, courtesy Peter Grosz.

Sarcasm is a common weapon of the revolutionary artist. Bankers, generals, clergymen, and businessmen were in fact the pillars of society in Germany during the 1920s. And quite a few were Nazis. Many others were fascinated by war, by its capacity to bring out "the best" in people. Grosz portrays these solid citizens as idiots—hateful idiots. Which is to say that society rests on a diseased foundation.

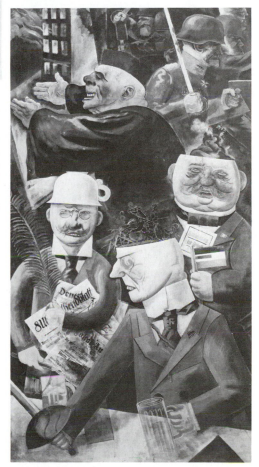

Francisco Goya. *Executions of the Third of May, 1808.* 1814–15. Oil on canvas. Prado, Madrid.

Goya is full of contradictions. He belonged to the Rococo age and to modernism; he was a court painter who denounced every kind of authority in Spain; he was a patriot and a powerful critic of his fellow citizens. Here he is a humanitarian protesting the execution of some poor Madrileños by Napoleon's occupying soldiers. We witness in this work the birth of the revolutionary vocabulary in painting: the oppressive, abstract power of the soldiers' repeated forms; the tragic breakdown of the civilians expressed by the disorderly shapes of their bodies; the flat illumination of the central figure (no halftones) to convey the victims' absolute terror; the contrast between the human faces and the impersonality of the firing squad. Great revolutionary artists—like David and Goya—go beyond the depiction of violence. They know how to use abstract organization *and* realistic detail to carry their message.

By representing religious personalities as working-class types, he departed radically from the tradition that had always shown the humble personalities of the Bible as if they were aristocratic, courtly figures. So artists with a leftward tilt can be found in a variety of settings. Indeed, they can be radical without knowing it. Nevertheless, the consciously revolutionary artist-type—the "left-wing" artist—is mainly an eighteenth-century French creation. Why is this so?

Emergence of the Artist-Revolutionary

It is an irony of history that revolutionary artists emerged because revolution cut them off from their livelihood. They were products of the abrupt termination of aristocratic and church patronage following the democratic revolutions of the eighteenth century. With the French monarchy abolished, the hereditary nobility wiped out, and high churchmen deprived of funds, the traditional sources of artistic commissions were dried up. A new and wealthy class of merchants, bankers, and manufacturers replaced the patrons of the old regime. But this class was, if anything, more cautious and conservative than the aristocracy it sup-

O. Louis Guglielmi. *Relief Blues*. 1938–39. Tempera on fiber board. National Museum of American Art, Smithsonian Institution, Washington, D.C.

Social description, or genre painting, displays its revolutionary potential. Here the theme is the humiliation of the family on relief, or "welfare." The proud father is mortified as he submits to the questions of the social worker. (Yes, he has looked for work.) The mother sitting next to the heating stove cannot watch what is going on. Their daughter strikes another note: indifferent to the family drama, she puts on her make-up; she must be going out on a date. The parents are immigrants—old-fashioned, strict; most likely they do not approve. But what can they do? The "system" has made them helpless.

planted. When it came to the patronage of art, the bourgeoisie knew what it did *not* like: it disliked frivolousness and sexual titillation, which it associated with the laziness and moral corruption of the royal court. The new commercial and professional classes saw the art of Boucher, Fragonard, and Nattier as decadent. They were suspicious, too, of any serious—that is, realistic—attention paid to working-class life, the social consequences of the factory system, or the ugliness of the new slums. As for satirical references to sacred institutions like the law, property, and banking, they were not amused. And everywhere they saw the threat of socialism.

Despite their intelligence, probity, and devotion to hard work, the middle classes of the nineteenth century did not feel comfortable with art unless it was pretty, sentimental, and safe. Artists, therefore, were faced with three alternatives. They could produce well-crafted but essentially fictitious representations of middle-class life; that is what Victorian art was mainly about. They could retreat into the never-never land of mythology and fairy tales; that is what Romantic art was about. They could become outlaws and depict the painful realities of a society giving birth to modern industrialism; that is what early revolutionary art was about.

Art and Propaganda

We have mentioned some artists, like the Mexican muralists, who were outright propagandists for revolution. A Neoclassicist like David was a more subtle and indirect propagandist. The use of art as propaganda is older than the French Revolution. The word was first employed in connection with religion: *propaganda fides*—spread the faith. According to that doctrine, all forms of culture are enlisted in the service of religion. The art of the Catholic Counter-Reformation, in the seventeenth century, was designed as propaganda; it was meant to resist the inroads of the Protestant reformers by depicting the splendors of the Church and the spiritual rewards of the true faith. Two of its greatest exponents were the Baroque masters, Bernini and El Greco. Do we think of them as "propagandists"? Not today, because the religious issue is now subordinate to other, mainly aesthetic, concerns. Nevertheless, the painters and sculptors of the Counter-Reformation created the model of an art that could promote psychological resistance, the enlistment of armies of supporters, the heightening of religious loyalty, the glorification of an institution, and the restoration of confidence in its leadership. Apart from

Alice Neel. *TB Case, Harlem.* 1940. Oil on canvas. Collection Mr. & Mrs. Wallace Holliday, Washington, D.C.

Illness and suffering are universal themes. What makes this painting a revolutionary work? First is the setting: Harlem, where poor people—blacks and Puerto Ricans, especially—live. Second is the disease: tuberculosis, which was believed to be caused by poverty and malnutrition. In other words, the poor suffer, get sick, and die because the social system is corrupt.

propaganda, this art was superb from the standpoint of technique and emotional power. It could thrill and persuade at the same time. But it was not a revolutionary art in that it sought to resist rather than promote change. Nevertheless, Counter-Reformation art established a revolutionary precedent: It showed that visual imagery could be employed "politically." Again we have an irony of history—the cultural techniques originally devised to support religious faith were eventually employed to destroy it.

Revolutionary Style

Is there a single style that revolutionary artists consistently adopt? Many claim to be realists, but the range of realism is very wide—from Courbet to Kollwitz to Orozco. Certainly some of the most caustic statements of social protest have been made by Expressionists like Rouault, Nolde, and Grosz. Agitated paint surfaces, distorted forms, repulsive subject matter —all these serve the purposes of the revolutionary artist by stimulating

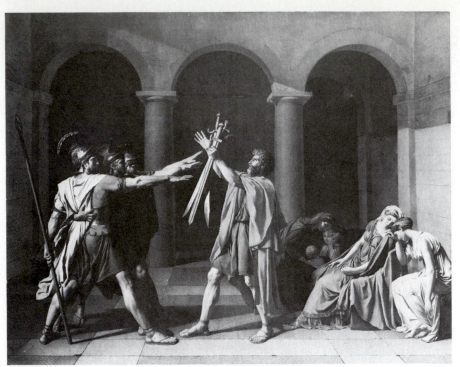

Jacques Louis David. *Oath of the Horatii.* 1784. Oil on canvas. Louvre, Paris.

Commissioned by the king, painted by the leading classicist of the time, the *Oath* is nevertheless a revolutionary work—and David was, for much of his career, a revolutionary artist. Here he enlisted a Roman myth in the service of ideals that would lead to the king's losing his head. Louis XVI must have regarded the painting as an allegory celebrating patriotism. Others saw it as a summons to revolution. The ideals it extolled were unity, sacrifice, simplicity (a republican, not a royalist, virtue), and willingness to kill for the sake of civic honor. During the revolution David became the artistic dictator of France. Afterward, he became Napoleon's official painter. Always he believed that art "must be the expression of an important maxim, a lesson for the spectator. . . ." And by "lesson" he meant an idea that is acted upon.

feelings of shock or disgust in the viewer. Before people are willing to take radical action, they must be aroused. Revolutionary classicists have a different approach. Like Jacques Louis David, they appeal to reason, depicting scenes of patriotic heroism, as in his *Oath of the Horatii* (1784), or portraying radical tragedy, as in his *Death of Marat* (1793). Even Diego Rivera's *Night of the Rich* (1927) is a classically ordered work from a purely visual standpoint, despite its revolutionary purpose, which is to show the matter-of-fact repulsiveness of the rich. An Expressionist like Jack Levine has the same objective in his *Reception in Miami* (1948). In both cases, the artist tries to stir up anger and class resentment.

A more romantic approach to revolution is seen in Delacroix' *Liberty Leading the People* (1830). To us it may appear somewhat posed and contrived compared to Daumier's *Uprising* (1860). By comparison, Daumier's lithograph of working people murdered in their beds, *Rue Transnonain, April 15, 1834*, has a more shocking, journalistic flavor, especially if we compare it to David's classically staged murder of Marat. For the masses of people, the realism of a Daumier or a Kollwitz arouses stronger feelings of outrage than the noble gestures of David or the dignified violence of Delacroix. So it is not style but bitterness that makes a revolutionary artist. Daumier and Kollwitz have it; David and Delacroix do not.

Eugène Delacroix. *Liberty Leading the People.* 1830. Oil on canvas. Louvre, Paris.

Several of the main features of revolutionary art were invented by Delacroix. Bare-breasted Liberty is normally an allegorical figure. Here she carries the tricolor flag of France. Striding over the bodies of patriots (morts pour la France) and followed by persons drawn from all classes, she inspires mainly nationalistic sentiments. But nationhood is forged in blood—blood and gore in the foreground; fire, smoke, and the mob in the background. Liberty galvanizes all emotions and events. A woman, a boy, a clerk, and an African are fused into the symbol of a revolutionary force. This is not a factual work, but people require symbols. Only symbols can make them fight.

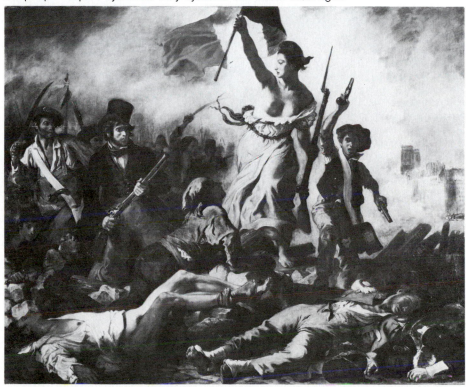

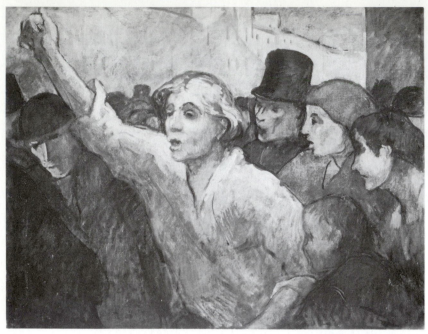

Honoré Daumier. *The Uprising*. c. 1860. Oil on canvas. Phillips Collection, Washington, D.C.

Unlike Delacroix, Daumier makes no appeal to classical mythology when he wants to depict a riot. He *does* follow Delacroix by including a few top-hatted figures, and that is supposed to indicate the broad base of the uprising. But Daumier is too much of a journalist and realist to use antique symbols as the animating force of the mob. His young worker is an idealist, but an idealist purged of sentimentality.

Ernest Meissonier. *The Barricade, Rue de la Mortellerie*. 1848. Louvre, Paris.

A realist specializing in battle scenes, Meissonier saw revolutionary violence from the standpoint of someone who knows what fallen bodies look like. When Delacroix created his romantic barricade drama, only eighteen years earlier, the canvas was filled with hope and noisy heroics. Meissonier reminds the viewer of warm blood spilled on hard cobblestones . . . and of a terrible silence in the street.

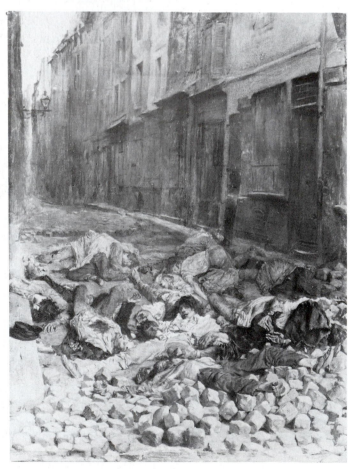

114

Socialist Realism

Although the revolutionary artist is not restricted to a single style, certain theorists—notably in the Soviet Union—maintain that "socialist realism" is the only correct style for a progressive artist. But realism is the style historically preferred by the despised bourgeoisie. Why is the revolutionary artist encouraged to create in this "reactionary" mode? The answer is that if the artist portrays bourgeois life as it truly is, its contradictions, cruelties, and injustices will be revealed. Conversely, the heroism, cooperativeness, and sacrificial spirit of the people under socialism will be similarly revealed by the progressive artist. The trouble with bourgeois realism is that it prettifies or glosses over the ugly truths of capitalist society. But the truth is there; the dialectical laws of history work themselves out inevitably. The artist's role is to record what happens—but not mechanically or photographically. The revolutionary artist needs to understand the laws of history—dialectical materialism, the

Dorothea Lange. *White Angel Breadline, San Francisco.* 1933. Photograph. Oakland Museum, Calif. (Dorothea Lange Collection).

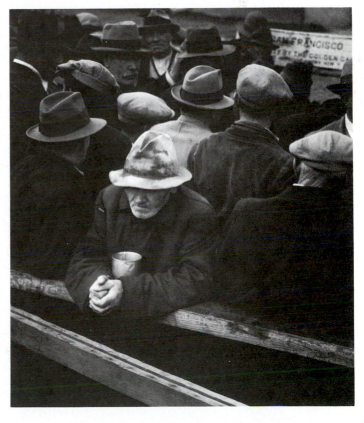

Photography is ideally suited to the development of revolutionary consciousness, because the photograph is almost always perceived as an exact record, a picture of the naked truth. Here it is used to document the breakdown of the capitalist system—the pathetic spectacle of people who live on handouts. The artistic and rhetorical qualities of photographic images are often overlooked because we are fascinated by their visual fidelity. Nevertheless, Lange has shaped the viewer's emotions, through her composition and angle of vision. In this photograph, no one's eyes can be seen; most of the faces are hidden; the repeated forms of the men's coats look like a gathering of burial shrouds. The one face we do see conveys a sense of overwhelming weariness.

processes through which society gives birth to socialism. Then the artist can select subjects correctly and portray them appropriately for the good of humanity.

It appears that the doctrine of socialist realism requires revolutionary artists to subordinate their imaginations to an official reading of the laws of society and history. There is nothing radically new about that; as we have seen, sixteenth and seventeenth-century Catholic artists submitted to rules of art promulgated by the Church at the Council of Trent (1545–63). Rubens and Bernini were not crushed by those ecclesiastical restrictions, and El Greco worked successfully in the shadow of the Spanish Inquisition. However, artists have experienced a considerable enlargement of their creative freedom since 1563. The doctrine of socialist realism was officially announced almost four centuries later.[2] So today's artists are inclined to resist the guidance of bureaucrats, however well-intentioned. But suppose that clumsy censorship and heavy-handed regulation are only Soviet aberrations. Would socialist realism be compatible with the highest aims of the revolutionary artist? Suppose

Jacob Lawrence. "One of the Largest Race Riots Occurred in East St. Louis," panel 52 from *The Migration of the Negro*. 1940–41. Tempera on composition board. Museum of Modern Art, New York (gift of Mrs. David M. Levy).

Flat forms, angular shapes, sharp edges: this is the geometry of conflict and violence. Compared to the revolutionary realists of the nineteenth century, Lawrence relies more on the power of abstract patterning. There is less blood and gore, more emphasis on position and silhouette. The result is a depiction of a riot as a kind of ritual—an urban dance with knives and clubs.

also that the freedom of the bourgeois artist is only the freedom to sell anything people are willing to buy. Suppose, finally, that the mission of the artist is to produce images that cut through the cliches, myths, and stereotypes of a decadent civilization.

The Revolutionary Artist Today

Today's revolutionary artist may be a self-proclaimed radical while turning out very tame stuff so far as the fundamental transformation of society is concerned. We have already mentioned the "radicalism" of the most famous of modern artists, Pablo Picasso (1881–1973). He was a member of the Communist Party, lived in France for most of his long life, and exercised an immense influence on artists throughout the Western world. Nevertheless, he had little influence on French politics or society. France remains in the camp of the liberal democracies. The large Communist Party of France used Picasso rather than his art. (The doves that Picasso designed for several Communist-sponsored peace conferences were probably the least impressive works in his vast and varied artistic production.) Spain, Picasso's native land, was ruled by a Fascist dictator for most of Picasso's career. His art cried out against Generalissimo Franco, who nevertheless ruled until he died, peacefully, in bed. The Soviet Union, a communist superpower officially dedicated to the highest ideals of socialist culture, had and has little use for Picasso's art. In the United States, however, Picasso's work has been collected by millionaires (who else could afford it?), and he was personally idolized by the middle classes. Yet ordinary Americans know about his wealth and fame without understanding his work. As for the revolutionary significance of Picasso's career, it is inconceivable that he could have lived and thrived as he did outside the protection of a Western-style democracy and without the support of a shrewd art dealer, Daniel-Henry Kahnweiler. At his death, Picasso left an estate worth more than three hundred million dollars. He worked hard, to be sure, but it was in this respect alone that he shared the destiny of the working classes.

Picasso's career is a dramatic illustration of the dilemma of the revolutionary artist who lives through the profit-oriented dealer system. Because of the way gallery art (see Chap. 10.) is publicized, displayed, and sold, there is little difference between the work of the revolutionary artist and the work of the reactionary artist. Art dealers are small capitalists: they invest in art and sell it at a profit. Often sensitive, discriminating, and supportive individuals, they must nevertheless deal with

David Alfaro Siqueiros. *Self-Portrait*. 1943. Museo de Arte Moderno, Mexico City.

The revolutionary artist as he sees himself and wants the world to see him. His fist is bigger than his head; his face speaks of anger and contempt; his outthrust arm breaks through the picture space. In that gesture he expresses his commitment to two objectives: the destruction of the existing social order and the demolition of bourgeois aesthetics.

artists much as merchant-manufacturers used to deal with cottage crafts-men. In other words, dealers are obliged by their business to treat artists as piece-workers and subcontractors. The work of art becomes a com-modity which is or is not marketable.

The aspect of a commodity that is marketable to an upper-class clientele is its style. Indeed, revolutionary *or* bourgeois content is ab-sorbed by style. Thus, the serious work of art becomes decorative, harm-less. The art dealer system may enrich revolutionary artists or neglect them altogether. But in either case it is not likely to change the social and political consciousness of the masses.

Ultimately, the problem of revolutionary art and artists is tied to the general problem of the dissemination of artistic ideas, which is closely related to the effectiveness of modern art educational techniques. We cannot deal with these important questions here beyond pointing out

that art galleries, art museums and school, college, and university art departments study and display works of art according to their preciousness as commodities or their position in a long, seemingly endless history of style. The impact of the fine arts—revolutionary or not—tends to be neutralized.

Conclusion

Who, then, are today's revolutionary artists? Clearly they are not the painters and sculptors, however gifted and ingenious, whose work appeals only to a small and privileged elite. Nor are they, necessarily, artists whose work appeals to the millions. A popular illustrator like Norman Rockwell may have a huge following, because his art soothes and reassures, but it is hardly revolutionary.

Genuinely revolutionary artists would be those whose work meets the following conditions: Their art would be quickly disseminated, easily accessible, and inexpensively consumed; it would be endlessly reproducible; it would be comprehensible to old and young, rich and poor, managers and workers; it would transcend differences of region, race, and education; it would exemplify lifestyles that could be widely emulated; it would have plausible connections to real life; it would exert enormous influence on styles of behavior. It would have the capacity to create vast markets for goods and ideas. It could begin and end wars, topple governments, and win elections. It would shape the aspirations of millions of people.

Can there be any doubt that film, television, and mass-produced graphics fill these conditions? Their creators are teams of artists, designers, technicians, and impresarios; star personalities and anonymous, behind-the-scenes managers, writers, poll-takers and publicists. It appears that the revolutionary function has been diffused among these media people much as invention is diffused among the scientists, engineers, and technicians of a research laboratory. The revolutionary artist is in there, in the media, someplace. Perhaps, like the Paleolithic shaman, pieces of the artist have been divided up in that galaxy of creative workers whose names we see listed at the end of a major film or television show. Mostly, they are entertainers. But a few are genuine form-givers.

THE BOHEMIAN ARTIST

The passerby who identified Leonardo, Raphael, and Michelangelo as artists knows about bohemianism, too. It means: no regular job, no regular hours, good times, and loose living. Most people make a connection among bohemians, hippies, and dropouts, and they suspect, rightly, that some bohemian artists spend more time perfecting their lifestyles than making art.

For at least two centuries assorted vagrants, rebels, and poseurs have attached themselves to the artistic scene, attracted by the tolerance, freedom, and easy camaraderie of artists and their friends. But here we need not dwell on the idlers and imposters who are drawn to bohemianism. It is more important to recognize that many of the major personalities of modern art were devotees of the bohemian spirit. At least, they started out as bohemians.

At first, the bohemian lifestyle appears to be nonconformist in the extreme, but it is in fact a code—a highly standardized code—for art students. Some never get over it. That code amounts to a philosophy of art-and-life (the two are wholly integrated) that enlists the fervent dedication of its followers. Following is a semiserious version[1] of bohemian

Pieter Bloot. *The Poor Painter Shivering in His Garret.* c. 1640. Drawing. British Museum, London.

The concept of the bohemian artist had not yet emerged in the seventeenth century, but Holland had plenty of poverty-stricken painters. And when the artist shivered, his wife and child shivered, too. Here they watch him hungrily, hoping he can produce a picture that will sell. For the Calvinistic Dutch, poverty in an artist, or anyone else, was no particular virtue. For nineteenth-century bohemians it was almost a sign of genius.

principles [with my semiserious comments attached]. It appeared in a Norwegian periodical, *The Impressionist,* around 1884:

1. .Thou shalt write thine own life. [Essential for escaping the curse of mediocrity.]

2. Thou shalt sever all family bonds. [Except for receiving monthly checks.]

3. One cannot treat one's parents badly enough. [Of course]

4. Thou shalt never soak thy neighbor for less than five kroner. [The bourgeois is good for something: money.]

5. Thou shalt hate and despise all peasants. [A peasant, by definition, is someone who doesn't appreciate bohemians.]

6. Thou shalt never wear celluloid cuffs. [Costume has great symbolic importance; it declares freedom from the nine-to-five business world.]

7. Never fail to create a scandal in the Christiania [Oslo] Theatre. [Happiness depends on stirring up the old fogies.]

8. Thou shalt never regret. [This is serious. Regret leads to hesitation, and hesitation kills artistic spontaneity.]

9. Thou shalt take thine own life. [Another serious note: suicide is the ultimate romantic gesture; it proves that life can be shaped, and ended, artistically.]

The tone of self-mockery in these "commandments" places them in the context of student cleverness. Toward the end, however, the self-destructive motif in bohemianism asserts itself. So the code parallels bohemianism as a style and a profession: it begins with antiestablishment wit and concludes with an early exit.

Bohemianism and Romanticism

Bohemian artists are children of nineteenth-century Romanticism. They try desperately to exploit its main discoveries—the "truth" of the emotions, the central importance of the inner life, the significance of intuition in artistic creativity, the secret meaning of irrational acts, the inseparability of art and life. These are the serious principles around which the bohemian tries to build a personal and aesthetic existence. So there *are*

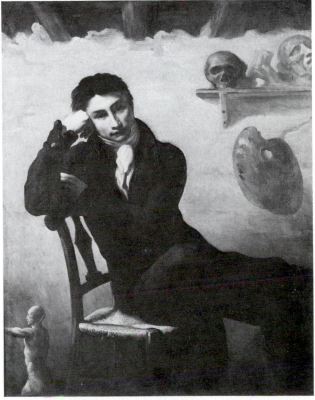

Théodore Géricault. *Portrait of an Artist in His Studio.* 1818. Louvre, Paris.

Bohemianism has its roots in the emotions, dress, and self-absorption of the Romantic artist. Romanticism had strong escapist tendencies. It is plain that life—life as it is—disappoints and bores Géricault's sensitive young painter. He seems to exude world-weariness and apathy. The skull behind him symbolizes human futility, and his costume (hardly a painter's working outfit) expresses a kind of well-tailored morbidity. What, if anything, does he care about? Playing the role of an artist, because only the artist's life is authentic. That means behaving like a great-souled person, a genius. And genius, of course, makes its own rules.

rules. They are rules for preventing the loss of what is most precious to the romantic artist: originality and emotional power—that is, the ability to excite viewers, to overwhelm ordinary men or women by the force of the artist's expression of feeling.

Romantics have a confidence, amounting almost to religious faith, in the capacity of art to change people by appealing directly to their emotions. They are convinced that logic, reason, and science (a hateful word in the romantic lexicon) deal mainly with superficial matters. Like psychoanalysts, they believe that conscious thought, official knowledge, and established institutions are little more than a thin veneer covering a deep deposit of truth that lies underneath. If artists permit themselves to be guided by everyday codes of behavior, they will never gain access to the rich deposit of truth that conventional codes were designed to conceal.

Here we have the bohemian conviction that social conventions are misleading as well as rotten. It makes sense, then, to defy convention. That is the only way to live honestly, to avoid the lies, shams, and compromises that make up the lives of respectable people. It takes courage to be a bohemian. Creature comforts are few, dirty jobs many. There

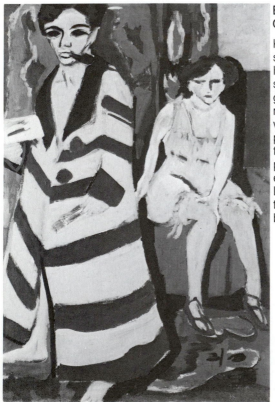

Ernst Ludwig Kirchner. *Self-Portrait with Model.* 1910. Oil on canvas. Kunsthalle, Hamburg.

Kirchner portrays the artist-model relationship from the standpoint of a worldly resident of Dresden and Berlin. His bohemianism is elitist and aggressive: the artist is a superior person who relaxes calmly after sex, enjoys a good smoke, and paints himself in an exotic robe. His model is angry and uncomprehending; she just sulks. If we compare this scenario to one of Modigliani's, it appears rather explicit and crude. The painter has penetrated the cheap eroticism of the cocotte—probably picked up on the Kurfürstendamm—but his victory is too easy. Here is the bohemian without the compassion of Lautrec or Pascin; the dominant emotion is contempt. But that emotion leads to nihilism and, in Kirchner's case, breakdown and suicide.

may be some bread and a little wine but not much else, because money problems are incessant. And there is persecution: official society oppresses its freest spirits, its most original talents. Finally, there is the painful spectacle of mediocrities and renegades receiving honors they do not really deserve. Are there any rewards? There is freedom, a feeling of personal authenticity, the friendship of fellow artists and lovers. With luck, there is immortality. Alas, it comes too late.

Love and Revolt

If revolutionary artists are fundamentally political radicals, then bohemian artists are social radicals. Their lives and persons are a protest against the social order and the cultural establishment. That protest may or may not take artistic form; it does take behavioral form. It is not essential for bohemians to practice art; their real artistic effort is devoted to perfecting a style of revolt. Seemingly casual about things, apparently indifferent to social expectations, bohemians are deadly serious about one purpose: their lives must express supreme contempt for everything that the middle class, the bourgeoisie, holds dear.

Ironically, the bohemian artist is almost invariably a product of the middle class—or even the aristocracy. Consider Henri de Toulouse-Lautrec! Also remember Cézanne, who was the son of a banker; Van Gogh, the son of a pastor; Picasso, the son of a drawing-master—all eminently respectable professions. Perhaps it is true that familiarity breeds contempt—especially among artists, writers, and intellectuals. Even today, the sons and daughters of lawyers, doctors, professors, manufacturers, and high civil servants produce more than their share of revolutionaries and bohemians. Seeing the pillars of society up close and for prolonged periods of time seems to generate a powerful desire to tear down society's most precious symbols.

The word "symbol" is important here, because the bohemian artist is engaged in what is essentially a symbolic revolt. Revolutionary artists are another breed: they mean business. Bohemians are satisfied to create consternation, disappointment, and unhappiness among their parents or among those who share their parents' values. What better way than to frustrate the elders' banal ambitions for their children?

But bohemianism is not all generational revolt. It has aesthetic dimensions that lift it above adolescent perversity. For one thing, the bohemian is dedicated to art as a kind of substitute religion. Art for art's sake: that is the bohemian's absolute! There is no other god—no social,

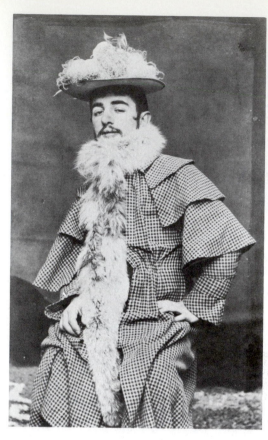

"Mademoiselle" Lautrec. c. 1892. Photograph. Musée Toulouse-Lautrec, Albi, France.

Toulouse-Lautrec in drag. The bohemian party—a combined costume ball and bacchanalian revel—provided the setting for artists to act out the disappointments and contradictions of their existence. For Lautrec, self-pity was unthinkable. Instead, he fought against the tragedy of his life with bohemian weapons. Thus, we have the spectacle of a proud aristocrat who makes his home in a brothel; the image of a misshapen little man who presents himself as an exquisite female doll; the travesty of an ardent male pretending to be a transvestite.

political, economic, or spiritual activity more important than making art or communing with great works of art. Perhaps sex is an exception, but even then, sexual relations have a subordinate purpose. The artist needs love as an inspiration to make art. And it is true that some great lovers among artists—Raphael, Bernini, and Rodin, for example—have been prolific producers of art. Of course, certain kinds of love can destroy the artist. Nevertheless, it is clear that for the bohemian, sexual expression and artistic creation are two sides of the same coin.

The Bohemian Artist and the Family

If the cornerstone of bohemianism is its fusion of art and free love, then Gauguin is a model of bohemianism, especially when we consider his respectable years as a stockbroker in Paris. When he abandoned his wife and children, it was so that he could devote his full time to art. In Tahiti he had numerous liaisons with teenage native girls, but those temporary unions had no serious claim on his emotions. Behind his flight to the

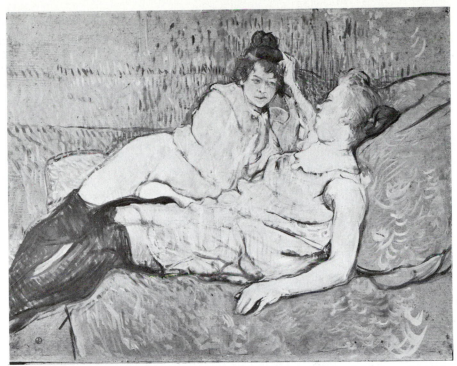

Henri de Toulouse-Lautrec. *The Sofa.* c. 1896. Oil on cardboard. Metropolitan Museum of Art, New York (Rogers Fund, 1951).

Brothels had an established place in nineteenth-century France, but prostitutes, of course, were outcasts. And that is what attracted Toulouse-Lautrec: his deformity made him an outcast, too. Degas, Rouault, and Pascin painted prostitutes, but Lautrec lived in their houses, becoming a member of the family, so to speak. He watched everything and painted what he saw—without moralizing. That was his contribution to bohemianism: he exposed the hypocrisies of respectable society while showing the brothel inmates as genuine, even sympathetic, human beings.

South Pacific was the assumption that a normal family life is incompatible with a real commitment to painting. For the same reason, Delacroix never married. Family life would have drained away the energies he needed for his art. Degas was another of those who never married. Cézanne married after a seventeen-year liaison with his Hortense, but for long periods he refused to live with the woman who bore him a son. Poor Van Gogh wanted desperately to marry, but no woman would have him. He did live with a prostitute and her child, but his father persuaded him to leave her. Rodin was consistently unfaithful to his Rose, marrying her only at the end of their long liaison, just before she died. Suzanne Valadon, who grew up on the streets of Montmartre—mother of a child (the painter Maurice Utrillo) out of wedlock, model, waitress, and tra-

(left) Suzanne Valadon. *Seated Nude.* Drawing in black chalk. Art Institute of Chicago (Mr. and Mrs. Lewis L. Coburn Memorial Collection).

(below) Suzanne Valadon. *Self-Portrait.* 1927. Oil on canvas. Lefevre Gallery, London.

A classic bohemian career—from street urchin to dishwasher to trapeze artist to artist's model. Love affairs with important painters: Puvis de Chavannes, Renoir, Lautrec (possibly), Degas (perhaps), and others. An illegitimate son, the painter Maurice Utrillo. Finally, a long, comfortable liaison with a banker. Then a much younger man. All along, she drew and painted. Self-trained in art (but with an abundance of good advice), she became a strong painter and etcher. At the foundation of her art were keen observation, solid drawing, bold color, and complete absence of sham. In the end there was modest fame and some money. Born in disgrace, neglected as a child, exploited in young womanhood, Valadon did not choose her bohemianism; it was thrust upon her. Suzanne Valadon got her artistic education the hard way.

128

Pablo Picasso. *La Vie*. 1903. Oil on canvas. Cleveland Museum of Art, Ohio (gift of Hanna Fund).

Picasso's "blue period" records his bohemian existence as a poor, young artist in Montmartre at the turn of the century. A close friend, Carles Casagemas, had committed suicide after an unhappy love affair, and Picasso painted *La Vie* as a memorial. But, as was usually the case with Picasso, the picture became an autobiographical work. It has been interpreted as an allegory of the various kinds of love. More likely, it expresses Picasso's youthful sadness as he separates himself from mother, and from Spain, and commits himself permanently to the sexual freedom of Paris and the French religion of art. Only 22 at the time, Picasso had discovered the creative principle that informed everything he did in a long, productive, and stylistically varied career. That principle, the exact expression of the Romantic-bohemian outlook, he stated as follows: "If one really thinks about it, all one really has is one's self."[2]

peze artist—married once or twice, but only as a passing phase in a busy bohemian career.

Clearly, the bohemian mode was the norm among nineteenth-century artists, regardless of style or politics. (Cézanne was a reactionary, Delacroix a conservative, Gauguin a socialist.) Picasso was very much a product of nineteenth-century bohemianism. To be sure, he married a few times and fathered several children whom he appears to have loved. But his many mistresses and their overlapping tenure suggests that he was incapable of sustained personal loyalty—where emotional demands were involved. He had lifelong *friends,* however.

It appears that an unwritten article of the bohemian faith is the incompatibility of art and marriage, and the incompatibility of marriage and love. Was this merely bohemian perversity? Artists should not marry, or stay married, or enjoy children too much, because these things belong to the contemptible bourgeois lifestyle. Perhaps it was also fear

Thomas Eakins. *William Rush Carving His Allegorical Figure of the Schuylkill River.*
1908. Oil on canvas. Brooklyn Museum (Dick S. Ramsay Fund).

America, of course, had no bohemia. But it knew about the licentious behavior of
artists and their models. The nude model posing for William Rush, early in the
twentieth century, was suitably accompanied by a chaperone. Eakins appreciated
the irony of the situation. In 1886 he had lost his job at the Pennsylvania Academy
when he posed a male model and a female model together, in the nude, to give an
anatomy lesson.

—fear that the creative impulse, being fragile, cannot survive the rigors
of family living, and especially, a permanent alliance with the same
person. Also, the religion of art demands sacrifices.

The Political Dimension

Bohemian artists espouse all sorts of causes and views, but fundamen-
tally they are apolitical. They attack the bourgeoisie and the industrious
working classes, from the left *and* the right. Political ideas serve them
mainly to express the conviction that the bourgeois is stupid and grasp-
ing. As for working people, they are aesthetically hopeless. The first
generation of bohemians—around 1830—adopted a rather aristocratic
pose toward the pillars of society, all of whom were condemned as
peasants and philistines. Subsequent generations of bohemians, though
poor or destitute, would not take regular jobs because that would put

them into the working class, which was unthinkable for an artist. This from avowed leftists!

The politics of the bohemian artist is expressed in costume and hair length, but rarely in art. The artist may be a dandy—like Manet— or pretend to be a rough peasant—like Cézanne, the banker's son. In both cases, clothing has nothing to do with the artist's style or themes. It is the artist's way of needling the establishment. At least Manet and Cézanne were productive painters. Most bohemians spent their energies on getting dressed for café meetings devoted to conversation and drinking followed by nocturnal rambles. One critic was led to say: "Once and for all, let us put our originality into our work and not into our dress."

There are three reasons why it was difficult for the bohemian to find a political focus in art or in life. First was a profound disillusionment with the revolutionary art of David and his followers. There was a painful gap between the ancient Roman virtues celebrated in David's canvases and the actualities of Napoleon's wars, which produced a terri-

Amedeo Modigliani. *Reclining Female Nude on White Cushion.* 1917. Oil on canvas. Staatsgalerie, Stuttgart.

Tuberculosis, drugs, alcohol, and love ended his life at 36. Even so, Modigliani completed a body of work that included the most sensuously beautiful representations of the female nude since Titian. But Titian lived to be 88, and he did good work in his last decade. What explains the tragic difference in their lives? Bohemianism. Titian lived well but moderately; his art and his life were not identical. Modigliani's art, on the other hand, was an almost direct transcription of his experience— experience heightened by absinthe and hashish. He carried the bohemian ideal to its perfect conclusion.

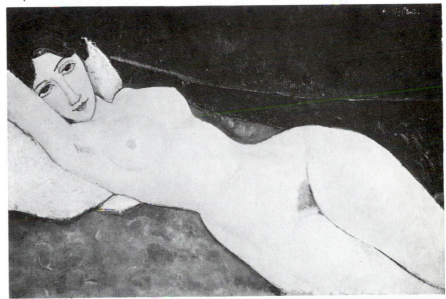

ble blood-letting for France and Europe, followed by the emergence of a rather unimaginative business civilization. Second, the Romantic reaction against David's Neoclassicism took largely escapist forms—escape into the past, into distant and exotic places, or into the deepest recesses of the self. The ultimate focus of Romanticism was the artist's ego, an all-consuming love affair that precluded serious political concern. Third was the failure of nineteenth-century society to find a suitable place for the creative artist. The Renaissance unity of art, science, and technology was broken. Many of the best nineteenth-century buildings were designed by engineers, not architects. And photography began to menace painting. New technologies of reproduction threatened the survival of handmade pictures and sculptures.

The artist was alienated and so became a bohemian, a nihilist. For the nihilist no social entity is worth preserving, and no political doctrine can be taken seriously. And as we know, family life is regarded as a creative trap. Then nothing is left: the salt has lost its savor.

From 1430 to 1830

The medieval artisan was a model of bourgeois respectability if only because guild regulations extended to personal morals as well as business affairs. As we know, a few fifteenth-century artists freed themselves from the collective spirit and the economic controls of the guild. With greater professional and financial independence there was more room for irregular behavior, not to say plain rascality; the Wittcowers recount it at length.[2] But without the imposed rectitude of the guild there were *artistic* reasons for temperance and sexual moderation. Cennino Cennini advised students of art on this subject in his *Book of Art,* written in 1430, as follows:

> Your life should always be regulated as if you were studying theology, philosophy or the other sciences, that is: eat and drink moderately at least twice a day, consume light but sustaining food and light wines. There is one more rule which, if followed, can render your hand so light that it will float . . . and that is not to enjoy too much the company of women.

Notice that Cennino's advice about diet and sex is not given in a moralistic spirit. He does not recommend fasting and celibacy. He talks about the kind of moderate regimen that will preserve the artist's health and enable him to do good work.

Edgar Degas. *Absinthe.* c. 1876. Oil on canvas. Louvre, Paris.

Absinthe is an aromatic, greenish, licorice-tasting liqueur with an alcohol base of 68 percent. It was the preferred apéritif of the bohemians and café dwellers of late-nineteenth-century Paris. Followed by a shot of gin or a beer chaser, it could destroy the brain. Certainly it ruined the great bohemian poet, Paul Verlaine. But alcohol was not the only bohemian escape. There were also hashish, opium, and morphine. The idea was to get an exalted high. Reality could be endured, a few hours at a time, if one could look forward to a few drinks, a good cigar, and a visit to lotus land. Degas handled the subject with his characteristic detachment. This picture was posed, however. He got two friends to sit for him in a Place Pigalle café: an out-of-work actress and a down-and-out engraver. She portrays the sodden type of drinker, frayed in body and spirit; he is just a standard-type alcoholic—puffy-faced and suspicious.

Four hundred years later we find bohemian artists following the exact reverse of Cennino's advice. They eat hardly at all; they drink heavily whatever they can, especially absinthe, a greenish liquor that causes brain damage. The number of alcoholics—Courbet, Gauguin, Van Gogh, Lautrec, and Munch, to name a few—is very high. The bohemian also uses drugs, mostly hashish, laudanum, and assorted opiates. Sexual life is certainly irregular. We know that prostitutes are an important part of bohemian existence. For a time Lautrec lived in a brothel, Cézanne was a regular patron, and Degas and Pascin painted prostitutes frequently. Venereal disease was very common among nineteenth-century artists, notably Gauguin and Van Gogh and, very likely, Manet. Most bohemians of this era lived in drafty, wet, and not especially sanitary attic rooms. It is not surprising that many died in their thirties—of pneumonia or consumption (tuberculosis). And quite a few ended up in the insane asylum. Others killed themselves, sometimes as a romantic gesture but mainly because life had become unbearable.

(above) Jules Pascin. *Claudine Resting.* After 1923. Oil on canvas. Art Institute of Chicago (gift of Mr. and Mrs. Carter Harrison).

Again, a gifted draughtsman, a brilliant career as an illustrator, a gregarious personality, an original approach to the erotic, a gay and alcoholic existence, a growing reputation as a painter—and suicide at 45. Pascin's style was made for the melancholy girls in the brothels, the girls who were not yet women. He understood their professional weariness; he appreciated their sad sexiness. Beyond that, he had little to say. So he killed himself.

(below) Jules Pascin (with cigarette) in the studio of the painter Pierre Marseille, with the models Paquita and Césarine. 1925. Photograph.

Instead of setting up the model as a piece of still life —in the academic manner—the bohemian artist sees her as companion and collaborator. They talk about art. But when she is not posing, she shops for groceries, cooks, makes love, cleans up the studio. Clearly there is exploitation as well as fraternization. The point of bohemianism is that painters and models have to experience life together in order to make art. Their intercourse has to be real before it takes on aesthetic coloration.

Whether the suicide is fast or slow, it is clear that self-destruction is an important part of the bohemian artistic scheme. In that sense, it is the pathological opposite of the Renaissance scheme. From pursuit of respectability to hatred of respectability; from the study of science to contempt for science; from pursuit of wealth to financial irresponsibility and indifference; from the "universal man" to the specialist in easel painting. This cycle in the evolution of the artist took four centuries.

Conclusion

The fatal error of the bohemian artist was refusing to come to terms with work. That would have meant personal and aesthetic salvation. Those artists who survived bohemianism realized it was appropriate only for the student stage of development. Those who prolonged the stage found

Pablo Picasso. *Sculptor's Repose II.* 1933. Etching. Museum of Modern Art, New York (Purchase Fund).

Here is the fulfillment of the theme Picasso announced so tentatively in his "blue period," thirty years earlier. In 1903 bohemian love was lean, hungry, and pathetic. Now it is well-fed and languid. The magnificently bearded sculptor (Picasso's fantasy of himself as a kind of Greek god) holds a voluptuous model in his arms, but he thinks mainly about art, symbolized by the sculptured head on a pedestal. That bust dominates everything—the mountains, the vase of flowers, and the lovers, too. No longer poor, no longer obscure, no longer misunderstood, the bohemian artist finds himself enjoying the richness and fullness of life. And that is what makes him sad.

themselves, at middle age, unproductive as artists and incapable of coping with the problems of ordinary existence.

The idea of genius, which the bohemian inherited from the Renaissance, could be realized only in a context of sustained creative effort. Work! Leisure class manners and attitudes might be simulated by a few bohemians with regular allowances from home, but eventually the remittances ran out. Socially and psychologically, this lifestyle could not be successfully carried off by the genuine artist, who is fundamentally a worker. That, at least, is the testimony of history. The artist as dandified aristocrat is simply a contradiction in terms. To be sure, Titian lived well and was ennobled by his king; still, he painted pictures into his ninetieth year. Airs of superiority and boredom, a studied remoteness from real life—these attitudes do not translate into the stuff of painting and sculpture. As for an aesthetic religion, a faith of the senses—Theophile Gautier's *l'art pour l'art*—it is too thin as religion and too insubstantial as art.

Bohemianism made sense as a gesture of defiance. Its targets of science-worship, middle-class conformity, and the bureaucratic regimentation of life were well chosen. Art could be inspired by bohemian defiance, but it could not be created. That required sustained effort, craft, commitment to life, not death.

the
illustrator

*I*llustration might be defined as visual art intended to accompany something else: song, dance, chant, spoken words, print. According to that definition, Leonardo's *Last Supper* (1495) is an illustration. It depicts the moment just after Jesus said, "One of you shall betray me." At the same time it shows his disciples replying, "Lord, is it I?" That great fresco is an illustration just as surely as are John Tenniel's illustrations (1865) for *Alice's Adventures in Wonderland.* These wildly disparate examples are cited to show that (1) even the "old masters" were illustrators; (2) illustration is not inherently "high" or "low"; and (3) few works of visual art are created to be experienced in purely optical terms.

The process of separating written words from visual images began about ten thousand years ago during the Neolithic era. Through countless copyings, imitations, and simplifications, pictorial images became symbols of objects, then events, places, ideas, words, and finally, sounds. (We can think of phonetic letters as pictures of sounds.) This process—from the picture of an object to the picture of a sound—took about six thousand years. It enabled the Sumerian priesthood (about 2,500 B.C.) to handle the problems of communication, information retrieval, and codification of laws without which a complex civilization could not be administered. Today, we could not assemble a baby crib or

William Hogarth. *Beer Street*. 1751. Engraving. National Gallery of Art, Washington, D.C. (Rosenwald Collection).

The ragged but happy wretch painting a sign in Hogarth's *Beer Street* is, of course, an illustrator. His sign is almost wholly pictorial. The lettering is small and, in any case, would not have meant much to these working-class Londoners. Hogarth's print is itself an illustration, a visual celebration of England's national beverage as extolled in one of the verses below the print: "Labour and Art upheld by Thee/Successfully advance,/We quaff Thy balmy Juice with Glee/And Water leave to France." Hogarth's practice was to paint a series of pictures based on a moral or satirical theme. From these he made engravings; then he sold the prints directly to the public—much like a novelist who prints and distributes his own book. Following this formula, *The Harlot's Progress, The Rake's Progress,* and *Marriage à la Mode* earned Hogarth a great deal of money . . . plus the honor of being copied by numerous poets, playwrights, and graphic artists. He had found a way to bypass the eighteenth-century art establishment (which cared not a whit for his painting), and he created an original artistic type: the combined writer-dramatist-illustrator-painter-engraver-publisher.

THE ILLUSTRATOR 139

a lawn mower without illustrations. No cribs and lawn mowers in other words, no civilization!

Because of the divergent paths taken by the development of writing and picture-making through the centuries, we tend to forget that they have a common root. That root is not confined to the physical image painted on a rock wall or incised in bone. It is not merely that letters must be seen (or felt, if the reader is blind). Their common root lies in a similar, if not identical, method of processing visual information. The human eye and brain have a long history of collaboration that they cannot forget, and this is why words and images are interchangeable. The fact of their interchangeability lies behind the often-quoted phrase of the Roman poet Horace, *ut pictura poesis;* poetry is spoken painting, and painting is silent poetry.

The modern independence of the artist, especially the "autonomy" of the easel painter, may lead to the conclusion that artists lose something in collaborating with writers and editors. The collaboration of the illustrator with a writer is widely interpreted as an artistic surrender. That may have been true early in the nineteenth century, when the prestige of the printed word was so much greater than it is now. But today, the author-artist, word-image, relationship is more nearly one of equals. Indeed, the image is often dominant. This is clear when we look at modern posters, corporate logotypes, magazine illustrations, package labels, book jackets, record albums, or television commercials. In all these cases printed or spoken words are used to *support the image.* Indeed, the image is often created first; then writers are called in. The practice of organizing words *around* pictures may testify to the declining literacy of the mass public, but most likely it reflects the fact that more information can be conveyed in less space (or time) by an image than by a string of words. When money talks, as in the media of mass communication, it speaks increasingly in the language of images. These are, in effect, illustrations. Words must be few; that leaves more space for pictures. Speakers may be heard on television ("voice-over," it is called), but they should not be seen. Visual space has to be preserved for the costliest commodity—pictures, illustrations!

The Revolution in Visual Reproduction

Gutenberg's invention of movable type, in 1446, changed more than printing; it profoundly affected the religion, politics, and economics of Europe. How could Protestants practice their religion without enough

Bibles to go around? In the nineteenth century a series of inventions in the reproduction of words and images had similarly far-reaching effects. The artist felt them especially. The development of photography by Daguerre, in 1839, was a shock and a challenge to the painter. Inexpensive color lithography (chromolithography), introduced in 1827, made it possible to reproduce a fairly wide range of tones and colors, especially in outdoor posters. As a result, the gap between an original work of art and its reproduction was dramatically reduced. In addition, "serious" artists like Lautrec created original work *for* reproduction. When photoengraving was invented in 1872, it became possible to reproduce almost any kind of image in black and white, regardless of the process that made the original. And when four-color presswork became technically and economically feasible, around 1900, everything but the scale of painting could be reproduced. Today, a 24-sheet outdoor poster makes street "murals" possible. Not as good as Tintoretto's huge canvases for the Doge's Palace, of course, but they can be changed every week or so.

An interesting irony: the illustrator J. C. Leyendecker would sell only the reproduction rights for his poster and magazine art; he kept the original paintings and sold them as "fine art." This was a shrewd instance of keeping the goose, selling the golden eggs, then selling the goose when it ceased to cackle. Today, the heirs of Pablo Picasso receive huge royalties from the mass sale of reproductions of his originals. Another irony: Picasso's *Guernica*—perhaps his greatest work—owes much of its imagery to the reproduced pictures and print of newspapers and magazines as well as cinema newsreel montage. In other words, modern processes of reproducing pictures became a central motif in the depiction of a modern tragedy. Picasso was, of course, a master-mimic, a master-reproducer! His *Guernica* testified to an aesthetic coming of age. Reproductions had become a fact of the environment, and therefore a fact of life, and therefore a fact of art. Everybody seemed to understand this except those artists who created one-of-a-kind paintings for single sale to one buyer at a time. But many of them hoped (secretly) for the joys of reproduction.

A Democracy of Images

The early perception of illustrators as, at most, artisans, was based on the fact that they "embellished" the writer's thought. Their craft had originated with decorations for medieval manuscripts—decorations that were in no sense crucial for understanding the meanings of the words. The medieval scribe and the medieval manuscript illuminator were, of course,

NEIGHBORING PEWS. Price, $15.00.

These groups are packed, without extra charge, to go with safety to any part of the world. If intended for Wedding Presents, they will be forwarded promptly as directed. An Illustrated Catalogue of all the groups, varying in price from $10 to $25, and pedestals (in mahogany and ebony finish), can be had on application, or will be mailed by inclosing 10 cents to

JOHN ROGERS,
860 Broadway, corner of 17th St. New-York.
Take the Elevator.

Advertisement for John Rogers' group, *Neighboring Pews*, in *The Century Magazine*. 1886. New York Public Library.

Rogers was a kind of three-dimensional Norman Rockwell. He had the same folksy touch. He also resembled Hogarth (but without the satirical bite) in appreciating the importance of the right details when telling a good story. That is what makes him an illustrator—the narrative implied by his sculptural groups: *The Slave Auction, The Wounded Scout, Checkers up at the Farm,* and so on. About 16 inches high, modeled in clay and cast in plaster, these groups cost from $6.00 to $25.00. Cast in bronze they cost $40.00. Rogers advertised and sold about a hundred thousand of them between 1860 and 1890. Statuary for the multitude! Like most successful illustrators, he was technically very able. Also, he had a shrewd understanding of popular American taste, and he did not deprecate that taste. That is the common trait of the best illustrators: they have a good opinion of the public.

the same person. However, it was the word, the *logos,* that mattered most; the image was a lovely adornment of the word. As we shall see, the reunification of artist and scribe, of image and idea, took place only recently under the auspices of the graphic designer. In the case of the first printed novels and poems, their *true* imagery was latent in their texts. The illustrator's task was merely to make that imagery explicit, or visual. The illustrator's role may have been technically demanding, but it had only minor intellectual significance. The real creative action was initiated by others.

Why then employ illustrators? Because their work enlarged the public for books and magazines—the public who refused to wade through lengthy descriptions; the public who could not follow intricate chains of logical reasoning; the public who required vivid sensory images; the public for whom verbal language was too abstract. Needless to say, those publics were large and, in the nineteenth century, increasing rapidly. Furthermore, their appetite for visual images grew on what it was fed.

The enlargement of the illustrator's role in print communication —gradual at first, and then very rapid—resulted in a dramatic reversal of the classical word-image relationship. These factors were involved: (1) technology steadily improved in its ability to reproduce visual images accurately and transmit them cheaply; (2) with accurate reproduction, the persuasiveness of images increased greatly in relation to printed words; (3) images combined with words (in newspapers, magazines, posters, catalogues, advertisements, comic books) gave people the illusion they were reading print. In a sense they were, for understanding an image enhanced comprehension of its accompanying text. In time, even scientific and medical texts employed illustrators. Architects and engineers, of course, could not work without illustrations. What are engineering drawings if not illustrations? Only legal texts held out against illustration, but that was because they were not meant to be understood by the lay reader.

So the growth of illustration in the nineteenth century was set in motion by technological, demographic, and political forces: improved methods of printing, a vast enlargement in the reading public, the evolution of publishing into a mass-consumer industry, and the democratic idea of bringing ideas, news, and visual stimulation to the general public. The populist implications of illustration were obvious. Hence, no matter how talented, the illustrator could not claim the status of "high" or "fine" artist. This troubled N. C. Wyeth and it angered Howard Pyle. Nevertheless, they lived very well.

The "Star" Illustrators

In the United States the time between the Civil War and World War I witnessed a quite dramatic expansion in the number of newspapers and weekly magazines, all of which depended heavily on pictorial illustration to compete for readers. The coverage of the Civil War by Winslow Homer for *Harper's Weekly* demonstrated the crucial importance of pictures in bringing home the vivid details of military life as well as building circulation. Shrewd publishers like Frank Leslie *(Leslie's Weekly)*, Cyrus Curtis *(Ladies' Home Journal, Saturday Evening Post)*, Pat Collier *(Collier's)*, S. S. McClure *(McClure's Magazine)* and William Randolph Hearst *(Harper's Bazaar, Cosmopolitan)* were among the first to recognize the potential market in a rapidly growing American readership. They realized, too, that this market could be reached only through lively writing *combined with* top-notch pictorial reportage and illustration.

Winslow Homer. *The Carnival.* 1877. Oil on canvas. Metropolitan Museum of Art, New York (Lazarus Fund, 1922).

This painting by Homer bears comparison with Degas! And the hands of the two women are worthy of Fragonard. But Homer was damned: he was an American and an illustrator. His treatment of color was not based on the scientific research of Chevreul. His understanding of light did not come from Helmholtz. He learned the rudiments of art as a lithographer's apprentice for two years. His mature style as a painter is the product of a good eye—which is to say, the eye of an illustrator who covered the Civil War in black and white for *Harper's Weekly*. Homer could paint because he could see, he could draw, and he could compose quickly. And he knew what he was looking for. He proved that a discipline—the discipline of the artist-journalist-illustrator—could make as fine a painter as a Beaux-Arts atelier.

At first, the illustrated English magazines were models for the American dailies, weeklies, and monthlies. But the American market was larger than the British by far, and soon American publishers could afford to pay large fees to illustrators and high wages to the artisans (engravers) who prepared their work for woodblock reproduction. With the rotary press and the perfection of photoengraving in the 1890s, it became possible to reproduce halftones inexpensively (hence wood engravers and certain printing craftsmen were no longer needed), while more illustrations could be included in each issue. When four-color printing was introduced in the early 1900s, American magazine readers were brought into delicious contact with the nuances of painterly style and technique —qualities that were necessarily absent from black-and-white woodcut

illustrations. (Even so, the "Gibson Girl" was essentially a pen, brush, and ink creation. All of the classic illustrators were masters of conveying skin quality, texture, and even the sense of color in black and white.) But with real color it became even easier to "fall in love" with an illustrator's treatment of people, costumes, houses, motor cars, furniture, and accessories. That is exactly what happened. Readers adored the beautiful women drawn by C. D. Gibson, Howard Chandler Christy, and James Montgomery Flagg. The "Arrow Collar" man of J. C. Leyendecker set the personal and sartorial styles for millions of American males, at the same time revealing the immense marketing potential of the so-called "slick" illustration—that is, the color reproduction on coated paper stock. If these juicy illustrations worked for haberdashery, imagine what they could do for fountain pens, soft drinks, gasoline, patriotism! And circuses, too. Who knew the value of outdoor advertising better than that master of hype, P. T. Barnum? Advertising, the American art *par excellence,* was then (c. 1910) in its adolescence; now it received a powerful thrust from the pictorial illustrator. Compared to the horse-and-buggy techniques of the carnival barker and the itinerant peddler of snake oil, the illustrator was driving a twelve-cylinder Dusenberg!

The major book and magazine illustrators between 1890 and 1930 —Howard Pyle, N. C. Wyeth, Frederic Remington, Maxfield Parrish, Norman Rockwell, Neysa McMeyn, and others—were paid like movie stars and lionized television commentators today. Most were "self-made" artists who had combined talent, pluck, some art school training, and a large capacity for hard work into spectacular success. All of them could draw fast and well; most of them used photographs, but—like Degas—with the authority of knowledgeable draftsmanship. All were superb technicians; they knew the reproduction process inside-out. And each of them produced a large body of work at a consistently high level of craftsmanship.

Today the work of these illustrators is collected like "fine art." Remington's oils and bronzes (he gave up illustration and turned sculptor) bring huge prices. The attitudes of the illustrators toward the "high art" significance of their work varied. Pyle and Wyeth believed they were creating a genuine, home-grown American art. Rockwell had few fine art pretenses; he was proud to call himself an illustrator. Christy became a portraitist à la John Singer Sargent. If they traveled to Europe, most of them returned to the United States substantially unchanged. The same was true at an earlier date of Winslow Homer; his characteristic way of seeing and composing was determined by the constraints of making black-and-white drawings for reproduction in *Harper's Weekly.*

Charles Dana Gibson. *The Sweetest Story Ever Told,* from *Collier's Weekly,* August 13, 1910. Pencil, pen-and ink drawing. Library of Congress, Washington, D.C.

C. D. Gibson worked for the old *Life* magazine, specializing in mildly acidulous satires of snobbism among the new rich. He had an old-fashioned Yankee contempt for social climbing, and he loved to puncture aristocratic pretensions. What Gibson especially detested was the spectacle of millionaire dowagers in grim pursuit of titled sons-in-law. Typically, this entailed selling off an American beauty to some impoverished and scrofulous English lord. That American beauty, of course, was "The Gibson Girl," his greatest creation. She was regally tall, spirited, sports-minded, self-assured, and possessed of a splendid decolletage. And her eyes were ever-so-slightly sexy. Millions of men desired her, and millions of women copied her posture, hairdo, shirtwaist, and bustle. Not until the era of the movie goddesses would there be so complete a capture of the American imagination. That capture laid the foundation for a substantial improvement in the perception of women—and their status: they won the right to vote ten years later.

Buffalo Bill's Wild West and Congress of Rough Riders of the World. 1899. Color lithograph by Courier Litho. Company. Library of Congress, Washington, D.C.

Late-nineteenth-century circus and theatrical posters of this (chromolithograph) type were produced on a craft-industry basis. Anonymous artist-illustrators, employed by a printing firm, made original paintings, which were then transferred to lithographic stones. The transfer process consisted of copying the original in crayon—with a different stone for each color. The result, printed on as many as 28 sheets of paper, had a fine-grained, stippled character. The color was somewhat overripe, but the chiaroscuro effects were fairly rich, quite well suited to the taste of America's mauve decade. The lithographic artisans—often young German women—had no artistic pretensions. They merely reproduced the original with photographic accuracy. But the result was fine art for the masses—chromo versions of the history paintings in Europe's museums.

(left) J. C. Leyendecker. "Arrow Collar" advertisement. 1912. Oil on canvas. Courtesy Cluett, Peabody, & Co., Inc.

J. C. Leyendecker did for males what C. D. Gibson did for females. He was not a satirist, however. Leyendecker's role was to create the prototype for a confident new masculine race. His image of the square-jawed, courageous, absolutely incorruptible American male was not to be equaled, perhaps, until the movies invented Randolph Scott. A commercial artist with solid academic training, Joe Leyendecker could convey the sheen and texture of things that C. D. Gibson could only hint at. His detachable collars were stiffly starched; his cuff links had just the right dull gleam; his striped shirts were immaculate; his trousers were always sharply creased; his ties were perfectly knotted; and his broadcloth fell into crisp folds the way broadcloth should. This sartorial image was more than a haberdasher's dream. The Arrow Collar man embodied a serious ideal—the man at home in gracious surroundings, the man destined to rise, the man accustomed to responsibilities, the man who can make decisions. An illustrator had signaled the demise of American country bumpkinhood. Leyendecker's statement transcended neckwear. He was saying that Americans were ready for world leadership.

Norman Rockwell. *Triple Self-Portrait,* cover for *Saturday Evening Post,* February 13, 1960. Oil on canvas. © 1960 Curtis Publishing Company.

In the mirror, Rockwell wears glasses, his pipe droops, and his eyes are empty circles. This gives his face a comic, cartoony look, like Little Orphan Annie. On the easel, Rockwell appears without glasses, clear-eyed, almost handsome; and his pipe is set at a jaunty angle. We see self-portraits of the masters tacked onto the edge of the canvas: Dürer, Rembrandt, Van Gogh, and, presumably, Picasso. Finally, there is the third person in the trio, shown from the rear, painting the other two portraits. We are supposed to ask: "Which is the real Norman Rockwell?" Obviously, the real Rockwell is the self-effacing fellow whose features we do not see. This is a clever parable of the fine artist and the illustrator ... as Rockwell saw their relationship. Fine artists, he seems to say, confront the public directly and announce who they are. Illustrators (who can be anyone they wish to be) are uncertain about their identities. They hide behind their creations.

Yet he and Eakins, equally resistant to European high art, produced paintings that hold their own with those of the great French realists—Courbet, Daumier, and Millet.

Daumier, of course, was a journalistic artist all his life, and Millet did a certain amount of sign-painting to eke out a living. From the standpoint of art criticism, we should guard against certain art-historical prejudices when viewing the work of the "star" illustrators. Popular success is not *prima facie* evidence of mediocrity; commercial sponsorship does not necessarily corrupt the artist; creating art for reproduction is no more demeaning than painting pictures for sale through a gallery. Winslow Homer did both.

Jules-Abel Faivre. *On les aura!* 1916. Victoria & Albert Museum, London (Crown Copyright).

An infantryman would get killed going over the top in that position. But there were other reasons for the pose: To employ the grand gesture. To enlist the diagonal in support of the idea, ''Let's get them!'' To enlist the revolutionary sentiments that Delacroix enlisted in *Liberty Leading the People.* To enlist French money. To enlist Frenchmen.

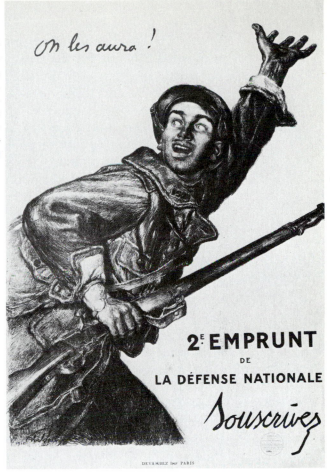

From Advertising to Aesthetics

When most of the public was illiterate, illustrated signboards and placards were essential for identifying shops, describing products or services, and announcing events. As literacy improved, however, the function of the poster, magazine, or newspaper illustration changed. The artist's image became a device for stimulating purchases. Visual description had the capacity to inspire, indeed to compel, emotional assent. The principle was as old as the ''illustrations''—the sculptures, mosaics, and stained glass imagery—of the medieval cathedrals. When, early in the twentieth century, mechanical reproduction multiplied the effect of the principle of illustration, the advertising artist became an important figure in the generation of a new kind of social and economic power.

The rise of the advertising artist around 1910 did not represent a changed function for the artist. As mentioned earlier, illustration was an artistic function virtually from the beginning. It was the artist's use of new media and techniques—especially the technologies of graphic reproduction—that seemed to announce a radical departure from the past. For collectors there was a kind of mystical purity attached to the old media: tempera paint, oil paint, copperplate etching, the woodblock print, pen-and-ink drawing. To be sure, advertising artists used these media, too, but for reproduction purposes, not to be seen directly. The operative principle here was that images made with traditional media were eligible for the status of fetish objects, whereas the newer media were tainted by their association with crass commercialism. Thus lithography and silkscreen printing suffer a loss of caste because they are used in commercial art. Perhaps that is why silkscreening practiced as a "high" art is called serigraphy. Change the name, change the status.

Only a short time passed—thirty or forty years—before the images made for reproduction became "collectibles." Today, the 1890s posters of Toulouse-Lautrec, Jules Cheret, and Alphonse Mucha are enormously expensive. Even reproductions of the "original" reproductions command fairly good prices. Comic book illustrations from the 1930s are avidly bought and sold, and collectors pay high prices for the book illustrations of a century ago. Museums of fine art mount large exhibitions of the work of the "classic" advertising artists Maxfield Parrish and J. C. Leyendecker and the great book illustrators Howard Pyle and N. C. Wyeth. As for the hero of American magazine cover illustrators, Norman Rockwell, he has been immortalized in more than one coffee-table art book. To be sure, he is not the sole support of an art publishing industry, like Picasso. Still, our principle holds: Yesterday's illustrator is today's art hero.

Although the primary purpose of the commercial artist remains mass persuasion, the aesthetic function of advertising images should not be overlooked. For a large part of the public, outdoor posters, magazine illustrations, book jackets, and package designs represent the main source of visual art. Even for regular museum- and gallery-goers, advertising imagery plays a very large role as art. Indeed, the "Pop Art" movement of the 1960s was a kind of parody of advertising art, a clever way of attaching the label of aesthetics to the imagery that people enjoyed spontaneously. It is interesting that several of the Pop artists became gallery artists after beginning their careers as window display artists (Robert Rauschenberg), fashion designers (Andy Warhol), illustrators (Wayne Thiebaud), and billboard painters (Tom Wesselman).

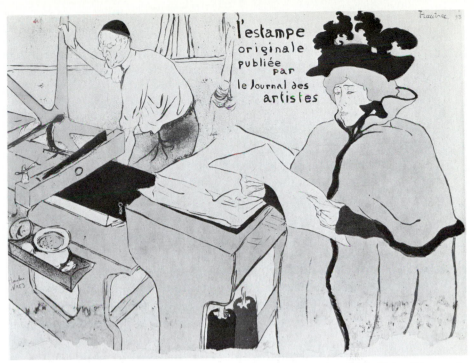

Henri de Toulouse-Lautrec. Cover for *L'Estampe Originale*. 1893. Color lithograph. Library of Congress, Washington, D.C.

Toulouse-Lautrec was among the first major artists to appreciate the potential of the color-litho poster. He realized that imitating academic painting and striving for deep-space effects in a poster was a mistake. The medium was ideal, however, for applying the principles of Japanese flat-pattern design. So he learned to draw directly on stone. He learned to make marvelous spatter textures with old toothbrushes. Above all, he learned to use empty space eloquently—an important discovery for the illustrators and graphic designers who followed. Employing silhouette, strong outlines, and a few Art Nouveau sinuosities, Lautrec created a brilliant gallery of café characters—La Goulue, Valentin, Aristide Bruant, Yvette Guilbert, and Jane Avril. Jane Avril especially fascinated him. She seemed made for the new poster style. Incredibly thin, with narrow eyes too close to her nose, clad always in a fashionable hat, gloves, and black stockings, she had a repertoire of jerky, double-jointed, rubbery, slithery movements that captivated audiences at the Moulin Rouge. Convinced of her great beauty, she engaged Lautrec to immortalize her person and to promote her act. The *artiste* was also an astute businesswoman. Here Lautrec shows her examining a print as it comes off the press.

Today, the walls of a college dormitory room are more likely to be adorned with posters in the quasi-Art Nouveau style of Peter Max and his many imitators than with standard museum-art reproductions. Indeed, museum book and picture shops are likely to sell the Peter Max reproductions! It is the same principle that accounts for the superiority of television commercials to the regular dramatic offerings in between.

The aesthetic of advertising is immensely potent, even in small doses. That tells us a great deal about the visual and technical competence of the advertising artist.

The Poster: Designing Appeal

Poster art appears to be a kind of folk craft if we think of the anonymous, hand-made signs and placards from which it derives, and the popular audience for whom it is intended. Yet many of the most advanced nineteenth- and twentieth-century artists were serious poster designers: Daumier, Toulouse-Lautrec, Miró, Kokoschka, Léger, Klimt, Picasso, and Matisse. Some of these painters were challenged by the interaction of social and aesthetic factors in the creation of a successful poster—the opportunity to influence mass thought and behavior through visual means. Others saw the poster as another kind of art catalogue, a means of displaying characteristic features of their personal styles.

In fact, the poster constitutes a severely pragmatic test of the artist's command of visual weaponry. Unlike the easel painting, the poster is not seen in the quiet, relaxed setting of a living room or an art gallery. It has to compete with architecture, street noises, moving vehicles, human commotion. Its imagery and message must be seen *and understood* quickly. Reflection, contemplation, practical disinterest, and reverie—the aesthetics of the palace or museum—have to be abandoned by the viewer, because they get in the way of action. The poster requires commitment or resistance. Indifference is rare. In general, the "beautiful" poster does not succeed because it perpetuates the hedonism, the optical massage, of the easel painting in an environment where languid detachment is inappropriate. Paintings call for long, lingering responses; posters call for decisions.

Because poster artists have to think about time and place, sound and movement, as settings for their imagery, the design process is immensely complicated. Visual strategies are not enough; social and psychological insights are needed. A crowd leaving a theater is not in the same frame of mind as a group of workers passing through a factory gate. But knowing that people are in a hurry or thinking about food is only the beginning; the designer must know how haste or hunger affects perception—not perception in general, but perception of a particular product, idea, or service. Also, who is doing the perceiving? In view of these variables, the poster artist must draw on many sciences, styles of seeing, types of representation, and modes of symbol construction.

(right) James Montgomery Flagg. *I Want You for U.S. Army.* 1917. Lithograph. Museum of Modern Art, New York.

(below) Alfred Leete. *Your Country Needs You.* Poster.

The British recruitment poster, with the pointing finger of Lord Kitchener, came first. Flagg followed. Same subject, same device, same purpose . . . but Flagg's illustration wins in any contest between the two. Part of the problem was the portrait of Kitchener—too square, too remote, too upper-class English. One can only guess at the mouth behind the moustache. Also, Flagg's technique is superior; there is more snap and sparkle in his brushwork, more crispness in the rendering of hand, face, and cuff. The decisive factor, however, is gestural. Flagg's Uncle Sam tilts his head; that means he's serious. One shoulder is slightly raised; that implies readiness to act. Most important is the finger. Kitchener's gloved finger is directed to the viewer's eyes; Flagg's finger points to the gut. Both illustrations were enormously effective as posters, but Flagg's image went on to become an icon, the new model for Uncle Sam. The knitted brow, the grim mouth, the forceful tilt of the shoulder, and the meaningful finger slant—these were burned into the American imagination.

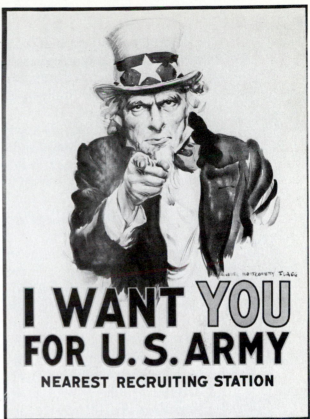

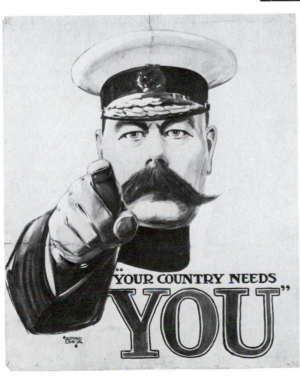

Poster design, like illustration, evolves into information design. Now the artist is required to engage in new sorts of research. Intuition, visual sensitivity, and attention to personal feelings of gratification are not entirely reliable in the business of mass communication and persuasion. This new artist—the graphic designer—is caught in a most interesting dilemma: artistic instincts are not the surest guide to effective communication. Technical skills are essential, but they need intellectual support. And that is precisely what the Renaissance artist learned: the technician executes; the artist investigates and analyzes—then executes.

From Illustration to Graphic Design

The success of the illustrator and the poster artist leads to the profession of graphic design—the comprehensive art of visual communication in printed or electronically reproduced form. Graphic designers preside over a complete visual strategy embracing words, images, and their relations to particular publics. Thus, artists move from the margin of the text, so to speak, into the text itself; they confront the reader directly. Now they design the letters, plan the illustrations, locate the captions, and organize the sequences in which viewers (not just readers) see a total visual presentation. Formerly, writers and editors made all the controlling decisions. They are still involved in graphic design, but it is now realized that effective communication of an idea requires sensitivity to the way a particular public perceives that idea. And perception, like thinking, is mainly a visual process.[1]

Norman McLaren, Canadian film artist. Courtesy National Film Board of Canada.

McLaren exemplifies the visual artist as filmmaker. That does not prevent him from using dramatic, literary, musical, and pantomime devices. Ultimately, however, he must communicate with cinematic language—which is to say, the language of the visual artist applied to the film medium. Filmic language—frame, shot, sequence, cut, dissolve, wipe, and fade—is not fundamentally different from the language of the painter, sculptor, or illustrator—model, carve, slice, draw, color, blend, silhouette, enlarge, reduce . . . compose. Hogarth would have made an excellent film artist. Also, Honoré Daumier, Winslow Homer, and "Grandma" Layton.

The graphic designer is the inheritor of the intellectual skills developed by the illustrator. Illustrators had to decide how best to make an author's ideas visible. This entailed intelligent reading of a text, an imaginative projection of the eye into the text, an understanding of where the illustrator could supply greater definition and vividness, and a realistic appreciation of what the reader could "see"—that is, understand. These prerequisites for the successful illustrator were more important than peculiarities of style or skill in rendering. They also provided an ideal foundation for planning and shaping—designing—any information package. The process repeats the evolution of the medieval mason into an architect. He began as a stonecutter. When he understood the problems of shaping spaces and organizing the movement of the people who used them, he became a designer. The moral of this story is, whenever artists rise in status, it is because their technical skills have acquired a new social utility.

Victory of the Graphic

About fifty years ago artists undertook the redesign of letters as an integral part of the graphic design function. The reunification of pictorial and literary intelligence was complete. In fact, this reunion represented a pictorial victory. The restricted idea of the letter as a vehicle of sound gave way to the much larger idea of the letter as a rich pictorial symbol. Experience with advertising had taught designers that typographic design sells just as much as illustration. Or, more commonly, that bad typographic design spoils a good illustration. The lettered label on a package of cornflakes, an automobile, or a pair of jeans became a symbol of the product as a whole; indeed, the label symbolized more than the physical product. Obviously, people went beyond a simple reading, or lexical understanding, of the words *Coca Cola, Levi's, Mercedes, Kellogg's.* They saw in the lettered label *the meaning and value* of the products.

The graphic designer succeeded in devising a way of restoring the pictorial values of letters. This entailed more than designing beautiful letters to associate pleasure with a product, service, or idea. Graphics should not be confused with calligraphy, or beautiful writing, although the art of calligraphy hinted strongly at the extra-lexical values of letters. Graphics is an art of selecting and composing with one of six hundred typefaces, of redesigning letters for a particular purpose, and of integrating typography with *the idea* of a product, the meaning of written copy, the expectations of consumers, and the requirements of the various media (outdoor posters, newspapers, magazines, direct-mail advertising, film, television).

he laughs best (:) who laughs last

Some people started laughing right off the bat when they heard we planned to concentrate on comedy this season. They were sure it wouldn't work. These days they're not laughing so hard—but the nation's viewers are, and so are the sponsors of our comedy programs. The audiences attracted by the average comedy program on the three networks this season tell the story: Network Y—7.3 million homes...Network Z—8.9 million homes...CBS Television Network, 9.5 million homes.* Moreover, in the latest Nielsen report three of our funniest shows are in the Top 10—and two of them are brand new this season.† But the thing that keeps all our advertisers smiling is that the CBS Television Network attracts the biggest average audiences in every category of entertainment, laughs or no laughs. *Nationwide Nielsen, 6-11 pm, AA, 1 Oct. 1960–1 Mar. 1961 †1 Mar. 1961, AA (CBS, 7 of Top 10)

CBS Television Network

Louis Dorfsman and Al Amato, designers. Newspaper advertisement for CBS Television Network. 1961. Reproduced with the consent of CBS Inc.

Graphic design as illustration. Letters acting like pictures. There is no need for the "ha ha ha" phrase to grow in size if we are only supposed to read the words. A small "ha" has the same meaning as a large "ha." Or does it? The purpose of the design was to illustrate the line: "He laughs best who laughs last." This required the designers to visualize the difference between a derisory snicker and a triumphant cheer. They did it with six lower-case letters. Notice that the printed copy is very small, almost invisible. The viewer reads it *after* getting the large idea, which is conveyed by ascending size and by letter forms that actually make us open our mouths. In a brilliant performance like this, what separates the graphic designer from the illustrator? It is hard to say.

Roy Good. Symbol for telethon in aid of International Year of Disabled Persons. 1981. Courtesy Graphics Department, Television New Zealand.

Again a combination of pictorial and letter forms (d p = disabled persons). In television communication, as with advertising in general, time-space is precious. A great deal of meaning has to be compressed into a symbol that is understood as quickly as it is recognized. For that purpose, the pictorial image has to be restored. Of course, the picture is reduced to its essential elements, but the representational and narrative functions are not lost. The illustrator still lives!

1981 INTERNATIONAL YEAR
of DISABLED PERSONS

Ivan Chermayeff, designer. *Danger: UXB,* poster for *Masterpiece Theatre* television series. 1980. Courtesy Mobil Oil Corporation.

Illustrators elaborate and supplement printed texts with seductive images of people, places, and things. Graphic designers operate at a more abstract level. They may use recognizable images, but usually they attempt to achieve an effect through the shape, size, and placement of letters. Notice how Chermayeff's letters have the same heavy silhouette, the same harsh texture, and the same angularity as the bomb. Unfortunately, the overall shape of a bomb is not inherently threatening. Hence, Chermayeff tore into his bomb with a brick, creating a jagged edge in its bottom contour. This is the typical tactic of a graphic designer—the manipulation of an edge, a shape, or a size relationship to communicate at a virtually subliminal level.

UNEXPLODED BOMBS–AFTER THE BOMBING THE DANGER BEGAN
A 13-PART TELEVISION SERIES
STARRING ANTHONY ANDREWS & JUDY GEESON M bil
BEGINS JANUARY 4 SUNDAYS AT 9PM CHANNEL 13 PBS
MASTERPIECE THEATRE

For a large segment of the public, the rectangular grid of the printed page generates feelings of monotony and boredom, not to mention resistance—refusal to read. Of course, illustrations can enliven an otherwise dull or intimidating stretch of print. However, graphic artists go beyond entertaining the eye or punctuating arid acres of text with pictures. They transfer the reader's emotional and intellectual focus: from the sounds inside the head to the imagery of the letters; from the imagery of the letters to the meaning or function of the product; from the function of the product back to the individual *using the product.* So the "victory of the graphic" represents more than a restoration of pictorial value to visual signs and symbols. It grows out of a calculated behavioral strategy. Graphic communication works because it constitutes a remarkable means of reaching *into* people through their eyes and manipulating their feelings and thought processes.

The Ascent of Man

An enthusiastic survey of science and human history, written and narrated by J. Bronowski and presented in 13 programs beginning January 7 on PBS. Made possible by matching grants from The Arthur Vining Davis Foundations and Mobil Oil Corporation. **Mobil**

Ivan Chermayeff, Chermayeff and Geismar Associates, designer. *The Ascent of Man,* poster for television series. Courtesy Mobil Oil Corporation.

The problem: how to convey Bronowski's eclectic approach to the history of science and humanity; how to describe the diverse roots that make up human history; how to combine the ideas of scientific inquiry and artistic creation in a single image. The solution: use the mosaic or collage principle—seven pieces from seven heads joined to form the image of one head. The execution: do not fit the pieces of the mosaic too exactly; vary the media sources—sculpture, painting, engraving, photography; include one certified genius—Einstein. Again the designer is revealed as master strategist and tactician. Painters, sculptors, engravers, and photographers can be hired, or their completed work can be rented. The erstwhile illustrator has become an art director/communications designer, someone who *thinks* an image and then engages an assortment of artisans to carry it out.

Conclusion

In distinguishing between the fine artist and the illustrator, Boardman Robinson said simply that the "practice of illustration . . . refers to something outside itself."[2] His comparison, of course, was with "fine artists" of the romantic persuasion. The focus of romantic art is the artist. Illustrators cannot afford that luxury. The dramatic emergence of the modern illustrator, followed by the professionalization of visual communication in the art of the graphic designer, has had revolutionary implications for business, industry, education, even the environment. Today's urban scene is a graphic as much as an architectural spectacle. At the same time, graphic art calls attention to the opposition between two basically different modes of artistic expression. To use David Riesman's categories, the first mode is "inner-directed" and the second is "other-directed."[3] The first assumes that art begins with disclosing the self, its feelings and responses to experience; the second assumes that art begins with a determined effort to communicate with others by discerning *their* needs.

To be sure, advertising artists have something to sell, but they cannot sell it until they find out how the product is used. Hence, there is an emphasis on research into the social and psychological character of particular markets. That research might be undertaken for crassly commercial reasons; nevertheless, it introduces vital new elements to art.

First is the necessity of understanding a product thoroughly. The same requirement applies to the practice of industrial design: a purely optical understanding of a product turns out to be inadequate for explaining its value or purpose, much less for changing its appearance.

Second is the necessity of understanding viewers—as members of a class, as people with special needs, as persons who think and act in certain ways. Again, Leonardo was first: he maintained that painters must understand the emotions of the witnesses to an accident if they wished to depict the event naturally and truthfully. To Leonardo that meant watching real people at real accidents. Direct observation, empirical research! For the graphic designer, inquiry lies at the foundation of artistic creativity.

Third is the serious study of human perception. The academic tradition, which remains alive in many places, simply overlooked the problem. If time and space are frozen, if nothing but the transmission of light energy takes place between objects and spectators, then artists cannot account for the emotional and cognitive impact of images on viewers. The Renaissance artist, operating on the assumption of a fixed and unchangeable universe, needed no theory of perception beyond what could be derived from geometry and optics. Of course, that was a great deal, since it produced the science of perspective! But graphic designers are obliged to accomplish their objectives within a time frame as short as six seconds. So they need a deeper and more sophisticated theory of perception.

Visual memory, the duration of sensory excitation, the connections between optical and tactile feelings, the processes of symbol formation, age, sexual and educational influences on vision, subliminal perception, the stimulation of latent imagery, the interactions among media—all these factors impinge on the work of graphic designers. They are both the tools and the objects of research conducted by specialists in graphic information. Let us call them artists!

Fifty years ago illustrators would have been thrilled to exhibit in an art gallery, to see their work in museums. Today their successors in graphic design work at the cutting edge of visual art. The best designers are the shock troops of art's *avant garde.* And the gallery painters and printmakers know it.

the INDUSTRIAL DESIGNER

We should not have to prove the industrial designer is an artist, but we do. The collaboration of artists with machines, mass production, and industrialists (!) creates the problem: for some of us the artist is a handcraft worker, now and forever. Of course, craftsmen use tools—extensions of their hands. And some tools may be small or simple machines—the potter's wheel, for example. Still, artists are supposed to achieve their effects by their own efforts alone, except for the architect, who works through others. Composers are another exception; they write music, but others actually *make* it. Obviously, the old, romantic definition of the artist is very limiting; it seems designed to prevent effectiveness in the real world. We need a definition broad enough to include the painting of a watercolor, the direction of a film, the design of a locomotive, or the construction of a power station. That would be about right for the industrial designer.

Industrial designers are artists who determine the form of objects for machine production. But their art is not confined to planning for mass production; designers provide a full range of visual services for business and industry—from product planning to the design of information systems, display systems, packaging, whole buildings, and the organization of indoor and outdoor environments. The designer's motto might be: today we work on an electric toaster, tomorrow a shopping center. After

Carey-type plow. c. 1800. National Museum of American History, Smithsonian Institution, Washington, D.C.

Who was responsible for the design of this plow? Over the centuries, thousands of farmers, blacksmiths, craftsmen, and tinkerers. Can all these people be called designers? Is the plow a work of art? These questions might be answered by asking some additional questions. Must a work of art be made by one person only? Must a work of art be useless? Do artists borrow from other artists? Does the plow have form? Is it pleasing to look at? Does it work? Was the plowshare shaped by nature, by accident, or by human purpose? The definitional problem is not easy if we approach it in the light of history. Today designers are professionals who do what many nonprofessionals used to do. They still use the best available technology; they still seek a balance between invention and evolution; they still are concerned with the size, shape, texture, color, weight, placement, and organization of things.

that, a city! It seems almost that architecture is a subspecies of industrial design. Indeed, designers may employ architects ... and engineers ... and sculptors ... and writers, typographers, and filmmakers—anyone who can play a useful role in determining the form (and function) of a manufactured (or constructed) object (or product).

It would be entirely correct to speak of Leonardo and Michelangelo as industrial designers. Both employed the best technology available; both invented and designed machines; both were "engineers" as well as painters, sculptors, and architects. Nor should their versatility be ascribed entirely to personal genius. The Renaissance artist was in fact a "compleat" designer. "Compleat" design is the normal role of the artist. It is the modern split between art and science, between craft and technology, between the beautiful and the useful—that is abnormal. The sad evidence for this assertion is visible in the unsightliness of modern cities, the refuse heaps outside of them, the trash within, the shoddy goods in our shops, the clutter in our homes.

Since the time of Leonardo and his colleagues we have devised a system of production that wastes human and material resources on a

Atwater sewing machine. 1860. National Museum of American History, Smithsonian Institution, Washington, D.C.

At first, industrial designers were confused about the relationship between function and decoration. It was thought that function—things working together—should be concealed. Decoration—the artistic part—was meant to conceal function, or make it palatable if it could not be concealed. As long as designers thought of themselves as "beautifiers" of "ugly" objects, they stood outside the real processes of determining the character of form. Engineers created form, and artists were hired to hide it.

monumental scale. And with that system we have learned to multiply the refuse, trash, clutter, and organized ugliness we call modern civilization. Perhaps the industrial designer cannot correct all that. When it comes to changing the large-scale environment, an informed and aroused citizenry is required. But designers need not be part of the problem; they might even be able to reduce the quantity of small-scale ugliness.

Art and Engineering

The relation of art to manufacture has to be clarified. Is the designer basically a problem-solver for industry? Yes and no. That function is closer to engineering. The company or client declares its problem; the engineer defines it in terms of special knowledge and then proceeds to fashion a solution that works. But we insist that industrial designers are a species of artist, with roots in the craft tradition and, more important,

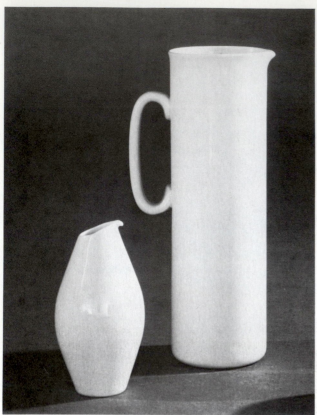

Contemporary ceramic ware: (left) Eva Zeisel. Cream pitcher. 1941–45. (right) Stig Lindberg. Pitcher. 1957. Museum of Modern Art, New York (gift of the manufacturers).

Zeisel and Lindberg make a virtue of the fact that plain materials and mechanical forming processes can be appealing if allowed to speak for themselves. In the past, good china had been decorated in imitation of traditional Far Eastern and Persian ceramics. Often, the ware was embedded with precious materials, at almost infinite expense of labor, by highly skilled handcraftsmen. Of course, that restricted the ownership of china to the very wealthy. The industrial designer, however, could reach a large public while making a visual asset out of the machine's preference for precision and simple geometric forms. A different set of aesthetic qualities came into play, and their acceptance required the public to abandon deep-seated social and pecuniary prejudices, namely, that cheap is cheap. It is still difficult to believe that low cost and high quality can be compatible. Which proves that aesthetics does not live in an economic vacuum.

a solid foundation in the history and aesthetics of seeing. So they design objects that look as good as they work. Indeed, "looking good" should parallel working well. That is the morality of industrial design.

Engineers bring admirable competence to their work, but artists are needed to bring *vision*—the vision of what is and what could be. Of course, engineering intelligence often produces beauty, as in Gustave Eiffel's Tower, Paxton's Crystal Palace, Roebling's Brooklyn Bridge, and the great constructions by Nervi, Morandi, and Candela. The "Barcelona" chair would a masterpiece of elegant design no matter how its creator, Miës van der Rohe, was trained. (In fact, he started out as a bricklayer.) But the education and outlook of artist-designers involves them in more than mechanisms, more even than the mechanics of seeing —their own or the spectator's. Genuine designers see with the mind's eye; they visualize the client's unspoken needs and translate them into three dimensions. Indeed, they can see the design as a part of a total social philosophy. Richard Neutra[1] and Eliel Saarinen had that kind of eye. So did le Corbusier and Frank Lloyd Wright.

Joseph Paxton. Crystal Palace, interior. 1851. Library, Cooper-Hewitt Museum, Smithsonian Institution's National Museum of Design, New York.

Paxton began as a designer of greenhouses for the great estates of England. That work taught him how to enclose large areas with small panes of glass supported by prefabricated, cast-iron parts. Had he been a conventionally trained architect, would he have developed the space conception of the Crystal Palace? Not likely. Nineteenth-century architects were devoted to masonry construction, classical aesthetics, and high building costs. They failed to see the architectural potential of glass, iron, and concrete. When they did see it, they denounced it. They were convinced that Gustave Eiffel's tower had ruined Paris. Today it is the city's most celebrated symbol. In a real sense, it was the practical designer who gave birth to modern architecture: Roebling the bridge-builder, Eiffel the engineer, and Paxton the builder of glass houses.

The problem of engineering design—especially in the nineteenth century—was that it did not adequately consider seeing. This was and is more than a matter of aesthetics. The great designer realizes that there is an organic connection between the way an object or a system functions and the way it is *seen to function.* Chains, pulleys, gears, and sprockets may be in the right places. Still, users must sense (see) where to start them going, where to touch or pull back, how to maintain the process, where to anticipate trouble, how to diagnose failure. Above all, the spectator-operator-user needs visual guides to the way he or she should *feel* about the thing.

Court of the Palace Hotel, San Francisco. 1878. New York Public Library.

The enclosed courtyard was the power center of the Renaissance and Baroque palace. Here is where the comings and goings of kings and bishops, courtiers and ministers, took place. (Imagine the clatter of horses' hooves over the cobblestones; imagine a king's messenger dismounting, breathless, just in time to deliver a sealed letter to a mysterious gentlewoman in a carriage whose curtains are drawn. Imagine it in technicolor!) Now shift the scene to America in the 1870s. The palace has become a hotel; the king's ministers have been replaced by barons of industry and trade. We still see arches and columns and balconies, but the columns are made of cast iron, painted to look like marble. And the building is six stories high, with glass panes overhead supported by steel trusses. Inside, the rooms have toilets and baths—more than the courtiers of Louis XIV could count on. The designer triumphs again, combining nineteenth-century commerce with Renaissance symbolism; modern conveniences with traditional spaces; democratic manners amid royalist forms. Greater height has become possible, hence ground space is more precious. But the wheeling and dealing are about the same. And there is still a mysterious lady.

166 THE INDUSTRIAL DESIGNER

The divorce of art and engineering took place officially in France, in 1795, with the founding of the École Polytechnique. The school was mainly intended to train engineers. The École des Beaux-Arts was founded in 1806 to educate painters, sculptors, and architects. The engineers studied the sciences and mathematics; the artists and architects studied the design principles of classical art. Thus, a wall of separation grew up between the science of building and the art of architecture; it symbolized the profound split between practical activity, on the one hand, and the expression of humane values, on the other. The best thinkers of the nineteenth century were aware of the painful consequences of that split. But, as we shall see, it was not until the early twentieth century that a practical, *educational* solution was found.

John Portman. Peachtree Center Office Complex, Atlanta. Courtesy John Portman & Associates.

Industrial production is increasingly automated. That means fewer hand and machine workers; more computers with more people watching, tending, and feeding them. That is what office work has become. These armies of computer-watchers need places to eat, meet, and circulate when they are not reacting to computer printouts. Also, they need to be reminded that they are people, if only to make them less angry about the flatness of their work. So Portman gives them tall interior spaces, stretching up to the sky. Enclosed vertical space on a monumental scale! This is what makes our horizontal mingling seem significant.

In the meantime, the environment (and that means people as well as buildings) suffered. To this day the technologist is often insensitive to what is called ergonomics, or "human factor design." If the engineers who designed the control panels for the thermonuclear reactor at Three Mile Island had exercised a modicum of aesthetic intelligence, a tragic and costly accident might have been averted. They should have carefully considered how operators respond to a complex visual display. But that is the same as saying engineers ought to be industrial designers.

Quality for the Millions

We have just discussed a divorce. Now we can define the industrial designer as the offspring of a *marriage*—a marriage between the crafts and engineering. The grandparents of the child were modern science, power equipment, the factory system, and industrial capitalism. At first, the stream of ugly products pouring out of the factories was attributed to the evils of mechanization, especially to machine-made imitations of handcrafted goods. In England, John Ruskin and William Morris were convinced that the displacement of the medieval craftsman by machine operators and mass-production methods was responsible for the endless duplication of shoddy goods. Morris was further persuaded that production for profit was a key part of the problem. The product was cheapened, and the worker was exploited because cheap materials and low wages led to low prices, larger markets, and higher profits. Only the capitalist owners benefited. The English Arts and Crafts movement was intended to reverse that deadly chain. But a new mass market now existed. What Morris did not realize, or refused to face, was that a return to medieval modes of production was impossible. The Industrial Revolution could not be abolished. However, its progress could be shaped and directed.

The real problem of industrialism was to find a way of using machines to produce products of high quality without violating the essential character of machine-forming or losing the economies of mass production. It was necessary to realize that the principles of mass production—precision, accuracy, standardization, and interchangeability—could also be principles of art. This necessitated the development of a different kind of form-giver—neither craftsman nor engineer (nor artist in the old-fashioned Beaux-Arts sense), but a combination of the three. So a new professional type, the industrial designer, was literally invented by the German architect and educator, Walter Gropius. Gropius put his ideas to work in a pioneering educational institution, the Bauhaus (1919–

Ettore Bugatti, designer. *La Royale.* 1930. Collection Greenfield Village and Henry Ford Museum, Edison Institute, Dearborn, Mich.

With Bugatti we get a consciousness of what the designer can do to express the *idea* of the machine, rather than apologizing for it. To some extent Bugatti's artistic opportunity was created by new social and psychological factors. The automobile had become a status object; therefore, its parts and appurtenances were worthy of sculptural (as opposed to ornamental) treatment. Second, the automobile had become a love object; therefore, it made sense to emphasize its lovable features —outside and inside. For some owners it was the fenders and headlights; for others it was the carburetor and manifold outlets.

1933). Employing craftsmen and artists as teachers, Gropius produced a new breed of artist-designers—men and women who were trained to use any forming tool or industrial method, to work with any material (fiber, fabric, paper, wood, paint, metal, stone, plastic, concrete, glass), to design any product (from a poster to a chair to a room to a house). They could analyze and intelligently use modern processes of production from beginning to end. The Bauhaus did more than study principles; it manufactured products.

The consequences for art, for art education, for industrial production, for the design of objects of everyday use, for the appearance of the large-scale environment, were enormous. The Bauhaus demonstrated that the correct analysis of a fundamental economic and artistic problem could have immense consequences for art and society. Today, we do not

(above) Eero Saarinen. Armchair. 1957. Molded plastic reinforced with fiberglass, painted aluminum base. Courtesy Knoll International, New York.

Some of Europe's best architects, like Saarinen, were also furniture designers. Le Corbusier, Mies van der Rohe, Alvar Aalto, and Marcel Breuer designed chairs that have become classics. In the United States, Frank Lloyd Wright insisted on designing the furniture for his houses, but his chairs were truly bad—idealogically correct, perhaps, but better to look at than to sit in. For the designer there is always a tension between visual form and practical function. Saarinen created a magnificent solution. His chair is strong, comfortable, and a pleasure to see. When it is not being used, it functions as abstract sculpture.

(below) Joan Burgasser. Club tub armchair. 1969. Tubular steel, plywood, urethane foam, and rubber webbing. Courtesy Thonet Industries, Inc., York, Pa.

During the nineteenth century the Thonet firm became famous for its inexpensive, gracefully curved bentwood chairs. We still use them. Here Joan Burgasser continues the tradition with a design employing a single continuous bend of polished nickel-chrome steel tubing. She uses another tube as a rail to support the seat. Apart from strength, comfort, and a feeling of protection in the soft, round seat, we receive a set of visual signals that contribute considerably to our awareness of the chair as an aesthetic object. Those signals come from the continuous frame; we see the tube standing and resting, curving lazily and bending sharply, attached to another material or completely exposed; we see it as hanger and as base, in tension and compression, as straight line and as curve. Perhaps that is only engineering, but, when sensitively done, engineering becomes art.

always admire Bauhaus design, but we recognize the revolutionary impact of the Bauhaus as an institution. It created the occasion and built the institution (Gropius designed the Bauhaus building as well as its curriculum) through which art and production resumed their old relationship. Just as the illustrator caused a revolution in the world of communication, the industrial designer produced a radical transformation in the world of production. The crafts would never be the same. Ideas of consumership, luxury, usefulness, beauty, work—all these acquired new meanings.

Form, Function, Ornament

Around 1850 the American sculptor Horatio Greenough declared that "form follows function," thus announcing one of the founding principles of industrial design. In effect, he said that beauty comes from within. That is, when we believe an object is agreeably proportioned and shaped, it is because the right skin or outer covering has been created for its inner working parts. That would be the equivalent of saying a beautiful face or body depends mainly on straight teeth, healthy blood circulation, good muscle tone, sound heart and lungs, strong bones, flexible joints, and functioning glands. Notice that this analogy says nothing about clothes, jewelry, hairstyle, or cosmetics. The soundness of the organism (or the formal beauty of a manufactured object) depends on a suitable covering for the work carried on by its various serviceable parts. There is little we can do in the way of hair dye, eye shadow, or mustache design to improve our looks. A glamorous wrapping for the package helps, but not much. It would be better to go on a good diet and take up jogging.

The point is that decoration (or cosmetics) does not constitute design. According to this view, ornamentation—handmade, expensive, stylistically significant, loaded with symbolism—changes nothing of fundamental importance. Probably it conceals structural defects or cheap materials. Perhaps it compensates for failures of basic design. Carrying this argument further, the Viennese architect Adolph Loos said as early as 1908 that ornament is a crime. A dozen years later, industrial designers made great capital out of these views. As manufactured objects were "cleaned up," they became compatible with machine production. Machines could reproduce carved decoration, but it always looked fake. Smooth, gleaming, regular surfaces declared their honesty and efficiency. Applied decoration signified handcraft; handcraft signified unnecessary cost and uneven performance. So the machine aesthetic arrived! During

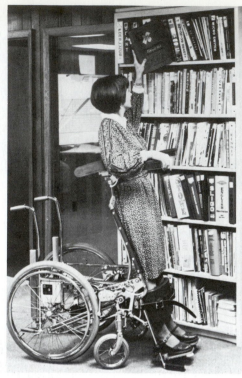

Contemporary bathtub, toilet, and lavatory. Courtesy Kohler Company, Kohler, Wis.

If bathroom fixtures are seen as mass-produced sculpture, then their designers must be artists. Bathing, washing, and eliminating are the processes that set the conditions for this type of sculpture. The dimensions of the human body, its range of movement, its vulnerability to accident, its requirements for comfort, its capacity for pleasure—these are the parameters or limits within which the designer finds form. Does that sort of form-finding destroy aesthetic potential? Not unless the designer's imagination has also been destroyed.

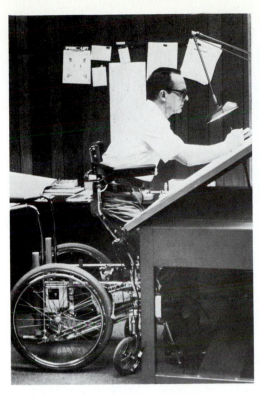

Conrad Deucher, designer. Levo stand-up wheelchair. Courtesy American Stair-Glide Corporation, Grandview, Mo.

The concept of the artist-as-designer raises interesting questions in aesthetics. Is the comfort and convenience of a handicapped person merely a problem in bioengineering? Not really. Is the wheelchair just a special kind of sitting-machine? Yes, but so is a throne. At what point does a chair become a work of art? When the chair becomes a symbol? Well, where do symbols come from? Somebody has to design them.

the Great Depression of the 1930s, when this design philosophy was dominant, absence of ornament actually stimulated sales. Austere design —art moderne—was chic, hence gratifying. Miës van der Rohe put it best: "Less is more." Designers like Raymond Loewy, Henry Dreyfuss, and Walter Dorwin Teague were heroes, because they could make consumers feel virtuous about buying new tableware, household appliances, personal articles. This was the way to get the economy moving again!

In fact, the Depression and the pioneers of industrial design, together, did advance the process of rationalizing modern production. They "engineered" the acceptance of functionalism; they showed that the machine could produce quality; and they broke the age-long connection among high cost, rarity or scarcity, and aesthetic excellence. Some designers, of course, carried a good thing too far: if it made sense to streamline an aircraft, a locomotive, an automobile, why not apply the treatment to everything? But a living-room sofa? A gas station? A fountain pen? None of them were going anyplace. Styling or "appearance-design" took over. A new kind of cosmetics was invented, and Horatio Greenough must have rolled in his grave.

From Designer to Stylist

Illustrators became the heroes of publishing because they increased book and magazine sales. Designers became the heroes of industry because they increased product sales. The earliest designers—Walter Dorwin Teague, for example—were called in by retailers to improve store and merchandise displays. But while point-of-sale improvements could be made, the key to creating mass markets lay in the improvement of a product's appearance. From this came product aesthetics, appearance design, jazzier packaging!

In the fifty years of its existence industrial design has committed many sins. The worst of them is called styling: the transformation of a product's skin to make it seem newer—hence improved, hence worth more—than the product it replaces. In the 1930s hard-headed manufacturers and retailers conceived a passion for aesthetics when they learned that an old product dressed up in a new costume would sell like hotcakes!

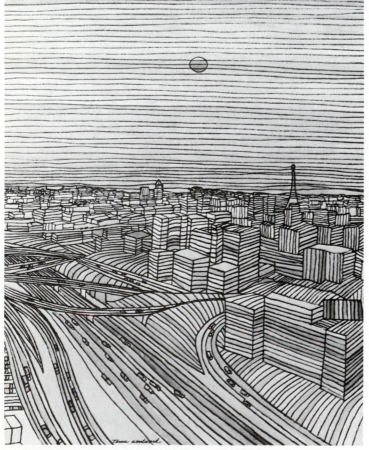

Teresa Woodward. Drawing for an advertisement. 1967. Pen and ink and watercolor. Courtesy Westinghouse Electric Corporation, Pittsburgh, Pa.

The city conceived as layers upon layers, neatly piled and stacked. Its highways (in a well-worn phrase) are ribbons of concrete. Even the sky is layered; the sun reaches us through stratified bands of haze. Why all these laminations? Because artists and designers are constantly seeking a language that will enable us to think productively about the environment and its variegated structures. The painting of an ideal city (p. 96) performed that function for the Renaissance designer. Here there is less emphasis on enclosed space and geometric symbolism. The idea is to find a common denominator for the city's streets, tunnels, viaducts, hotels, shops, plazas, parks, and promenades. We know the world's great cities are in terrible disarray. Saving them will require many and diverse talents, including the designer's talent—the ability to create a logic of urban form. To create that logic, designers need all the help they can get.

But money spent on styling was money spent on merchandizing, not design. Nevertheless, the styling strategy worked. Consumers could not really tell whether Detroit's new model was an improvement over the old model. All they knew was that the old car suddenly looked decrepit. The stylist (along with the advertising artist) had learned how to create a totally new aesthetic—for cars, radios, refrigerators, anything—every three years.

Styling produced a triumph of visual appeal over common sense; the discrepancy between appearance and performance was ignored or papered over. So stylists prospered; General Motors prospered; and mounds of Detroit iron piled up along the highways. Junk dealers prospered. Then came Volkswagen and, later, Toyota. These manufacturers sold good cars at moderate prices because their capital was not wasted on retooling for meaningless style changes. That had been Henry Ford's philosophy; it worked in Germany and Japan but was abandoned in its country of origin. By 1976—three years after the OPEC oil embargo—Americans realized they had been wallowing in sin—the sin of unnecessary redesign, or styling. They had ignored the wisdom of the great man who said: "If it ain't broke, don't fix it." The economic turmoil, the social penalties, the political costs—all have been staggering! Was there ever such a debauch? Was there ever such a hangover?

Design by Computer?

If we examine the general history of the various artistic professions, it may appear that drawing and painting evolved into graphic design. In a parallel process, architecture and sculpture evolved into industrial design. In both cases, a form of technology—mechanization—was the revolutionary factor. The new design professions were characterized by unlimited reproducibility, microscopic precision, standardization and mass distribution, and the substitution of mechanical, electrical, or chemical power for animal or human muscle. They also tended toward the elimination of the human hand. All these factors, in combination, have the effect of increasing the distance between the artist-designer and the image people see or the tools and objects people use. The logical culmination of the process would seem to be computerized design.

Here fundamental questions are raised about industrial design: Is it truly an art? Can or should human organs of perception be bypassed in the design process? Do computers have access to more and better information than people? Does the designer act as data-gatherer while the computer becomes the form-giver? Are human powers of judgment

superseded by the lightning-fast calculations of an electronic "mind"? To all of these questions we can confidently answer "no."

A product designed by computer would have to be purchased and used by a computer. Presumably it would be discarded by computer, too. To be sure, many manufactured objects look as if they have been designed by computers, but that is because the human beings responsible for them have managed to ignore their sensory appetites, repress their emotional experience, and forget the questions reasonably intelligent

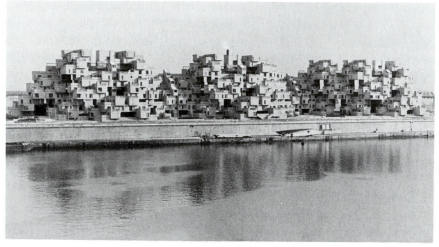

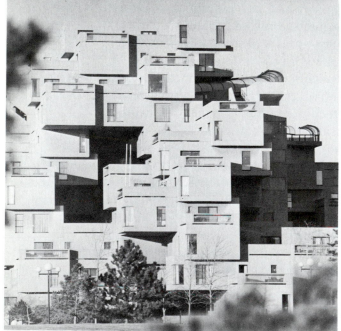

Moshe Safdie and David Barott. "Habitat." 1967. Courtesy city of Montreal.

North Americans are devoted to the single detached dwelling. But single, detached dwellings are costly and inefficient, especially in a time of growing energy costs. What about the design of collective dwellings? Must we settle for mass "housing"? Is there an alternative to the sterile, anonymous box? Safdie offers the concrete cluster: architectural excitement combined with prefabricated construction; individuality and community; visual variety and overall oneness. Before there can be truly human habitation, there has to be a designer who understands how people live alone and together. Without that understanding we get large-scale, abstract sculpture—monumental, perhaps, but deadly to live in.

persons ask about the things they buy. The computer is, at best, a tool of design, a device for storing, retrieving, and even visualizing masses of data. But the computer is not capable of making choices about form-function-expression alternatives. That is not because such choices are complex; computers can handle complexity better than humans. The underlying problem is that computers cannot initiate new lines of inquiry about products and their human users. They can only recall the information they have been fed.

The premise of an artistic profession is that we always need new solutions—creative solutions—to the problems of shelter, transport, communication, sanitation, work, health, recreation, and social interaction. This means that industrial designers cannot be reduced to computer programmers; they have to be artists—persons who can use the best available technology but who function as humans working for humans. This is a way of saying that form-givers must be capable of seeing, using, and responding to form. In time, computers will be taught to read foreign languages and to recognize and name complex forms. But to respond? Warmly, affectionately? Or with feelings of regret? I doubt it.

The Team Approach

Designers for commerce and industry work in teams, and that offends our notions of art as an individual creation. It does not prevent our enjoyment of a film, a play, an opera, a shopping mall, or a cathedral. Still, we like to think of a work of art as the expression of a single, controlling personality. Unified planning and execution from beginning to end—that is our model of art. It probably has its roots in the Renaissance notion of genius: the painting or sculpture as the outcome of a dialogue between a supremely gifted individual and the single source of all being, God. The romantics made their contribution to this idea with the notion of the art object as a gateway to the quivering emotions and heightened sensibilities of one great soul.

Well, the industrial designer may be a *group* of individuals rather than a single person. We do not wish to claim some sort of collective consciousness for that group, although some teams have a way of getting along together very well. Certainly collective creations can have a unified aspect. Only the most discerning connoisseurs know where Rubens' hand stopped and where his assistants' hands began. Indeed, the fact that a dozen or so design specialists have concentrated all their knowledge and skills on the presumed needs of a single consumer is rather pleasing to consider.

When it comes to the solution of certain problems—social problems, especially—two heads are better than one. So industrial design is necessarily a social art, like architecture. Collaborative analysis of consumer behavior followed by collaborative planning and decision-making is a necessity, especially when the market is huge and complex. Outside of building a palace for an Arab sheik, very few great structures are made for individuals. But even a toothbrush or a light bulb is designed for the millions. Would either of these products be better if they were especially made by a single designer for a single consumer?

Notwithstanding the team approach, the use of statistical science, behavioral research, and econometric and demographic data, there is room for the play of creative genius. It should be remembered that even Edison worked with a team of assistants. We should realize, too, that materials—wood, clay, metal, and paint—do not know who it is that shapes them. Thousands of workers labored on the construction of the

Gerald M. Cope. "The Mall" at Columbia, Maryland. 1972. Cope Linder Associates, architects, Philadelphia.

The old-fashioned shopping arcade was a street roofed over with thin arches supporting thousands of glass panes. It combined the outdoors with the indoors, the feeling of a public thoroughfare with the protection of a covered shelter. The modern mall retains these qualities, but on a larger scale. Here there are two levels under a single roof supported by a new-fangled creation of the designer—the steel space-frame. It covers a much wider expanse, admits light from the top and sides, and permits a highly flexible arrangement of shops and passageways. The mall tries to be a market, bazaar, and emporium in a single package. Pedestrians want to circulate and socialize in a stylish environment. Shoppers want to be entertained and surprised. They like to make discoveries. Shopkeepers want an ambience that lowers buyer resistance. The designer has to create a space where all these good things can happen.

pyramids. Today thousands are engaged in the planning, design, and fabrication of a supersonic jet, and yet it appears to us as the beautiful conception of a single intelligence. That is the miracle and mystery of art.

Design as an Ethical Profession

A new profession, a new occupational type, is formed out of bits and pieces of older types. The modern physician, for example, is part surgeon (which means part barber); part druggist (which means part alchemist); part psychiatrist (which means part witch doctor); and part engineer (which means part nurse, bone-setter, midwife, and dosologist). What holds these bits and pieces of antique practice together is science guided by an ethical code. When the ethic is gone, the profession disappears.

In Europe, industrial designers came out of the practice of architecture and the crafts. In the United States, they came from related design fields—stage set design, window display, book design, typography, and, of course, advertising art. This was not only because marketing is *the* great American art form. These ancestor professions had a useful common trait—the ability to maintain two simultaneous relationships: one with a client and one with the public. Needless to say, both are human relationships; hence, they have an ethical dimension.

Bell Laboratories and Henry Dreyfuss Associates. Two-station coin telephone booths for New York City's World Trade Center. Smoked glass, stainless steel, and Travertine marble. Courtesy Bell Laboratories, Short Hills, N.J.

What is a phone booth? A device for conducting a private conversation in a public place. There's nothing furtive about it. And that is the designer's message: making a phone call is smart, chic, admirable. The people in the booths and the equipment they operate are stylish adornments of the lobbies and corridors of commerce. The telephone company and its designers have conspired to use them as elegant punctuation marks for our entrances and exits.

J. Morgan, D. F. Kopka, and R. F. Snow, designers. Lamp pole system. 1973. Courtesy Industrial Design Department, Ford Motor Company, Dearborn, Mich.

Traffic lights, mailboxes, park benches, and lamp poles: these serve as furniture for our communal living rooms. Once their practical purposes have been performed, they nourish our civic consciousness. Good lamps make good citizens.

Designers quickly learn that their intuitions of harmony, grace, and elegance—beauty—mean nothing unless they can convince clients of their salability. That calls for the weighing of economic and psychological factors in planning a product. The client's needs and perceptions are as much a part of the design process as visual forming skills. As with architecture, there are several jobs of education to be done. First, the client's aesthetic indifference, fear of change, and affection for reliable precedents have to be overcome. Second, the client must be persuaded that ugly or unsafe products are morally, hence professionally, unacceptable—even though they will sell! Third, there must be a genuine effort to reconcile the constraints of manufacture with the consumer's needs and expectations in the form of an appealing product. This entails negotiation, trade-offs, the balancing of convenience and cost, beauty and maintenance, durability and weight. Whatever the result, the professional designer must operate on the basis of internal standards that are often *higher than* those of the client or the consumer. Consumers can be deceived, visually, about the cost, usefulness, workmanship, reliability,

Chanel No. 5 bottle. Courtesy Chanel, Inc., New York.

We can smell a perfume's bouquet, but we cannot see it. How, then, can its "essence" be visually communicated? Through a simple, unadorned bottle of strongly geometric character. Its edges, slightly chamfered at the shoulders, should convey just a trace of the crystalline, just a hint of the diamond. This designer's gem should be dominated by a bold, hexagonal stopper that makes a clear statement of command. Then the label might announce—simply and quietly—the elegance that attends the name. With a classic fragrance, flowers are unnecessary.

or symbolic meaning of a product. We need only think of the empty space under the elongated hoods of those pre-OPEC automobiles! While designers may not have perfect judgment in all things, they should not lie about form. That is the essence of their calling.

Honest design, then, is like honest surgery: it must be needed. Hence, there is only one way to do it: the right way. This issue is crucially significant in a culture that is heavily committed to mass-consumership. Designed objects occupy a great deal of space, and they cost a great deal of money. More important, they shape the lives of their users. Designers must realize that their highest function is to fuse the aesthetic with the ethical. And, since mass production is involved, ethical design has a social foundation. Without this foundation, the industrial designer is a hired gun—skilled but dangerous. Civilized societies require physical and ethical foundations; without honest designers, both are impossible.

Conclusion

The various design professions evolved, especially in the United States, under conditions of cheap energy and plentiful raw materials. One of their main motivations was to enlarge markets, increase profits, and speed up rates of consumption. This led to the growth of a use-and-discard philosophy with strong emphasis on attractive and expensive packaging but relatively little concern for product durability and usefulness. The realization in recent years that raw materials are limited and that energy is expensive has begun to produce fundamental changes in design philosophy and practice. Here we might speculate about some future developments.

First will be a revival of old notions of craftsmanship and a renewed emphasis on quality of materials and workmanship, long-term utility, and redesign only for functional improvement.

Second, the higher cost of new products will result in less impulse buying and more deliberation about making purchases. Longer-term ownership will lead to greater feelings of intimacy and emotional attachment to personal possessions, from drinking glasses to shoes to stereo equipment to automobiles.

Third, the greater emotional investment in objects of personal use will result in a design emphasis on the aesthetics of permanent ownership as opposed to the aesthetics of innovation, dazzle, and disappointment when a new model appears. Style innovations will make sense if they appear related to durability.

Fourth, much ingenuity will be devoted to redesign of wasteful and inefficient objects and their adaptation to the constraints of high energy and material costs. This will lead to fresh aesthetic ideas as industrial designers concentrate on stylistic reconciliation and synthesis.

Fifth, handcraft and related types of labor-intensive production will hold their own despite, or because of, an increase in automated manufacture. The most costly products will be machine-made in automated factories and will probably be publicly owned. The services of industrial designers, like those of architects, will be devoted increasingly to planning products and services for use in the public sector.

Finally, the steady integration of the architecture and industrial design professions will be fostered simultaneously by regional governments and by large quasipublic corporations operating as legal monopolies—that is, like public power, transport, and communications utilities. Like law and medicine, which are so fundamental in the conduct of civilized life, the design professions cannot continue to operate according to the principles of early-nineteenth-century entrepreneurship. The great problem of the next century will be to maintain the freedom and creativity of artist-designers while insisting that they serve the public interest.

the GALLERY idol

From the standpoint of the traditional or "pure" artist, illustrators, graphic designers, and industrial designers are renegades, traitors to the cause of true art. Morally, they are no better than poets who write advertising copy, or playwrights who produce scripts for soap operas. Prostitution may not be too strong a word for what they do. Genuine artists, of course, will not sell their professional virtue. Or will they? Artists must live; they need money like everyone else. The question of professional virtue becomes one of deciding whose money is tainted.

There are certain artists who manage to live, even to prosper, without "selling out" to business or industry: the gallery idols. When confronting the problem of money and artistic integrity, these artists "have it made." Their work is created to their own exacting standards; no one tells them directly what to do or how to do it; they live and work where they please; they need not engage in the tawdry business of hustling up buyers or bargaining over prices. The arrangement is ideal for getting the money one needs to live without seeming to ask for the stuff or becoming soiled by contact with the tedious side of the art business: paying gallery rent, advertising in the press and by word of mouth, entertaining potential buyers, cultivating art journalists, critics, and museum officials, organizing traveling exhibitions, bidding up prices at art auctions. All this is handled by the dealer.

Money that passes to the artist through a dealer is seemingly without taint, because modern art dealers have wrought a miracle. They have succeeded in perpetuating the myth of aristocratic patronage fully two centuries after the French Revolution! The dealer becomes the patron. By "handling" artists carefully, by protecting them from serious knowledge of actual offerings, negotiations, and sales, the dealers preserve artistic innocence. Thus, the great dealers in living artists have invented a new social type—the artist whose professional existence is not unlike that of a queen bee attended by worker bees. The bees construct a hive, send out scouts, forage for food, operate a complex communication system, organize as defensive or aggressive brigades, and, by the fanning action of their wings, keep the hive cool and the queen comfortable. The queen, in turn, produces the next generation of workers.

This analogy from the insect world may not be exact. However, it correctly describes the extraordinary efforts of dealers in relation to the

Jan Vermeer. *Woman Holding a Balance.* c. 1664. Oil on canvas. National Gallery of Art, Washington, D.C. (Widener Collection, 1942).

Not much is known about Vermeer. What we do know throws an interesting light on art as a profession. Obviously, Vermeer was a painter of superb taste and technical gifts. Yet only about thirty of his pictures exist. Perhaps there were more. (That possibility has motivated some clever forgers.) But perhaps he produced no more because he could not sell the few he did paint. He ran a shop that sold the work of other artists. And he may have been a merchant who traveled a great deal; that would have reduced his output. Vermeer had a large family and many mouths to feed. If his pictures did not sell, he had to find other work. In the end, this master of seventeenth-century painting died penniless. What does this sad story tell us about the artist's profession? First, Vermeer *was* a gallery artist, even if he served as his own dealer. Second, gallery artists often work at other jobs. Third, painting full time does not guarantee excellence; Vermeer was an exquisite painter and a genuine professional, yet unquestionably a part-timer. Finally, even successful artists cannot know when the public will lose interest in their work. Thus, the gallery idol faces the same dilemma as the rock musician, the teenage singing star, or the prize-fighter: yesterday's hero is today's bum. All of them need to make hay while the sun shines.

Eugène Delacroix. *Michelangelo in His Studio.* 1850. Oil on canvas. Musée Fabre, Montpellier, France.

Delacroix misunderstands Michelangelo physically and psychologically. But in doing so, he gives us an insight into the romantic view of the artist, a view that survives in our conception of the gallery idol. Here the emphasis is on creative and emotional isolation. Michelangelo's cosmic moral protest is reduced here to the alienation of the misunderstood romantic genius. The gallery idol may be the beneficiary and victim of that myth: originality is synonymous with greatness; greatness is never recognized in its own time; the art world appreciates avant-garde art only when it is too late. The inferences are obvious: the advance guard has to be identified before it becomes the rear guard; genius must be recognized early. But this reasoning raises problems. Once genius is recognized, it ceases to be avant-garde. Then we need new misunderstood geniuses to appreciate. This leads the public to search frantically for the signs of artistic originality. And the turnover in gallery idols accelerates.

artist with an established name. Art critic John Russell puts it pungently as follows:

> These galleries [Hanover, Gimpel Fils] pioneered that envelopment of the artist by his dealer which has now reached a stage at which any dealer who wants to get on must expect to do everything for his artists except brush their teeth and do up their shoes.[1]

Not many artists become gallery idols, to be sure, but many have aspirations. Historically, it has been a long journey from the status of slave-artisan. As we shall see, the role of the dealer in this development is more than servile.

Rise of the Dealer

Traders in art go back to Hellenistic times, at least, but art dealing in the modern sense, with its overtones of pure capitalism (build-up of special inventories, control of sources of supply, and manipulation of markets) goes back to seventeenth-century Holland. Some of the earliest dealers were themselves artists—like Vermeer—because they could not live by the sale of their own work. Others taught, sold the work of their students, painted signs, made prints, and picked up odd jobs to stay alive. This mode of working was a survival of the medieval master craftsman's shop. But without corporate protection artists were helpless; as part-time capitalists they lacked the money to finance other artists and build up stock. And time spent selling is time taken away from artistic work.

In Rembrandt's time, the appetite for pictures in Holland was enormous, and it kept an army of painters busy. But without guilds to regulate production and ban imports, and without church commissions or aristocratic patronage to sustain them on a long-term basis, most artists worked for a pittance. Under capitalism artists could starve as well as become rich. Few had the organizational genius of Rubens. Rembrandt and Vermeer were both forced into bankruptcy, and Hals ended up in the poorhouse. This was not only because they were poor managers of money (Rembrandt) or heavy drinkers (Hals), but because vicious competition in the trade devoured the independent artist-businessman.

The dealer, therefore, comes into the picture. As an intermediary between the artist and the public, the dealer brought a certain amount of stability to the situation—advancing funds to the producers, anticipating the needs of buyers, commissioning work to build an inventory *in the light of* the market, and keeping prices "reasonable," that is, very low.

Photograph of André Emmerich and Jules Olitski, April 1980. Courtesy André Emmerich Gallery, New York.

The artist-dealer symbiosis ranges all the way from a grudging alliance to mutual admiration and support; from a relationship between an employer and his workers to an arrangement between independent professionals.

If you, as a customer, want a still life, you get it; if you want a landscape with cows, you get it; if you enjoy tavern scenes, you get that, too. In time, the art-buying public knows where to shop for its special requirements. The artist becomes a reasonably consistent supplier of goods, and the dealer learns the value of that great principle: buy cheap and sell dear.

Dealers emerged because they performed a valuable economic function: they established and stabilized a market for pictures and then standardized the production of pictures. They exercised a discipline over producers by carrying the pictures of foreign artists. And, by gaining the confidence of collectors, a dealer could "steer" their purchases toward the most cooperative suppliers. This sounds unpleasant, but the total arrangement had a virtue so far as the artist was concerned. Instead of being obliged to satisfy many customers with frequently conflicting ideas of quality, the artist needed to establish a relationship with only one person, or one firm of dealers. With reasonable give and take on both sides, a mutuality of interest developed: artist and dealer became allies. For the duration of their association, they were for each other.

Art for the Dealer

Without art dealers, many artists would have little reason to create. They literally paint for the sake of an annual or biennial exhibition at a gallery, from which they hope to earn enough to paint for another year, or two, in order to exhibit again, and sell again, and so on. The object of this seemingly endless round is to accumulate a set of loyal collectors who will in time pay larger prices as the artist grows in reputation. With regular buyers and higher prices the pressure to produce many canvases

will be somewhat reduced. The artist may also feel free enough to try a new direction, or to switch to another dealer—one who promises higher prices, better publicity, more famous collectors, representation in more prestigious shows and museums, long-term personal support—whatever the artist wants or needs.

The ultimate goal of the gallery system is a situation in which every exhibition is a sell-out; where famous collectors and important museums get in line to purchase anything the artist produces; where the artist's dealer must ration annual output; where a dealer like Kahnweiler can deal only with other dealers and a few privileged collectors; where sales are for prices so high that they are paid in installments, like the salaries of basketball stars.

Success for the gallery artist has significance over and above wealth and recognition in the art world. It brings artistic freedom, the opportunity to experiment, the chance to work without fear of economic consequences. To be sure, there are drawbacks. It may be emotionally and technically impossible for a successful artist to depart from the style or subject matter that initially brought recognition. Nevertheless, the gallery system does provide this option—in theory at least—for a few highly regarded artists. Whether they choose to exercise the option is another matter.

Honoré Daumier. *Visitors in an Artist's Studio.* Watercolor. Walters Art Gallery, Baltimore.

Daumier was intrigued by the relations between artists, on the one hand, and among dealers, collectors, and critics on the other. Here he portrays a somewhat austere painter, wearing a smock and holding a palette, gesturing with his maulstick toward a framed picture on an easel. The visitors appear to be fascinated and delighted. Usually it is embarrassing for artists to talk about their own work. Yet many sell directly from their studios. The go-between is eliminated, and the buyer experiences the thrill of acquiring a work of art hot off the griddle, so to speak. Aside from appreciating quality and value, collectors often are motivated by the desire to be first. First to see a new direction, first to recognize a special facet of the artist's genius, first to own what later turns out to be a masterpiece.

The great dealers—Durand-Ruel, Vollard, Kahnweiler, and others—have been more than business managers. The dealer frequently plays the role of enlightened patron and friend, even more than a friend. Again, John Russell describes the services of the dealer as "estate agent, decorator, employment agency, resident psychoanalyst, sea lawyer, chauffeur, maquereau [pimp], social secretary, handyman, investment counselor, impressario and scribe."[2] To the extent that the interests of artist and dealer coincide, the arrangement works beautifully. Often it has been a matter of personal chemistry as between editors and their authors or between an impressario and the stable of performers. However, we should not overlook the underlying assumption of this relationship, namely that art and business are incompatible; that artists should have social but not commercial relations with collectors; that it is best if the world of the artist and the world of the collector touch but do not overlap.

Paul Gauguin. *Self-Portrait.* 1889. Oil on wood. National Gallery of Art, Washington, D.C. (Chester Dale Collection, 1962).

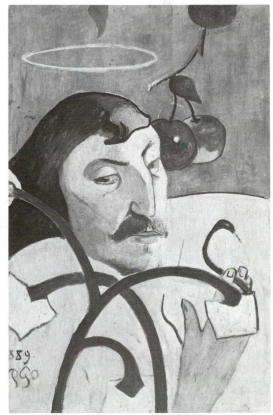

Gauguin represents himself with a halo, a snake, and a strong hint of a cross. This imagery is meant to say three things: Gauguin, like Christ, has been betrayed; Gauguin was betrayed by a viper, someone he had taken into his bosom; the progressive artist, like Christ, is sacrificed again and again. Betrayal, sacrifice, martyrdom, sainthood: these are the rewards of the artist who tries to save humanity through his vision of a more perfect existence. We know that Gauguin was a charismatic personality. Van Gogh almost worshiped him . . . before attacking him with a knife. Behind these events, and behind this extraordinary self-portrayal, is a new artistic ideology. The artist is no longer an artisan, decorator, or illustrator of the ideas others create. The artist has become a kind of savior. Now that is different from a mere genius.

From Talent to Celebrity

There are thousands of excellent artists alive and working today. Those known to museums and the gallery world through regular exhibitions may number in the hundreds. Perhaps two or three hundred actually live by the sale of their work. Perhaps half of those live well. Perhaps fifty are gallery idols—rich, celebrated, and assured of eager buyers for anything they make. The rest teach, work at nonart jobs, or fall by the wayside. What accounts for the few who succeed as gallery artists and the rest who do not? Can the great differences in reputation and reward among artists be ascribed to great differences in ability, motivation, and willingness to work? Does luck play the principal role?

Surely many nonaesthetic factors influence success in the gallery art world. Nevertheless, the decisive factor is the dealer system. The same might be said of success among actors. Many talented young people go to Hollywood every year, but only a few get opportunities to perform at high salaries, and those we see in films or on television do not always

Raphael Soyer. *Self-Portrait with Self-Portraits of Corot, Degas, and Rembrandt.* Oil on canvas. Courtesy Shorewood Publishers, Inc., New York.

Here is a painter's homage to the artists he admires most. Their self-portraits stand behind his somewhat quizzical self-portrait. Soyer seems to wonder whether he belongs in their company. This sense of gratitude—even reverence—toward one's artistic ancestors is a very old emotion; it goes back to the craftsmen of antiquity. But Soyer introduces some modern notes: the complex question of the artist's identity; the mixed roots of his style; the deep sources of his vision. In addition, there is the modest but slightly self-serving suggestion that when we see a Soyer we see bits and pieces of Corot, Degas, and Rembrandt filtered through the personality of the artist in the foreground. What touches us most, however, is the blend of pride and humility.

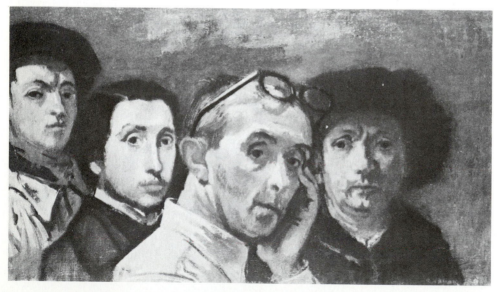

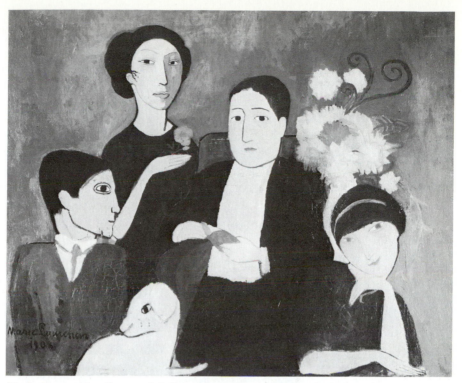

Marie Laurencin. *Group of Artists.* 1908. Oil on canvas. Baltimore Museum of Art (Cone Collection, formed by Dr. Claribel Cone and Miss Etta Cone of Baltimore, Maryland).

A group portrait of the artist and her friends: Picasso and his dog, Frika; Picasso's mistress, Fernande Olivier; Apollinaire, Laurencin's lover; and Laurencin herself. All of them have a quasi-Persian, slightly feline look—which was Laurencin's stylistic trademark. A painter of only modest gifts, she tries in this picture to achieve fame by association. Soyer, at least, was trying to understand himself. Laurencin, on the other hand, is engaged in a rather obvious self-advertisement. One thing she knows: in the picture trade, connections are important.

appear to be especially gifted. One cannot escape the conclusion that film stars, like gallery idols, are themselves the creations of a *system.* It is the system that discerns the real or potential needs of the market and selects individuals who can be moulded to fit those needs. Rarely does an artist arrive on the scene, readymade for the public. The truly creative and inventive persons in the system are those who manage it: producers, directors, show packagers; or in the art world: museum directors, critics, art publicists, collectors, and dealers. Artists and actors are necessary but interchangeable, like the technicians who operate the cameras, build stage sets, and arrange lighting. It is the producer, the impressario, *the art dealer,* who makes the decisions that cause the system to work.

The dealer's selection of an artist may begin with the serious consideration of the artist and his or her work. Thereafter, it is a matter of carving out a market for that work, feeding the market, shaping the critical environment, maintaining the artist's morale, promoting the artist as a public personality, and building depth into the market. It would seem that there is genuine artistry in the creation of a gallery idol. Picasso's great dealer, Kahnweiler, may say there are no tricks to his trade: "I don't know a single trick. I know a way of selling pictures, which is to acquire them and wait until people come to buy them, but I don't know a single trick."[3] He says he waits until people "come to buy." This is ingenuous, to say the least. It is very *creative* waiting.

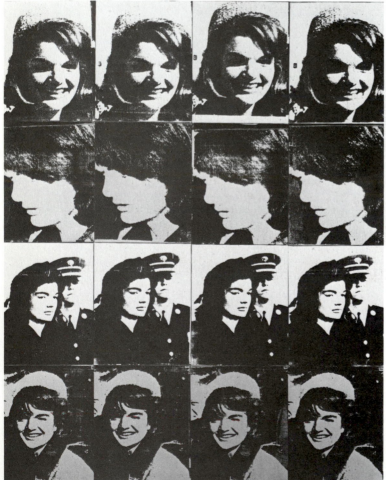

Andy Warhol. *16 Jackies.* 1965. Acrylic and silkscreen enamel on canvas. Walker Art Center, Minneapolis.

A celebrity painted by a celebrity. Actually, not painted—photographed and silkscreened. The design, the technique, and the multiple images are not nearly as important as the identities of the artist and his subject. Warhol is the very model of a gallery idol—which is to say that his reputation transcends the usual questions of form, style, and content. When an artist achieves celebrity status, the normal processes of criticism are suspended. Temporarily.

Taxes and the Artist

Tax laws in the United States have been an important stimulus to the collection of works of art. Until recently, an individual could deduct up to 30 percent of adjusted gross income (the basis on which personal income taxes are calculated) for the current value of art gifts to charitable or educational institutions (colleges, universities, public museums). Clearly, the purpose of tax policy was to encourage the movement of works of art out of private hands and into public places where all could enjoy them. And this policy succeeded. No other country in the world has so many fine public museums, often in remote or little-known places, as does the United States.

American tax policy concerning art gifts has served noble educational purposes, but one of its side effects—perhaps unintended—has been evasion of taxes. If a collector bought a painting for $1,000 and kept it a few years (until the collector and dealer believed it was worth $5,000), the painting might be donated to a museum. A dealer or museum

Robert Morris. *Untitled.* 1967–68. Black felt. Courtesy Leo Castelli Gallery, New York.

Here is a work of art whose form literally depends on the gallery. Its soft shapes and the spaces between them require a point of suspension on the gallery wall and a place of rest on the gallery floor. Of course, conventional pictures need walls for their display. And sculptures need to be located somewhere. But they are made in advance, in a studio, a workplace. Once created, they need not be re-created. The same art object can be shipped from one place to another. Morris seems to raise questions about this system. He candidly acknowledges the fact that the workplace and the display place are the same. We can see that, apart from the gallery, the work of art has no existence—except in a photograph or a book. That could be its most durable and authentic embodiment.

person could be found who would gladly testify to its $5,000 current worth. Then the collector could deduct that amount from income taxes. The individual whose income falls in a high enough tax bracket could actually deduct a larger sum than the painting originally cost. Thus, a wealthy person might retain a substantial part of income from other sources. Or, if desired, the collector could deduct *a portion* of the gift's value over a period of years. Indeed, one might even have *physical possession* of the painting by "borrowing" it from the museum from time to time. In effect, the museum would act virtually as a storehouse for a private collector. (And it would take good care of the paintings, too.)

Dan Flavin. *Untitled (To Jane and Brydon Smith).* 1969. Cool white, daylight, and blue fluorescent light. Installation, National Gallery of Canada, Ottawa.

The subject of this sculpture is light. Again, gallery walls are indispensable; otherwise, the light would dissipate in endlessness and formlessness. The situation is curious. The artist needs the gallery in a physical sense, a visual sense, and a commercial sense; yet the art "object" lacks object-ness. It cannot be sold (unless someone engages the artist to install the same fluorescent tubes in an identical room). Aesthetically, too, there is an endeavor to dissolve the walls and corners of the room. The light is used to deny that the gallery exists. Thus, we witness a love-hate, dependence-revenge relationship. A deep motive, quite possibly hidden from the artist, seems to be at work. If the gallery can be destroyed as a place, it may also disappear as an institution. Then the artist inside the gallery idol might be reborn.

To make this arrangement work (an arrangement in which everyone seems to win: artist, dealer, collector, museum, and the public) there must be a dramatic rise in value of the gift. Here the dealer's usefulness comes into play. Well, what is a painting worth? Answer: it is worth what someone is willing to pay for it. Let us suppose that dealers sell paintings to each other—three, four, or five times, at increased prices each time. Little or no money actually changes hands, of course. (Importers of scarce crude oil have been known to employ this practice before the oil is finally sold, at a high price, to a public utility that needs it to generate electricity.) With a little ingenuity and working within the law, dealers can establish a public record of very high prices paid for the work of their artists.

It would be a mistake to say that tax avoidance or reduction is the main objective of the art collector. Nevertheless, lowering of taxes is certainly an important motive for buying art at one price and donating it to charity at a much higher valuation. Surely aesthetic pleasure enters the picture, but just as surely, aesthetic pleasure is enhanced by the expectation of large pecuniary rewards. In addition, there is the prestige of patronizing art and the excitement of speculation—of buying unknown artists and watching their work rise to immense values.

Most European countries do not grant tax favors of this sort; hence their public collections of art by living artists are few and not as large as those in the United States. In England, heavy estate taxes and death duties have the effect of bringing valuable works of art into the public domain, but there it is the work of a deceased artist—a Gainsborough or a Romney—that is involved. In the United States, it is often the work of a living artist (or one recently deceased—Gorky, Pollock, Rothko) that experiences astronomical increases in value. Such increases depend on the maintenance of a market in which truly "important" artists are few and precious works of art are scarce because *preciousness is controlled.*

Obviously, the gallery artist is caught in a maelstrom of forces: dealer rivalry and cooperation, collusion between museum officials and collectors, manipulation of prices at auction, the rise and fall of business cycles, changes in government tax policies, the aesthetic appetite of the small art-buying public, and alternative investment opportunities for persons of wealth. These factors generally operate beyond the capacity of the artist to understand, much less control. As for actual art-money transactions, they are the culmination of an exceedingly complex and often protracted process. The artist is best left out of it, and this is what creates the illusion of artistic purity.

Linda Benglis. *Adhesive Products.* 1971. Iron oxide and polyurethane. Walker Art Center, Minneapolis.

Instead of dissolving the gallery wall, Linda Benglis uses it as a vertical platform for a series of sculptures that reach out menacingly toward the spectator-pedestrian. Again, the gallery is converted into something else—an avenue of monsters or a chamber of horrors in an oversized penny arcade. But the walls and floors of the gallery are still immaculate; the sedate atmosphere of the museum still prevails. We get an aesthetic *frisson* along with our horror-movie thrills.

The gallery idol is engaged in a business, and not necessarily an evil business. Still, it is difficult to discern its inherent moral or aesthetic superiority over the business of the illustrator, the craftsman, the graphics specialist, or the product designer.

Conclusion

What are some of the problems of the system? First is that it works well only for creating "stars." Many artists of comparable or even greater ability do not achieve similar recognition. As Sophy Burnham says, the system creates the impression that "there are only a very few real artists in a society at any one time."[4] That notion is widespread even though it is a "myth."

Second, there is little in the system that encourages confidence in its adequacy as an instrument for discerning the visual and aesthetic needs of a democratic society. It serves best to enrich a small number of artists and to create an aura of chic around the display and sale of art regarded as a fashionable commodity.

the hyphenated artist

Third, the gallery operates essentially as an art boutique. It employs the merchandizing methods of a small shop in an exclusive neighborhood, while our needs for a humane visual culture call for the scope of a department store chain and the visual power of a television network.

Fourth, the dealer system concentrates decisions about art and artists in very few hands, suggesting no improvement over the prerevolutionary salon system or earlier forms of courtly and aristocratic patronage. As far as the aesthetic culture of most people is concerned, the system appears to be largely irrelevant. Indeed, its most vital themes seem to "filter up" from the mass media.

Fifth, although works of art created for gallery display may be sold to private collectors, their hoped-for destiny is the museum. Once in a museum, they rarely come out. And although museums are increasingly places of mass education, art created solely to rest in museums is likely to be dead at birth. We should remember that the vital art of the great museums was made to be experienced elsewhere. Originally it was intended to function in the lives of people at work, at worship, at home, and in places of public congregation. It is healthy for paintings and sculptures to be "used" before they are installed in a temple of art.

Sixth, the merchandizing-marketing emphasis of the gallery world virtually guarantees that art and artists will be fashion items. As art styles are force-fed or hothouse grown, prematurely buried or arbitrarily resurrected, they lose their significance as vehicles of serious artistic ideas and insights.

Seventh, speculation in art has become a very potent influence on its creation. As a result, there has been a tendency for the apparatus of art criticism, art publication, art exhibition and museum acquisition to be recruited into the service of building selected artistic reputations. When enormous money values are attached to the work of living artists, there is an increased risk of corrupting the persons and institutions engaged in the art trade.

Perhaps this list of problems in the world of "high art" paints too gloomy a picture. Does it matter greatly if a few dealers engage in shady practices? In reply, let me ask whether it matters if millions of dollars are advanced to the authors of trashy novels while good books cannot find publishers. Does it matter if art is corrupted and literature languishes? Of course it matters.

Categories and classifications seem to confine the artist, but they have their usefulness. If you are a museum director, they help divide museum space; if you are a curator or an art historian, they help define your specialty; if you run a gallery, they help attract a particular public or clientele. Nevertheless, many artists resent this sort of classification; it seems to reduce their stature.

It may be correct, but is it fair to call Rufino Tamayo a Latin-American artist? He has lived and worked in Paris and New York. He makes his home in Mexico City. Wherever Tamayo's residence may be, his art is addressed to the world. Still, we sense that Tamayo's work has pre-Columbian roots. A critical discussion of his art would have to consider the climate, landscape, folklore, and religions of Mexico. If that is so, should we not consider the fact that Jacob Lawrence is black? That Georgia O'Keeffe is a woman?

Rufino Tamayo. *Personages Contemplating Birds*. 1950. Oil on canvas. Krannert Art Museum, University of Illinois, Urbana-Champaign, Ill.

Tamayo is a hyphenated (in this case, non-European) artist who has fully comprehended the major developments of international modernist painting. Yet there is a powerful archaic element in his art—the legacy, perhaps, of his Zapotec ancestors. Although Tamayo's forms remind us of French experiments with unconscious symbolism, his ochres and siennas come from the soil and dust of Mexico. Most of all we are impressed by the strange excitement of his people, who tremble and gesture as they watch a bird. It is here that we witness a universal anxiety—the primitive in each of us.

Today's artist is not always a full-time artist. Some artists teach, some preach, some are dentists, some are stevedores, some create for their friends and relatives. We might call them artist-teachers, artist-preachers, artist-physicians. Does that mean they are amateurs? Perhaps. But it does not mean they are aesthetically or technically inferior. Sometimes the hyphen separates a person's artistic commitments from the way he or she makes a living.

There is also a category of artists in which the hyphen is not used but is implied. Here artists are classified by age, race, religion, gender, and nationality. Such classifications may not be artistically relevant, but we cannot doubt that they are real. There have been exhibitions by artists in prison, by artists under thirty-five, by women artists, by black artists, and so on. There are museums and galleries that specialize in the work of artists in particular racial, ethnic, or age categories. As for classification by geography, nationality, and religion—that is the practice in the great museums of the world. Thus Rubens is northern European, Flemish, and Catholic; Rembrandt is a northern artist but he is Dutch and Protestant. You will not see Rubens among the Italians, or Rembrandt among the Germans. Of course, this creates problems in a cosmopolitan world: Chagall is Jewish, but should he be shown with the Russians or the French? And where should we display the work of atheists?

In this chapter we shall examine a few of the problems that face at least some hyphenated artists. Then we shall discuss artists' relations to critics, their attitudes toward amateurs, and finally the dilemma of definition: Who is an artist?

The Artist-Teacher

The most common type of hyphenated artist is the artist-teacher. Why? Because artists have had pupils from the beginning; even shamans had assistants. In the medieval guild system, especially, teaching was an expected function of a master. In fact, there were regulations limiting the number of apprentices a guild master might have. Clearly, the economic significance of the teacher-pupil relationship was uppermost. An apprentice was really an assistant. His work contributed to his master's income. But when the personal style of an artist became a crucial factor in determining the value of the work, apprentices became something of a burden. As the guild system began to break down, major artists taught somewhat less, and obviously not for the sake of increasing their output. Indeed, if they taught it was in an atelier or state-supported classroom, not in their own shops or studios. Established artists did not want students to see their new projects or half-finished work.

Today, artists teach for a variety of reasons: for prestige, to have artistic descendants, because they want to influence the aesthetic climate, or simply because they enjoy teaching. Mainly, they teach for a living, to have a steady, predictable income. It should be added, too, that many artists seem to need the adulation of students. Teaching satisfies appetites that artistic performance leaves unfulfilled. Finally, the necessity of sharing ideas, technical approaches, and artistic objectives with students often serves serious artists as a means of defining their own creative philosophy. In any kind of work or study, the teacher learns in the process of teaching.

Needless to say, teaching holds perils as well as opportunities. For some artists it stimulates personal exploration and productivity; for others it discharges energies that would normally be expended in work. One thing we know: teaching entails talk, and for a certain kind of person talk overdefines the artistic act, killing the spontaneity and sense of discovery that impels artists to take chances. For that reason, many excellent painters, sculptors, and craftsmen have been ruined by good teaching jobs, either because they gave too much or because they gave the wrong part of themselves to their students.

Notwithstanding the psychological dangers, however, the satisfactions of teaching seem to outweigh the liabilities. Today, most serious artists are full-time or part-time teachers in our schools, colleges, and universities. The so-called fine artist is almost without exception sponsored by an educational institution. Because schools of one sort or another are today's most generous patrons of art, the "outside" job an artist usually has is teaching. This arrangement can be wonderful for artist and pupil when it works. Still, not every artist should teach. Alas, this is not generally known.

Women Artists, Ethnic Artists

These categories are by no means identical, since gender differences cannot be equated with national, racial, and religious differences. Nevertheless, there are certain commonalities between the problems faced by women artists and those faced by members of various minority groups.

The first problem, as mentioned above, is the suggestion of inferiority when someone is called a "woman-artist" or a "Jewish-artist" or

Anonymous. *The Drawing Class.* 1815–20. Watercolor. Art Institute of Chicago (Emily Graves Chadbourne Collection).

All the students are "ladies." They exemplify the genteel tradition of women "dabbling" in the arts—needlework, china-painting, watercoloring, sketching, and pottery. For them, art was a leisure-time activity, a minor accomplishment but not a serious pursuit, certainly not a profession. That tradition of un-seriousness is not dead. Today's hyphenated woman-artist belongs to a culture that still regards painting as a suitable activity for females—provided they are not resolved to be very good at it.

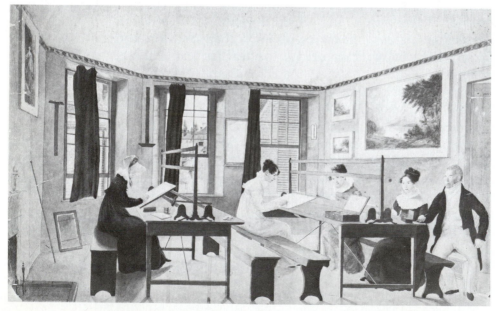

a "black-artist." The hyphen—real or implied—has the effect of reducing the size of the category. It suggests that these artists need only be considered in relation to other female, black, or Jewish artists. The implication is that they are not strong according to "universal" artistic criteria.

The second problem has to do with the relative paucity of famous or great or important artists in the above-mentioned groups. Linda Nochlin has dealt with this question in a well-known essay, "Why Have There Been No Great Women Artists?"[1] Of course, part of the problem may lie in the way the question is posed. Perhaps "greatness" has been defined in a way that excludes what women, for example, make and do.

Third is the difficulty women and minorities have experienced in getting an artistic education, in gaining recognition as competent professionals, and in supporting themselves by their work as artists. Hyphenation may have the effect of consigning the woman or black artist to permanent residence in the artistic minor leagues. Or it may mean that one's work, when sold, always brings lower prices. In either case, there is a sense of being treated unfairly because of race, gender, or ethnicity.

Grant Wood. *Dinner for Threshers* (right section). 1933. Pencil and gouache on paper. Whitney Museum of American Art, New York.

Why have there been so few women artists in our museums and galleries? Here's why.

Peggy Bacon. *The Whitney Studio Club.* Drypoint. Whitney Museum of American Art, New York.

At least half of these artists are women. Forty years earlier they would not have been permitted to work from a nude model—whether the model was female or male.

The resulting feelings of oppression often lead women and minority artists to band together, to seek recognition as women, black or Spanish-speaking artists. The irony is obvious: protection is sought in hyphenation even though hyphenation may have been responsible for unjust discrimination in the first place.

These are the common problems. They have emerged whenever oppressed and victimized groups have sought a rightful place in the economic, political, and aesthetic sun. Still, we can see that hyphenation becomes part of a vicious circle and that it is ultimately self-defeating as a professional strategy for the artist. Nevertheless, there have been some gains due to hyphenation. The art world has been obliged to recognize the distinctive artistic values that grow out of the experience of being a women, a black, a Jew, or a Mexican in New York, London, Chicago, or Los Angeles.

Our common aesthetic fund was enlarged early in this century when European artists began to assimilate African, Polynesian, Far East-ern, and pre-Columbian motifs. Today, for a variety of social and

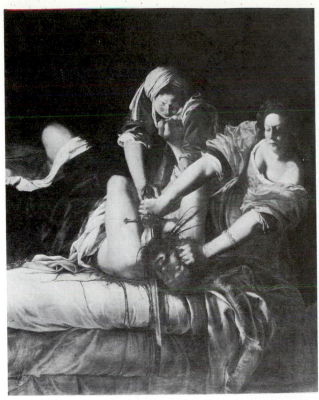

Artemisia Gentileschi. *Judith Beheading Holofernes*. Oil on canvas. Uffizi, Florence.

It was not easy for a woman to get an artistic education in seventeenth-century Italy. Then where did Artemisia Gentileschi acquire the painterly theatrics demonstrated here? In the studio of her father, Orazio, and from a teacher he engaged for her. That teacher raped Artemisia when she was fifteen. At the sensational trial that followed, she was subjected to a thumbscrew to test her veracity. This may account for her several versions of this beheading, and the grim enthusiasm with which Judith goes about her work. Of course, any number of beheadings were painted by men, from Caravaggio to Gustave Moreau to Puvis de Chavannes. But the ability of women artists to deal with gory or violent themes has often been questioned. Well, there's no question about Gentileschi.

Mary Cassatt. *The Caress*. 1902. Oil on canvas. National Museum of American Art, Smithsonian Institution, Washington, D.C. (gift of William T. Evans).

Cassatt is usually treated as an important American painter, a fine draughtswoman, a designer and colorist who specialized in the mother-and-child themes typical of the woman-artist. That may be true, but it misses the point. Maternal and domestic scenes were not thrust on her because they were expected of a woman-artist; she painted these subjects because that was what she cared about. Although very family-minded, Cassatt never married . . . for reasons we do not know. What we do know is what we see: an accurate, affectionate, but unsentimental portrayal of a mother and her children enjoying each other. Sometimes hungry artists paint well-fed people as a kind of wish-fulfillment. Not so in Cassatt's case. She was a healthy woman who painted healthy mothers and babies. There's nothing complicated about that.

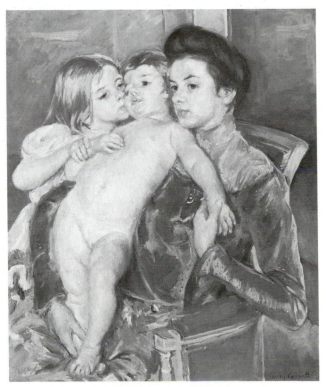

geopolitical reasons, the peoples outside the mainstream of western art history are endeavoring to make their contributions directly. Perhaps they are tired of being ignored or treated lightly. As for women artists, it is clear that their experience has been mainly available to the world of art in translation—that is, translation by men. The male translation is not necessarily bad or wrong, but it does not hurt to hear from the source.

The Poet as Model

If the problems of artistic hyphenation are being solved, more fundamental dilemmas remain: economic survival, creative durability. Here gallery artists are especially vulnerable. Today it appears that their prosperity—mainly during the twenty-year period following World War II

Georgia O'Keeffe. *The White Flower.* 1931. Oil on canvas. Whitney Museum of American Art, New York.

O'Keefe's flowers have been widely interpreted as metaphors for female sexuality. But it is a chaste sexuality. O'Keeffe employs the same austere approach to form in her paintings of animal bones, cow barns, and eroded hills. It is true that she dwells on mysterious depths and declivities, but they are singularly lacking in erotic content. The statement that recurs in her work again and again is purity, immaculateness, the world unsullied by the masculine principle. Is this feminist art? Not necessarily. Could it have been created by a man? Not likely.

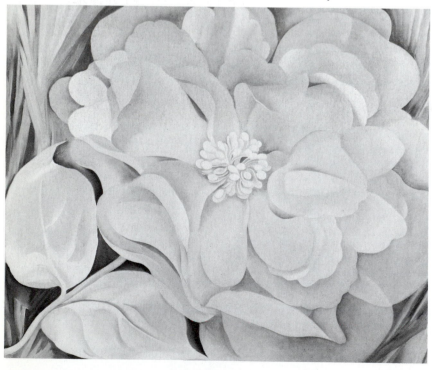

—was a temporary phenomenon. Henceforth, painters and sculptors, printmakers and craftsmen are likely to share the fate of poets and composers. A few "fine artists" may prosper and even wax wealthy under the patronage of the upper bourgeoisie. But most will probably revert to the marginal existence of the painters and sculptors left stranded by the French Revolution of 1789. Well, is the condition of the poet too dreadful to contemplate?

Poets, of course, do not expect to support themselves by the sale of their poems—with the exception of popular rhymsters like Edgar Guest or Rod McKuen. The serious poet usually has another job. Walt Whitman worked as a printer, a journalist, a nurse, and a schoolteacher. William Carlos Williams practiced medicine in Rutherford, New Jersey; Wallace Stevens was an insurance company executive in Hartford. Other examples could be cited. But it would be a mistake to think that Whitman, Williams, and Stevens found their "outside" jobs drearily oppressive. Indeed, writing poetry every day, *all* day, might be oppressive. This principle was well understood by the medieval monastics. St. Benedict

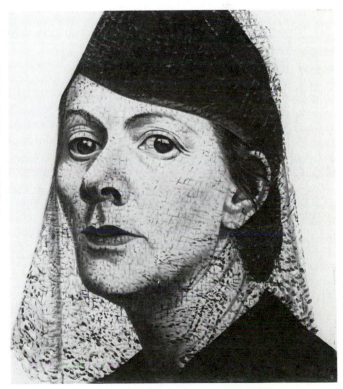

Charley Toorop. *Self-Portrait with Hat*. 1938. Oil on canvas. Stedelijk Museum, Amsterdam.

Like many woman-artists, Charley Toorop was the daughter of a painter, Jan Toorop. Jan had been a leader of the Symbolist movement in the Netherlands around 1900. Charley's style, however, is solidly in the realist camp. According to the woman-artist stereotype, she should have followed her father's example. The Symbolists had a penchant for hazy effects, moodiness, and representations of other-worldly experience—just the sort of thing sensitive females were suppose to relish. Well, Charley wouldn't have it. From her self-portrait, we can see why.

advocated a tripartite regimen of work, study, and prayer. This is to say that only a part of one's time can be spent effectively on creative work. Perhaps there is a case for the artist who works at another trade.

The great medieval philosopher Spinoza ground lenses to make a living; Rubens was a diplomat as well as an artist; Samuel Morse painted portraits and invented the telegraph; Thomas Eakins developed a workable motion-picture camera. It appears that the imaginative worker needs to grow humanly in order to grow artistically and intellectually. Consider the colonial preachers who were also farmers; this was

Isabel Bishop. *Two Girls.* 1936. Oil and tempera on composition board. Metropolitan Museum of Art, New York (Arthur H. Hearn Fund, 1936).

Isabel Bishop has built her reputation as a painter of working women and female nudes. Her approach is realistic but with a classical sense of selection. There is no explicit social commentary, no overt feminist message. Yet she seems to understand women—when they are alone or together—from a uniquely female perspective. Perhaps Raphael Soyer comes close to Bishop in his ability to represent a woman's sadness. But Bishop is the master of a different, possibly wider, range of feelings. She is especially good with intelligent but plain women, as in this painting. She understands what happens in an intimate exchange: the inquiring glance, the friendly appraisal, the tactful silence. Even her single figures appear to be engaged in dialogue. What we have here, in addition to superb modeling and draughtsmanship, is very intelligent painting.

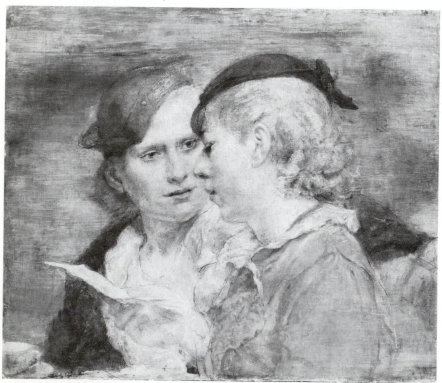

long the practice on the American frontier. Readers may judge whether today's full-time preachers are any better. In the 1930s the French worker-priest movement played a considerable role in the vitalization of the Catholic Church. For centuries religious orders of women have been involved in teaching, nursing, and social work as necessary complements to their lives of prayer and devotion. Obviously, there is a mutually enhancing relation between the everyday world of work and the private world of the artistic imagination. We may not wish to advocate a life of holy poverty for every creative worker, but we ought to recognize the value of nonartistic work for the artist. The good surgeon does surgery all the time, but art is different. For artists or poets complete immersion in painting or poetry is probably unhealthy from a physical and creative standpoint.

Why this stress on outside work for the artist? Because it counters the tendency to become wholly wrapped up in the internal problems of one's art. To be sure, a line must be drawn between the amateur and the professional. (See "The Artist and the Amateur," below.) Also, we have to recognize that technical mastery does not come except through hard, unremitting work at one's craft. Yet the artist needs to be warned against the perils of excessive specialization. It may lead to a kind of perfection, but beyond a certain point it becomes very like incest.

The Artist and the Critic

Artists never will be rid of critics even if that were desirable. Where there are huge rewards for even a few performers, there will be intense competition. And where reward is closely tied to successful competition, critics are inevitably involved. They create the arena of struggle, they build the publics that follow artistic developments, they announce artistic fashions and trends, they declare standards, they foment aesthetic controversies, they explain the value of the new, they destroy and resurrect reputations. Although the long-term consensus of history may overrule current critical judgments, living artists must contend with their short-term impact. So an artist's career is not built exclusively on the development of a unique outlook or the perfection of a unique style; it depends also on the critical reception of that style and outlook.

Why do critics have such power? Our system of artistic production for public display and purchase requires "outside" professionals to represent the aesthetic (and property) interests of buyers. It is interesting that critics have relatively little influence over transactions in the world

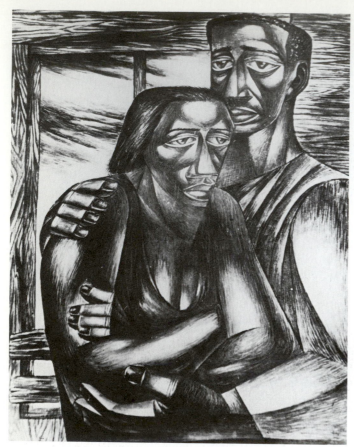

Charles White. *Two Alone*. 1946. Oil on canvas. Atlanta University Collection of Afro-American Art, Atlanta, Ga.

Truly hyphenated (his father was a Creek Indian), White has consistently addressed his art to black people, just as Siqueiros and Rivera (with whom he studied) tried to speak directly to Mexico's proletariat. At the same time, White's style is rooted in the European academic tradition. Hyphenation applies to form as well as race and culture; it can be a source of confusion, contradiction, or strength. Obviously, White is trying for strength. In this painting, he attempts to connect with the color, texture, and planarity of tribal woodcarving. He reaches for an African sense of mass and frontality without abandoning the Western conventions of drawing and modeling that he knows so well. It is a large order to fill. Still, artistic hybridization is responsible for some of the most impressive achievements of modernism. We have seen only the beginning of the contribution that the hyphenated artist will make along these lines.

of graphic design, industrial design, and large-scale architecture. That is because the public does not invest directly in these forms of artistic production. The critic becomes powerful when an intangible factor—the artist's reputation—plays a large role in establishing the prices of art-works. The connections among critical opinion, artistic reputation, and prices cannot be underestimated. This is clear when we consider the enormous price differences between the work of able but unknown artists and the work of able but famous artists. Where rising and falling reputations are involved, where art inventories are built on the basis of critical promotion, where prestige is measured by the ownership of rare and precious commodities, and where lay people do not trust their judgment about the value of an experience—here critics are powerful.

The power of a critic begins with the development of an authoritative voice, which translates into the "right" to rank artists, which amounts to the ability to determine their collectibility. This chain de-

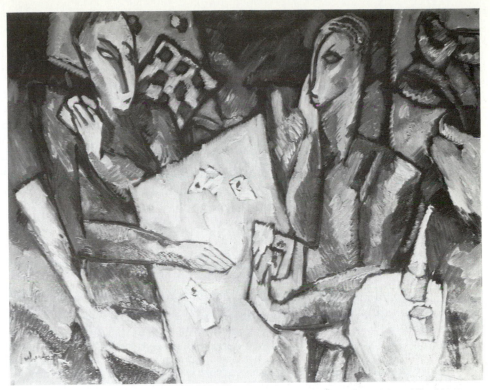

Hale Woodruff. *The Card Players.* 1930. Oil on canvas. National Archives, Washington, D.C. (Harmon Foundation).

Woodruff was a multifaceted person. An associate of the Mexican muralists Rivera and Orozco, a superb teacher, and a leader among American black artists, he had also lived and studied in France, where he gained a sophisticated understanding of school of Paris painting. *The Card Players* represents his endeavor to assimilate what he knew, where he had been, who he was. The result is a kind of synthesis—the card players of Cézanne passed through the consciousness of a black artist who knew what Picasso and Matisse were trying to do.

pends on the prior existence of a culture in which works of art are regarded as a precious commodity. In such a culture—*our* sort of culture —the critic is necessarily involved in the creative act. Thus, critics function as artistic accomplices, so to speak. Most artists would just as soon do without the help. What they want from critics is unstinting admiration. But that amounts to an infantile wish for the unquestioning, neverending love we get from our mothers.

The saga of the artist's perpetual search for love has certain comic overtones. There is also a cultural problem. The critic's participation in the creative process may represent the invasion of the aesthetic realm by nonartistic—especially pecuniary—motives. Even scholarly critics and

connoisseurs—those working in educational and museum settings—find it exceedingly difficult to ignore the existence of art markets and hence the investment values of works of art. However, in the absence of money motives, others—perhaps more unattractive—might enter the picture. What this means is that there is no way for art to be created in a political or ideological vacuum.

Here we might summarize the roots of the artist-critic antagonism. From the standpoint of artists, the function of the critic is to celebrate their work, to extend their reputations, to explain why their work is good. From the standpoint of the critic, the artist creates the raw

Jacob Lawrence. *Going Home.* 1946. Tempera. Collection IBM Corporation, courtesy Terry Dintenfass Gallery, New York.

The train carrying blacks back to the South for a vacation. Probably they work in Harlem, Newark, or Detroit. Lawrence is not a painter of cotton-pickers; he is strictly a big-city artist. And what he tells us about black people up North is that they are funny and sad, frantic and tired. Lawrence taught with Josef Albers at Black Mountain College, but we can see that the austere Bauhaus geometries associated with that school were not for him. He may use flat patterns, hard edges, and angular forms, but they are meant to convey the gait and movement, the fatigue and boredom, of urban blacks accustomed to fitting themselves into narrow spaces and getting a rest where they can. He also paints a man reaching for a suitcase with the sure moves of a basketball player about to sink a basket. This sort of geometry was not taught at the Bauhaus; it comes from direct observation.

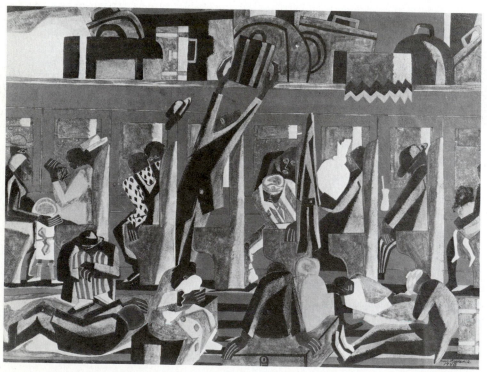

material for an important dialogue with the public. Enlightened artists may concede a critic's special ability to sharpen the public's sensibilities and heighten its perceptions of meaning. Enlightened critics may concede that artists have some inkling of the meaning and value of their work. What artists resent is *the flow of power* to critics precisely because of their ability to discover and publicize aesthetic values. So we have the spectacle of an adversary relationship between two mutually dependent cultural workers. John Gardner puts it well when he says: "Thus criticism and art, like theology and religion, are basically companions but not always friends."[2]

Romare Bearden. *The Prevalence of Ritual: Baptism.* 1964. Pencil and synthetic polymer paint on composition board. Hirshhorn Museum and Sculpture Garden, Smithsonian Institution, Washington, D.C.

The black experience: in the tenements, in the streets, in the church. Again, the form-language is drawn from the Cubist experiments of Picasso, Braque, and Gris. But the content is straight out of the beauty shops, storefront chapels, and funeral parlors of Harlem. Bearden's use of collage is almost cinematic; he employs pieces of photographs, patches of cloth, and fragments of newspaper to convey his urgent sense of life—life oozing out of the brick walls, stone porches, and concrete sidewalks of the inner city. And always there are eyes—mostly sad. He juxtaposes the eyes of an African funerary mask with the eyes of a black youngster and asks us to make the connection.

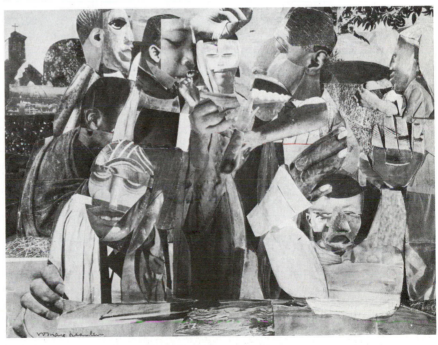

The artist-critic interdependence, like a marriage, has its ups and downs. For artists it is psychologically and socially painful. Dependence makes them realize that they are fundamentally artisans, workers, more or less well-paid. Since the eighteenth century many artists have come to think of themselves as free intellectuals, as professional persons who set the terms of their employment. Their model, of course, is the lawyer or the physician—both members of powerful professional guilds. Only a surgeon criticizes the work of another surgeon; only lawyers examine the fitness of lawyers. But artists are subject to the vagaries of public taste—taste shaped by members of another guild, the critic's guild. Critics were apprenticed to professors of history or literature; artists were apprenticed to other artists. How galling it is to be judged by strangers! That is the root of the enmity between those who create and those who comment.

Can there be any sort of truce? Yes, if we recognize that the division of labor between artists and critics is necessary because artists live in and depend on society, however much they may feel estranged from it. Collectors cannot rely on the aesthetic detachment of dealers, and artists lack the time or inclination to defend each other's work. Furthermore, ordinary viewers need instruction and guidance. Originality and rare forms of excellence require champions, and critics are better placed than artists to push unpopular causes. So the tension between those who create and those who criticize is probably inevitable. There is no reason to complain about it. That tension is our best guarantee of a lively visual culture.

The Artist and the Amateur

When they are not grumbling about critics, artists grumble about amateurs—amateurs who rent gallery space, amateurs whose art is admired and written up, amateurs who have the effrontery to sell their work (for good prices!), amateurs who confuse the public and lower its standards, amateurs who unwittingly burlesque or badly imitate the major museum and gallery artists. The dilettante sculptor, the Sunday painter, the weekend potter, the kitschy craftsman—these part-timers are regarded as poisoners of the aesthetic wells, and they are usually held in contempt by those who spend their lives working to make a living through art. Serious artists think of themselves as struggling to create forms that will endure through the ages; it pains them when amateurs enjoy the benefits of that struggle.

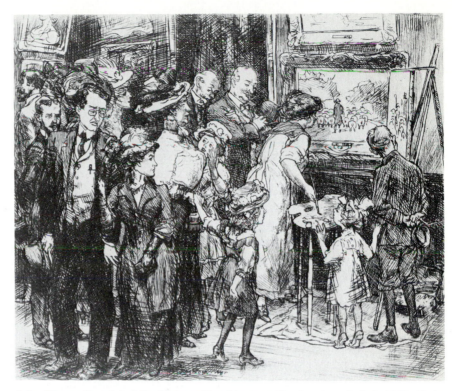

John Sloan. *Copyist at the Metropolitan Museum (An Amateur Artist).* 1908. Etching. National Museum of American Art, Smithsonian Institution, Washington, D.C. (gift of Mr. and Mrs. Harry Baum in memory of Edith Gregor Halpert).

Half a century ago copyists were a frequent sight in the world's major museums. Most were students or amateurs. The students were trying to learn the secrets of the masters; the amateurs simply enjoyed what they were doing. Sloan portrays himself and a companion in the foreground of his etching. Both are disgusted by the spectacle of the copyist and her admiring crowd. A matron and her children watch as the copyist tries to fathom the mystery of a pastoral scene; a child seems to be smelling the paint on her palette; a dignified old gent stands at reverent attention next to the copyist. And she works away, oblivious of her public. Her adulating public! That's what angers the "real" artist.

What can we say to the unhappy professional? There have always been amateurs, but never so many. At this moment it seems as though every other American citizen is exhibiting raku pots, enamel-on-copper jewelry, or watercolor paintings of eucalyptus trees. But is that an unmitigated aesthetic disaster? Actually, many part-time artists and craftsmen are exceedingly able. In addition, it can be argued that they are fertilizing the creative soil, the aesthetic humus, from which a high artistic culture may eventually emerge.

Assuming that the growth of amateurism is beneficial in an overall cultural sense, do we also anticipate a situation in which the professional simply disappears into a population consisting almost wholly of artists? Are we approaching the point where the line between the professional and the amateur is invisible because it has become unnecessary? No, the differences between professionals and amateurs are real and necessary. There are differences in artistic preparation and in quantity of output. There are differences in compensation; amateurs do not reckon their costs, hence their prices, the way professionals do. Most significant, there are differences in sponsorship. Amateurs are their own patrons; they initiate and subsidize their own artistic activity. The professional, however, usually works with someone else in mind. We cannot overestimate the importance of the social connection, the social obligation, the relationship between the professional artist and his or her sponsoring public. By this we mean the public as it is represented by clearly definable institutions and agencies: museums and galleries, business firms, educational bodies, religious denominations, professional and workers' associations, political parties, government, communications systems.

This distinction between the amateur and the professional is crucial. It leads us to the following basic proposition: when the artistic act is socially isolated, when artists are their own patrons, then they are fundamentally no different from amateurs. After all, amateurs can be, and often are, exceedingly good from a technical standpoint. It is the artist's dialogue with society that defines his or her professionalism. This is not merely a matter of external pressure on the artist; the relationship with a sponsor other than oneself has a direct effect on the creative process. Hence, social relationships affect artistic forms. If the professional's work looks different, that is because it grows out of a real or strongly felt dialogue with individuals or groups who care about, and have an interest in, what the artist makes. What distinguishes professionals from amateurs, then, is the kind of dialogue that informs their creative effort.

With this in mind, we can attempt, finally, to define the artist.

Who Is an Artist?

If nothing else, this book should have demonstrated that there are many kinds of artists, many sorts of people who call themselves artists. Even amateurs belong; we call them amateur-artists as distinct from professional-artists. The hyphen is useful here.

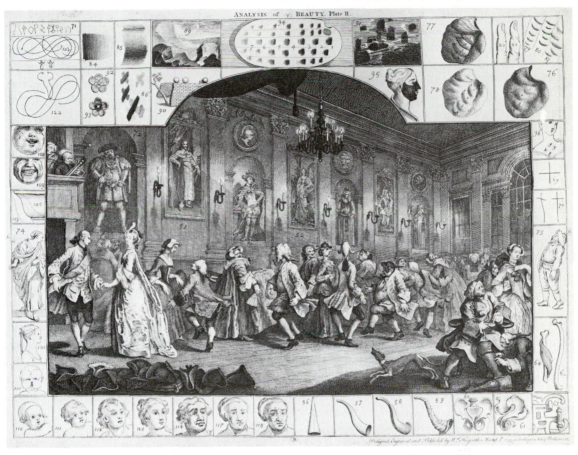

William Hogarth. *The Analysis of Beauty,* detail. 1753. Engraving. New York Public Library (Astor, Lenox, and Tilden Foundations).

Compare the gyrating rustics in this engraving with the solemn tourists in Zoffany's *Tribuna of the Uffizi* (p. 83). This is the second of two plates Hogarth engraved to illustrate his book on art and beauty. In it he gave instruction to art students and offered opinions (mostly negative) on world travelers, picture dealers, critics, and connoisseurs. The book made him a number of enemies and brought him considerable personal abuse. Hogarth speaks of the country dance scene as a demonstration of the "unnatural and ridiculous" effects an artist can achieve with combinations of straight lines and the S-curve, which he called "The Line of Beauty." The images of the noble lords and ladies on the walls of the great room are supposed to show how straight lines and restrained curves produce the effects of astonishment, dignity, and grace. Well, the spectacle is certainly ridiculous. These periwigged folk look like a bunch of picnickers attacked by ants. Hogarth's genius was for comedy and satire, not aesthetic theory. While the picture is very funny, Hogarth is not especially convincing at explaining why. Stated otherwise, his art is better than his argument. The moral of this story? Artists are wise to let others discuss their work.

Perhaps the question should be rephrased: Who is a professional artist? Now the answer is easier. A professional is anyone who makes a living as an artist. We should add that a professional is not necessarily a good artist, but only someone who gets paid for his or her work. We commonly use the word "artist" to designate a very good performer, but that usage creates problems, since there are obviously many artists who live by the sale of their work or artistic services but who are not especially good when it comes to judging excellence. (Incidentally, the existence of bad art is very important. It reminds us that failure is always possible—for the professional as well as the amateur.) What should be added is that it is one of the functions of criticism, operating over a period of time, to determine what is good art and therefore who is a good artist. The word "artist" like the word "carpenter," "lawyer," or "dentist" does not by itself guarantee superb performance.

Is there any common attribute of the various kinds of artists we have examined: professionals and amateurs, young and old, originators and imitators, famous and unknown, rich and poor? I believe there is. Regardless of the media employed by these individuals, regardless of their status, and regardless of the era in which they lived, we encounter their work in the form of images. Even buildings and battleships are images; we see them as we use them. Hence, an artist might be defined as a person (sometimes a group of persons working together) who makes images. Furthermore, those images are made *for others to see.*

Images made for others to see—that should serve nicely as a definition of art. It gets at the point I have been trying to make throughout this book: the social point, the idea of art as communication, as expression intended to be understood, as form meant to be used while it is seen, as shared experience, as the endeavor to reach people through their eyes, as the visual record of our common joys and sorrows. The artist is just someone who sets these processes into motion.

Concluding Thoughts

It has been an interesting voyage from the shaman to the slave artisan to the designer to the gallery idol to the amateur triumphant. It prepared us, I believe, to answer the question raised at the beginning of the book: Who is the artist? We have seen that the processes of historical and social change made that question far from easy to answer.

When we encounter an artist today, he or she is likely to be a modern incarnation of one of the historic types described herein—or if not a reincarnation, then a hybrid of several of them. Even among practitioners of new art forms—photography, cinema, television, and industrial design—we can recognize the persistence of old, well-established types. The fastidious craftsman, the conservative guildsman, the genius-inventor, and the fierce revolutionary—they still circulate among us.

Let me be specific. Chagall is a conjurer, a throwback to the shaman-visionary; Nevelson is a sorcerer, a living successor to the temple priestesses of the ancient world; Klee is a wizard, a descendant of the Stone Age magician-tricksters; Picasso is a mimic, an offshoot of the prehistoric impersonators who disguised themselves as animals or devils.

Today it would not be difficult to find a fragment of Leonardo's genius in a successful product designer, a morsel of Dürer in a good scientific illustrator; a piece of Michelangelo in one of those contemporary architects who find tensions in steel and muscles in concrete.

What this shows, if I am right, is that art and artists go forward only by consolidating and renewing their past. The same cannot be said of science, which advances by throwing off its past. Indeed, it would be dangerous for a modern physician to practice the medicine of Hippocrates, but classical Greek sculpture still looks good. This does not mean that artists are better than scientists—only that they are different.

Artists practice a profession that obliges them to see in two directions at once, like Janus, the two-faced deity of Roman myth. That twin vision—so necessary to avoid being trapped by immediate sensation—is not easy to live with, but it also has its satisfactions. Otherwise, art would have died out long ago, replaced by the latest technological breakthrough. I am sure that will not happen. The artist-type will continue to evolve.

bibliography

Antal, Frederick. *Florentine Painting and Its Social Background.* London: Kegan Paul, 1948.

Argyle, Michael. *The Social Psychology of Work.* New York: Taplinger, 1972.

Arnheim, Rudolph. *Visual Thinking.* Berkeley and Los Angeles: University of California Press, 1971.

Barnicoat, John. *A Concise History of Posters.* London: Thames and Hudson, 1972.

Baxandall, Michael. *Painting and Experience in Fifteenth Century Italy.* London: Oxford University Press, 1972.

Behrman, S. N. *Duveen.* New York: Random House, 1951.

Berger, John. *The Success and Failure of Picasso.* Harmondsworth, Middlesex, Eng.: Penguin, 1965.

Best, Fred, ed. *The Future of Work.* Englewood Cliffs, N.J.: Prentice-Hall, 1973.

Isabel Bishop. Retrospective exhibition catalogue. Tucson, Ariz.: University of Arizona Museum of Art, 1974.

Blunt, Anthony. *Artistic Theory in Italy 1450–1600.* London: Oxford University Press, 1962.

Borne, Etienne, and Francois Henry. *A Philosophy of Work.* London: Sheed and Ward, 1938.

Brentano, Lujo. *On the History and Development of Gilds, and the Origins of Trade-Unions.* London: Trubner, 1870.

Brochmann, Odd. *Good or Bad Design?* London: Studio Vista, and New York: Van Nostrand Reinhold, 1970.

Burford, Alison. *Craftsmen in Greek and Roman Society.* Ithaca, N.Y.: Cornell University Press, 1971.

Burnham, Sophy. *The Art Crowd.* New York: McKay, 1973.

Callen, Anthea. *Woman Artists of the Arts and Crafts Movement 1870–1914.* New York: Pantheon, 1979.

Cardinal, Roger. *Outsider Art.* New York: Praeger, 1972.

Carpenter, Edmund. *Eskimo Realities.* New York: Holt, Rinehart and Winston, 1973.

Cassou, Jean, Emil Langui, and Nikolaus Pevsner. *Gateway to the Twentieth Century: Art and Culture in a Changing World.* New York: McGraw-Hill, 1962.

Cellini, Benvenuto. *Autobiography.* Garden City, N.Y.: Doubleday, 1960.

Chamberlain, Betty. *The Artist's Guide to His Market.* New York: Watson-Guptill, 1970.

Chase, Judith Wragg. *Afro-American Art and Craft.* New York: Van Nostrand Reinhold, 1971.

Childe, V. Gordon. *What Happened in History.* London: Penguin, 1942.

Christensen, Erwin O. *Primitive Art.* New York: Viking, 1955.

Clark, Kenneth. *The Romantic Rebellion.* New York: Harper & Row, 1973.

Coke, Van Deren. *The Painter and the Photograph.* Rev. ed. Albuquerque: University of New Mexico Press, 1972.

Coon, Carleton S. *The Hunting Peoples.* Boston: Little, Brown, 1971.

Crone, Rainer. *Andy Warhol.* New York and Washington: Praeger, 1970.

D'Ancona, Paulo. *Modigliani, Chagall, Soutine, Pascin.* Milan: Edizioni del Milione, 1971.

Diehl, Gaston. *Pascin.* New York: Crown, 1971.

Dockstader, Frederick. *Indian Art in America.* Greenwich, Conn.: New York Graphic, 1968.

Dorfles, Gillo. *Kitsch: The World of Bad Taste.* New York: Universe, 1970.

Duby, Georges. *Foundations of a New Humanism: 1280–1440.* Geneva: Skira, 1966.

Easton, Malcolm. *Artists and Writers in Paris.* New York: St. Martin's, 1964.

Egbert, Donald Drew. *Social Radicalism and the Arts, Western Europe.* New York: Knopf, 1970.

Egbert, Virginia Wylie. *The Medieval Artist at Work.* Princeton, N.J.: Princeton University Press, 1967.

Evans-Pritchard, Professor Sir Edward, ed. *Man the Craftsman.* Vol. 19. Danbury, Conn: Grolier, 1972.

Evers, H. G. *The Art of the Modern Age.* London: Methuen, 1970.

Ewen, Stuart. *Captains of Consciousness: Advertising and the Social Roots of the Consumer Culture.* New York: McGraw-Hill, 1976.

Fairservis, Walter A., Jr. *The Threshold of Civilization: An Experiment in Prehistory.* New York: Scribner's, 1975.

Feder, Norman. *Two Hundred Years of North American Indian Art.* New York: Praeger, 1970.

Ferebee, Ann. *A History of Design from the Victorian Era to the Present.* New York: Van Nostrand Reinhold, 1970.

Fermingier, André. *Toulouse-Lautrec.* New York: Praeger, 1969.

Fine, Elsa Honig. *The Afro-American Artist: A Search for Identity.* New York: Holt, Rinehart and Winston, 1971.

Fletcher, Alan, Colin Forbes, and Bob Gill. *Graphic Design: Visual Comparisons.* London: Studio Vista, and New York: Van Nostrand Reinhold, 1963.

Fraser, Douglas. *The Many Faces of Primitive Art: A Critical Anthology.* Englewood Cliffs, N. J.: Prentice-Hall, 1966.

Freudenheim, Tom L. *Pascin.* Berkeley: University Art Museum, University of California, 1966.

Friedländer, Max J. *On Art and Connoisseurship.* Oxford: Bruno Cassirer, 1942.

Fundaburk, Emma, and Thomas G. Davenport. *Art in Public Places in the United States.* Bowling Green, Ohio: Bowling Green University Popular Press, 1975.

Gallo, Max. *The Poster in History.* New York: McGraw-Hill, 1974.

Gedo, Mary Mathews. *Picasso: Art as Autobiography.* Chicago: University of Chicago Press, 1980.

Getlein, Frank, and Dorothy Getlein. *The Bite of the Print.* New York: Bramhall, 1962.

Giedion, Siegfried. *Mechanization Takes Command.* New York: Oxford University Press, 1948.

Gilot, Francoise, and Carlton Lake. *Life with Picasso.* New York: McGraw-Hill, 1964.

Gimpel, René. *Diary of an Art Dealer.* New York: Farrar, Straus and Giroux, 1966.

Goldwater, Robert. *Primitivism in Modern Art,* New York: Harper & Row, 1938.

———, and Marco Treves. *Artists on Art.* New York: Pantheon, 1947.

Goodrich, Lloyd. *Winslow Homer.* New York: Braziller, 1959.

Gottlieb, Carla. *Beyond Modern Art.* New York: Dutton, 1976.

Gowans, Alan. *The Unchanging Arts.* Philadelphia: Lippincott, 1971.

Grana, Cesar. *Bohemian Versus Bourgeois.* New York: Basic, 1964.

Grosser, Maurice. *Painting in Public.* New York: Knopf, 1948.

Hadas, Moses. *Hellenistic Culture: Fusion and Diffusion.* New York: Columbia University Press, 1959.

Haftmann, Werner. *Painting in the Twentieth Century.* 2 vols. New York: Praeger, 1960.

Hamilton, Edward A. *Graphic Design for the Computer Age.* New York: Van Nostrand Reinhold, 1970.

Hammacher, A. M. *Genius and Disaster, The Ten Creative Years of Vincent van Gogh.* New York: Abrams, 1968.

Harvey, John. *The Master Builders: Architecture in the Middle Ages.* New York: McGraw-Hill, 1971.

Harvey, John Hooper. *The Mediaeval Architect.* London: Wayland, 1972.

Haskell, Frederick. *Patrons and Painters.* New York: Knopf, 1963.

Hauser, Arnold. *The Social History of Art.* 2 vols. New York: Knopf, 1951.

———. *The Philosophy of Art History.* New York: Knopf, 1959.

Hawkes, Jacquetta. *Prehistory: History of Mankind, Cultural and Scientific Development.* Vol. 1, Part I. New York: Mentor, 1963.

Hemphill, Herbert W., Jr. *Folk Sculpture U.S.A.* New York: Brooklyn Museum, 1975.

Hess, Thomas B., and Elizabeth C. Baker, eds. *Art and Sexual Politics.* New York: Macmillan, 1972.

Hodin, J. P. *Modern Art and the Modern Mind.* Cleveland and London: Press of Case Western Reserve University, 1972.

Hogarth, William. *The Analysis of Beauty: Written with a view of fixing the fluctuating Ideas of Taste.* London: Reeves, 1753.

Howell, George. *Trade Unionism, New and Old.* London: Methuen, 1907.

Huyghe, René. *Larousse Encyclopedia of Prehistoric and Ancient Art.* New York: Prometheus, 1962.

Jacobs, Jane. *The Death and Life of Great American Cities.* New York: Random House, 1961.

Janis, Sidney. *They Taught Themselves: American Primitive Painters of the 20th Century.* Port Washington, N.Y.: Kennikat, 1942.

Kahnweiler, Daniel-Henry, with Francis Cremieux. *My Galleries and Painters.* New York: Viking, 1971.

Kearns, Martha. *Kathe Kollwitz: Woman and Artist.* New York: Feminist Press, 1976.

Keen, Geraldine. *Money and Art: A Study Based on the Times-Sotheby Index.* New York: Putnam's, 1971.

Kelly, Francis. *The Studio and the Artist.* London: David and Charles, 1974.

Key, Wilson Bryan. *Subliminal Seduction.* Englewood Cliffs, N.J.: Prentice-Hall, 1973.

Klingender, Francis D. *Art and the Industrial Revolution.* Rev. ed. London: Evelyn, Adams and MacKay, 1968.

Kranzberg, Melvin, and Joseph Gies. *By the Sweat of Thy Brow.* New York: Putnam's 1975.

Kuhns, William, and Robert Stanley. *Exploring the Film.* Dayton, Ohio: Pflaum, 1968.

Kulski, Julian Eugene. *Architecture in a Revolutionary Era.* Nashville, Tenn.: Aurora, 1971.

Lang, Berel, and Forrest Williams, eds. *Marxism and Art: Writings in Aesthetics and Criticism.* New York: McKay, 1972.

Lazzaro, G. di san. Trans. Baptista Gilliat-Smith and Bernard Wall. *Painting in France, 1895–1949.* New York: Philosophical Library, 1949.

Leuzinger, Elsy. *Art of Africa.* New York: Crown, 1967.

Levey, Michael. *Painting at Court.* New York: New York University Press, 1971.

Leymarie, Jean. Trans. James Emmons. *Who Was Van Gogh?* Geneva: Skira, 1968.

Lindsay, Jack. *The Ancient World: Manners and Morals.* New York: Putnam's, 1968.

Lipman, Jean. *Provocative Parallels.* New York: Dutton, 1975.

Lippard, Lucy R. *From the Center.* New York: Dutton, 1976.

Loevgren, Sven. *The Genesis of Modernism.* Bloomington: Indiana University Press, 1976.

Lommel, Andreas. *Landmarks of the World's Art: Prehistoric and Primitive Man.* New York: McGraw-Hill, 1966.

———. *Shamanism: The Beginnings of Art.* New York: McGraw-Hill, 1967.

———. *Masks: Their Meaning and Function.* New York: McGraw-Hill, 1972.

Lucie-Smith, Edward. *Symbolist Art.* London: Thames and Hudson, 1972.

Lynes, Russell. *The Tastemakers.* New York: Harper, 1955.

Martin, Alfred von. *Sociology of the Renaissance.* New York: Harper & Row, 1963.

Martindale, Andrew. *The Rise of the Artist in the Middle Ages and Early Renaissance.* New York: McGraw-Hill, 1970.

Mayhall, W. H. *Machines and Perception in Industrial Design.* London: Studio Vista, 1968.

McCausland, Elizabeth. *Work for Artists: What? Where? How?* New York: American Artists Group, 1947.

McIlhany, Sterling. *Art as Design: Design as Art.* New York: Van Nostrand Reinhold, and London: Studio Vista, 1970.

McLuhan, Marshall. *Understanding Media: The Extensions of Man.* New York: McGraw-Hill, 1966.

Meyer, Susan E. *America's Great Illustrators.* New York: Abrams, 1977.

Mossé, Claude. *The Ancient World at Work.* London: Chatto & Windus, 1969.

Mulas, Ugo, and Alan Solomon. *New York: The New Art Scene.* New York: Holt, Rinehart and Winston, 1967.

Mumford, Lewis. *The City in History.* New York: Harcourt, Brace, Jovanovich, 1961.

Munsterberg, Hugo. *A History of Women Artists.* New York: Potter, 1975.

Myers, Bernard S. *Problems of the Younger American Artist.* New York: City College Press, 1957.

Naifeh, Steven W. *Culture Making: Money, Success, and the New York Art World.* Princeton, N.J.: Princeton University Press, 1976.

Nelson, George. *Problems of Design.* New York: Whitney, 1965.

Newton, Eric. *The Romantic Rebellion.* London: Longmans, Green, 1962.

Nochlin, Linda. *Realism.* Baltimore: Penguin, 1971.

Pelles, Geraldine. *Art, Artists & Society: Origins of a Modern Dilemma.* Englewood Cliffs, N.J.: Prentice-Hall, 1963.

Pericot-Garcia, Luis, John Galloway, and Andreas Lommel. *Prehistoric and Primitive Art.* New York: Abrams, 1968.

Perruchot, Henry. *Toulouse-Lautrec: A Definitive Biography.* Cleveland: World, 1961.

Peterson, Karen, and J. J. Wilson. *Women Artists.* New York: New York University Press, 1976.

Pevsner, Nikolaus. *Academies of Art, Past and Present.* Cambridge: Cambridge University Press, 1940.

———. *Pioneers of Modern Design from William Morris to Walter Gropius.* New York: Museum of Modern Art, 1949.

Plekhanov, G. V. *Art and Social Life.* London: Lawrence and Wishart, 1953.

Plumb, J. H. *The Horizon Book of the Renaissance.* New York: American Heritage, 1961.

Porter, Fairfield. *Thomas Eakins.* New York: Braziller, 1959.

Prinzhorn, Hans. *Artistry of the Mentally Ill.* Heidelberg: Springer-Verlag, 1972.

Pye, David. *The Nature of Design.* London: Studio Vista, and New York: Reinhold, 1964.

Rank. Otto. *Art and the Artist: Creative Urge and Personality Development.* New York: Tudor, 1932.

Raphael, Max. *Prehistoric Cave Paintings.* New York: Pantheon, 1945.

Read, Herbert. *Art and Industry.* London: Faber and Faber, 1934.

———. *Art and Society.* New York: Schocken, 1966.

———. *Art and Alienation.* New York: Viking, 1969.

Reed, Alma. *Orozco.* New York: Oxford University Press, 1956.

Renard, Georges. *Guilds in the Middle Ages.* London: G. Bell, 1918.

Rewald, John. *Post-Impressionism from Van Gogh to Gauguin.* New York: Museum of Modern Art, 1956.

Richardson, Joanna. *The Bohemians.* New York: Barnes, 1971.

Robertson, Bryan, John Russell, and Lord Snowden. *Private View: The Lively World of British Art.* London: Thomas Nelson, 1965.

Rosenberg, Bernard, and Norris Fliegel. *The Vanguard Artist: Portrait and Self-Portrait.* Chicago, Quadrangle, 1965.

Roskill, Mark. *Van Gogh, Gauguin and the Impressionist Circle.* Greenwich, Conn.: New York Graphic, 1970.

Rudofsky, Bernard. *Streets for People.* Garden City, N.Y.: Doubleday, 1969.

Sandars, Nancy K. *Prehistoric Art in Europe.* Pelican History of Art. Baltimore: Penguin, 1968.

Sandler, Irving. *The Triumph of American Painting.* New York: Praeger, 1973.

Schaefer, Herwin. *The Roots of Modern Design.* London: Studio Vista, 1970.

Schapiro, Meyer. *Vincent Van Gogh.* New York: Abrams, 1950.

Schmalenbach, Werner. *African Art.* New York: Macmillan, 1954.

Schutte, Thomas F., ed. *The Uneasy Coalition: Design in Corporate America.* Philadelphia: University of Pennsylvania Press, 1975.

Schwarz, Michael. *The Age of the Rococo.* New York: Praeger, 1971.

Shapiro, David, ed. *Social Realism: Art as a Weapon.* New York: Ungar, 1973.

Shearman, John. *Mannerism.* Baltimore: Penguin, 1967.

Shorter, Edward, ed. *Work and Community in the West.* New York: Harper & Row, 1973.

Sloan, John. *Gist of Art.* New York: American Artists Group, 1939.

Smeets, René. *Signs, Symbols & Ornaments.* New York: Van Nostrand Reinhold, 1975.

Sommer, Robert. *The Behavioral Basis of Design.* Englewood Cliffs, N.J.: Prentice-Hall, 1969.

Steegman, John. *Victorian Taste: A Study of the Arts and Architecture from 1830–1870.* Cambridge, Mass.: M.I.T. Press, 1971.

Storm, John. *The Valadon Drama.* New York: Dutton, 1958.

Sutton, Denys. *Triumphant Satyr: The World of Auguste Rodin.* New York: Hawthorn, 1966.

Swinton, George. "Eskimo Art Reconsidered," *Artscanada,* December 1971/January 1972, pp. 85–94.

Tomkins, Calvin. *The Scene: Reports on Post-Modern Art.* New York: Viking, 1970.

Vasari, Giorgio. *The Lives of the Most Eminent Painters, Sculptors and Architects.* New York: Simon and Schuster, 1959.

Venturi, Lionello. *Modern Painters.* New York: Scribner's, 1947.

Wittcower, Rudolf, and Margot Wittcower. *Born Under Saturn: The Character and Conduct of Artists: A Documented History from Antiquity to the French Revolution.* New York: Random House, 1963.

Wooley, Sir Leonard. *The Beginnings of Civilization.* New York: Mentor, 1965.

Wraight, Robert. *The Art Game Again!* London: Leslie Frewn, 1974.

Zimenko, Vladislav. *The Humanism of Art.* Moscow: Progress, 1976.

NOTES TO THE TEXT

Chapter 1

1. Carleton S. Coon, *The Hunting Peoples* (Boston: Little, Brown and Company, 1971).
2. See Lommel, *Shamanism: The Beginnings of Art* (New York: McGraw-Hill, 1967); and *Landmarks of the World Art: Prehistoric and Primitive Man* (New York: McGraw-Hill, 1966).
3. See Edmund Carpenter, *Eskimo Realities* (New York: Holt, Rinehart and Winston, 1973).
4. *Ibid.*, p. 71.

Chapter 3

1. *What Happened in History* (London: Penguin Books, 1942).
2. *Art and Society* (New York: Schocken Books, 1966), p. 22.
3. *Architecture Through the Ages* (New York: G. P. Putnam's Sons, 1940), p. 511.

Chapter 4

1. Leonard Wooley, *The Beginnings of Civilization* (New York: Mentor Books, 1965), p. 296.

Chapter 6

1. Anthony Blunt, *Artistic Theory in Italy: 1450–1600* (London: Oxford University Press, 1940), p. 53.

Chapter 7

1. See John Berger, *The Success and Failure of Picasso* (Harmondsworth, Middlesex, England: Penguin Books, 1965).
2. In 1934, at the All-Union Congress of Soviet Writers.

Chapter 8

1. Quoted in Edward Lucie-Smith, *Symbolist Art* (London: Thames and Hudson, 1972), p. 183.

2. Statement to Edward Teriade, 1932. Quoted in Germaine Bazin, *The Avant-Garde in Painting* (New York: Simon and Schuster, 1969), p. 265.
3. Rudolf and Margot Wittcower, *Born Under Saturn: The Character and Conduct of Artists: A Documented History from Antiquity to the French Revolution* (New York: Random House, 1963).

Chapter 9

1. See Rudolph Arnheim, *Visual Thinking* (Berkeley and Los Angeles: University of California Press, 1971).
2. Albert Christ-Janer, *Boardman Robinson* (Chicago: University of Chicago Press, 1946).
3. David Riesman, *The Lonely Crowd* (New Haven: Yale University Press, 1973).

Chapter 10

1. See *Survival Through Design* (New York: Oxford University Press, 1954).

Chapter 11

1. Bryan Robertson, John Russell, and Lord Snowdon, *Private View: The Lively World of British Art* (London: Thomas Nelson and Sons, 1965), p. 26.
2. *Ibid.*, p. 27.
3. Daniel-Henry Kahnweiler with Frances Cremieux, *My Galleries and Painters* (New York: The Viking Press, 1971), p. 88.
4. Sophy Burnham, *The Art Crowd* (New York: David McKay Co., 1973), p. 4.

Chapter 12

1. Linda Nochlin, "Why Have There Been No Great Women Artists?" *Art News* (January 1971).
2. John Gardner, *On Moral Fiction* (New York: Basic Books, 1978), p. 8.

INDEX

A page number in *italic type* refers to an illustration.

Photographic Credits